3/2000

PAINTING
MASTERPIECES

3/2000

PAINTING
MASTERPIECES

CONSULTANT EDITOR
MARK CHURCHILL

Sterling Publishing Co., Inc.
New York

Contributors

Consultant editor

Mark Churchill

Contributing artists

Michael Copas

Barbara Dorf

Richard Eastwood

Ian Sidaway

Donald Stubbs

Tony Tribe

A QUANTUM BOOK

Library of Congress Cataloging-in-Publication Data
is available upon request

10 9 8 7 6 5 4 3 2 1

Published in 1998 by Sterling Co., Inc.
387 Park Avenue South
New York, NY 10016

Copyright ©1982 Quarto Publishing Inc.

Distributed in Canada by Sterling Publishing
c/o Canadian Manda Group
One Atlantic Avenue, Suite 105
Toronto, Ontario, Canada M6K 3E7

This book is produced by
Quantum Books Ltd
6 Blundell Street
London N7 9BH

QUMPYM

Printed and bound in Singapore by
Star Standard Industries Pte. Ltd

ISBN 0-8069-3768-8

Art director Alastair Campbell
Production director Edward Kinsey
Editorial director Jeremy Harwood
Senior editor Kathy Rooney
Editors Nicola Thompson, Judy Martin
Art editor Caroline Courtney
Paste-up Janel Minors, Richard Sloan
Special photography Jon Wyand

QED would like to thank the many art galleries and
copyright holders, particularly S.P.A.D.E.M., for their
invaluable cooperation in the preparation of this book.
We would also like to thank Langford & Hill Ltd, London
and Green's Art & Graphics Supplies Ltd, Harrow for
kindly supplying materials for photography. Thanks
also to Annie Collenette and Paul Griffiths for their help.

Contents

Foreword		6
Editor's note		7
Introduction	Historical background, equipment and materials	8
Van Eyck	Man in a Turban	24
Botticelli	The Birth of Venus (detail)	28
Dürer	Young Hare	32
Leonardo	Mona Lisa	38
Michelangelo	Delphic Sibyl (detail from Sistine Chapel ceiling, Rome)	44
Titian	Mother and Child	48
Velazquez	Old Woman Cooking Eggs	52
Rubens	Portrait of Susanna Lunden	56
Rembrandt	A Woman Bathing in a Stream	62
Vermeer	Head of a Girl with Pearl Earring	68
Chardin	Still Life: The Kitchen Table	72
Constable	Boatbuilding near Flatford Mill	76
Turner	Norham Castle	80
Millet	The Gleaners	84
Manet	Olympia	88
Whistler	Harmony in Gray and Green – Miss Cicely Alexander	94
Rossetti	Proserpine	98
Renoir	Woman's Torso in Sunlight	104
Cézanne	Mont Sainte-Victoire	108
Cassatt	The Sisters	112
Seurat	Bridge at Courbevoie	116
Degas	Woman Combing her Hair	120
Van Gogh	Cornfield and Cypress Trees	124
Toulouse-Lautrec	Jane Avril Dancing	128
Monet	The Waterlily Pond	134
Gauguin	Tahitian Women	138
Picasso	Seated Woman in a Chemise	142
Matisse	Lady in Blue	146
Mondrian	Composition with Red, Yellow and Blue	150
Hockney	A Bigger Splash	154
Index		158

Foreword

Ever since painting began, the work of great masters has been imitated and copied by other painters. Indeed, many famous artists themselves began their careers at work in an older master's studio, learning by imitation and example. This long established practice, in an adapted form, has persisted to the present day, not only among the ranks of professional painters and art students, but also in the work of countless amateurs of all levels of ability.

What was the purpose of such an exercise? In professional terms, the aim was not so much to produce a perfect copy of an existing work, but, through experience, to absorb the essential elements involved, such as techniques and tonal harmonies, and to use them in practice. The aims of this tradition still hold good today, for, though the practice fell out of fashion for a time, it is now once again being recognized as an important element in the curricula of major art colleges and schools.

As far as amateur artists are concerned, however, there is a further important factor to be taken into consideration. Copying the work of the masters does not merely help encourage a good eye, natural talent and the development of technical expertise. It is also a profoundly satisfying experience to end up with a completed version of a painting, which can be compared with the work of an acknowledged master.

The aim of this book is to enable you to achieve these goals. Paintings by 30 of the world's greatest artists have been selected and recreated especially by a team of contemporary artists. The works themselves include examples from the Renaissance to the present day and deliberately differ widely in approach, style and subject matter. The step-by-step illustrations provide the key to the copying process. Each one of these shows a particular stage of the painting process, while the detailed captions explain fully how to copy the work.

None of the artists involved would claim that their copies are perfect, photographic replicas. Indeed, if they were, it would defeat one of the main aims of the book, which is to illuminate an entire artistic tradition and show how it is still relevant today. Modern materials, for instance, have been used throughout, though, obviously, these were carefully chosen to match those used for the original as closely as possible. More importantly, each individual artist has differed slightly in his or her approach. The approach of each artist varies according to the painting under consideration – so, for instance, some works, especially the earlier examples, are built-up gradually layer by layer, while in other cases the artist has tackled areas of the work individually. Nonetheless, the artist's chief aim was to be as faithful as possible, but differences inevitably show in the copy. Some of the final versions too are not as successful as others. How successful each is, however, inevitably remains a matter of personal choice.

Our aim from the start has been to stimulate thought, as well as to encourage you to develop your style and technique.

Mark Churchill

Editor's note

This book is designed to enable even the most inexperienced artist to recreate works by famous artists. The original work is illustrated together with a step-by-step outline of the process of recreating the work. A suggested selection of equipment and materials provides the basis for the reconstruction. However, always remember that it is more important to have a small range of good quality equipment rather than a large number of poor quality items.

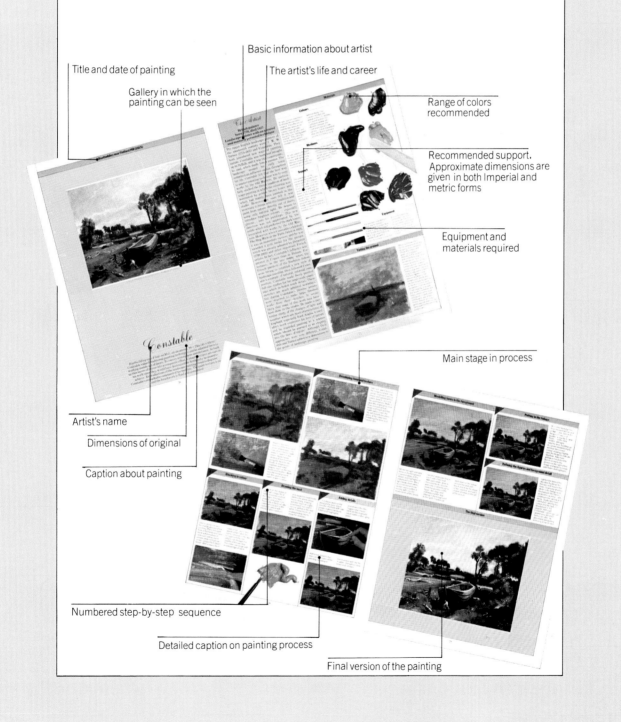

Title and date of painting

Gallery in which the painting can be seen

Basic information about artist

The artist's life and career

Range of colors recommended

Recommended support. Approximate dimensions are given in both Imperial and metric forms

Equipment and materials required

Artist's name

Dimensions of original

Caption about painting

Main stage in process

Numbered step-by-step sequence

Detailed caption on painting process

Final version of the painting

Introduction

*I*ndividual careers and a changing pattern of ideas are important factors in the history of art, but the materials available to artists in any particular period also dictate the character of the work produced. The physical material of which a painting is composed is vital to its construction and final appearance.

The earliest works of art, prehistoric cave paintings, usually regarded as magical symbols of a people dependent upon hunting animals for survival, were executed in natural earths and clays, ochres and umbers easily found and put to use. Soot or charred wood provided rich black pigment. As civilization progressed, paintings remained connected to the religious and cultural life of a tribe or race, and the range of materials used expanded gradually. With the invention of metal tools, minerals could be crushed and ground, making more color pigments available. The Egyptians discovered a bright blue, while the Romans added indigo, purple and a green known as verdigris to the artist's palette. Early murals and tomb paintings show well developed drawing skills and coloring techniques. Encaustic, the use of wax to bind pigments, was a common technique in early times, but had been largely discarded by the eighth century AD. In encaustic painting the wax must be kept constantly warm and pliable and so possibly the technique was found too laborious and did not produce a sufficiently durable result.

Tempera painting was the dominant medium of the Byzantine and medieval periods. Tempera consists of pigments bound in egg, and it dries to a tough, waterproof surface. Painters worked on wooden

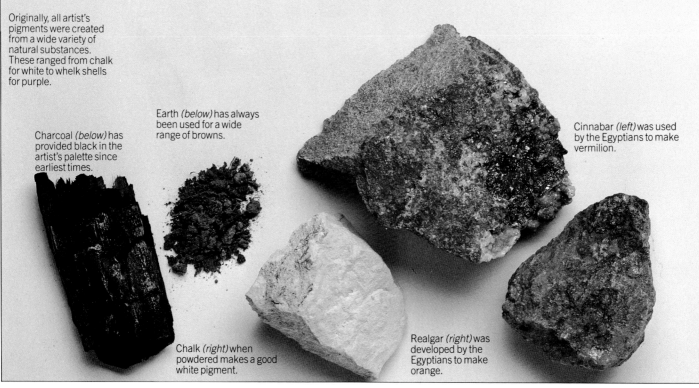

Originally, all artist's pigments were created from a wide variety of natural substances. These ranged from chalk for white to whelk shells for purple.

Earth *(below)* has always been used for a wide range of browns.

Charcoal *(below)* has provided black in the artist's palette since earliest times.

Cinnabar *(left)* was used by the Egyptians to make vermilion.

Chalk *(right)* when powdered makes a good white pigment.

Realgar *(right)* was developed by the Egyptians to make orange.

panels to make, for example, altarpieces and icons with rich, vivid hues and gold leaf decoration. The wood was covered with a ground of gesso, a smooth mixture of whiting and glue size. Tempera dries quickly and the style of the paintings was of clearly defined shapes, shading underpainted with finely hatched brushmarks and smooth glazes of color over the top. Gold leaf was applied to a ground of red clay called bole. One of the most accomplished tempera painters was Botticelli (1445-1510), who explored the medium extensively.

The invention of oil painting is often attributed to the van Eyck brothers who worked in the Netherlands in the early fifteenth century. In fact, their contribution was rather to perfect a technique with which artists had been experimenting for years. Jan van Eyck (active 1422-1441), found a mixture of linseed and nut oils, which dried reasonably quickly without cracking, as a vehicle for pigments. Early oil paintings, done on wood panels, often had an underpainting in tempera and for a while retained the precision typical of tempera paintings. However, unlike tempera, the new paint could be blended and used more fluidly, encouraging a less formal style of imagery.

Fresco was another important early technique before and during the Renaissance. Frescos are wall paintings executed in diluted pigment on wet plaster. Leonardo da Vinci (1452-1519) worked in fresco as well as other media, while some of the best known frescos are on the ceiling of the Sistine Chapel in Rome painted by Michelangelo (1475-1564), who was also a sculptor and poet.

By the sixteenth century, more colors were available, yellow,

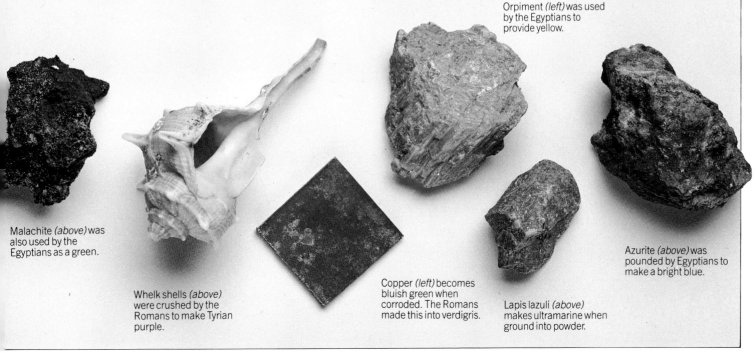

Orpiment *(left)* was used by the Egyptians to provide yellow.

Malachite *(above)* was also used by the Egyptians as a green.

Azurite *(above)* was pounded by Egyptians to make a bright blue.

Whelk shells *(above)* were crushed by the Romans to make Tyrian purple.

Copper *(left)* becomes bluish green when corroded. The Romans made this into verdigris.

Lapis lazuli *(above)* makes ultramarine when ground into powder.

madder, vermilion and ultramarine. The latter was expensive as it was made from the semiprecious stone, lapis lazuli. As it had to be imported to Europe, it could also be scarce if trade routes were disrupted. A full palette was not necessarily available to every artist, but they learned to exploit optical effects, a mutual enhancement between blue and red for example, to make the colors appear more vivid.

Another important development of this period was the use of canvas rather than wood as a support. This gradually became standard practice as canvas was more convenient, lighter on a large scale, and could be more easily stored or transported. Since gesso was too brittle as a ground for flexible canvas, painters began to use oil priming. The Venetian artist Titian (c1487-1576) exploited the possibilities of scale and texture offered by canvas.

Throughout the seventeenth, eighteenth and nineteenth centuries, oil painting remained the dominant medium. A procession of artists developed the use of oil paint in many varied styles and techniques. The use of a colored ground, rather than the white characteristic of gesso, became accepted convention. Rubens (1577-1640) applied a streaky gray-brown to a white ground, while the Spanish artist Velazquez (1599-1660) used a dark ground. Rich techniques evolved in which paint was dragged brokenly across the canvas or pasted on in thick lumps, contrasted with glowing, translucent glazes. The work of the Dutch master Rembrandt (1606-1669) is notable for the textural quality of the paint surface, as well as his striking compositions. In contrast, another Dutch artist Vermeer (1632-1675) produced sensitive depictions of domestic scenes, as well as delicate portraits with a smooth surface.

Paper became more freely available after the invention of mechanical printing in the fifteenth century, and artists began to build

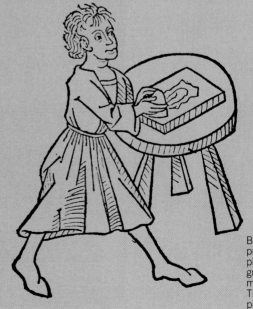

Before the mass production of paints, pigments had to be ground by hand with a muller on a slab of stone. This shows a medieval pigment grinder.

up a body of work consisting of drawings, prints and watercolors, as well as major works in oil. Pastel drawing achieved great popularity among portraitists in eighteenth century France including Chardin (1699-1779) who also painted still lifes. Watercolor was particularly favored by British landscape artists, such as Constable (1776-1837) and Turner (1775-1851).

In the nineteenth century, the Impressionists such as Monet (1840-1926), Renoir (1841-1919) and Degas (1834-1917), revived the use of white grounds for painting and opened the way to a greater appreciation of color. The artist's palette was greatly enriched during the nineteenth century as brighter, cheaper synthetic colors were discovered. Painting became less arduous with the invention of tube paints and the rise of artists' suppliers. Technological advances, improved communications and more varied philosophies and scientific disciplines opened a new world and painters were largely freed from traditional constraints in both their ideas and their materials. Major artists of this time were Seurat (1859-1891), van Gogh (1853-1890) and Gauguin (1848-1903). In the early twentieth century, Cubism, Futurism and Constructivism, and the work of artists such as Pablo Picasso (1881-1973) led to an entirely abstract art. A major exponent of abstract art was the Dutch painter Mondrian (1872-1944).

Oil has remained the dominant medium of painting but a new type of paint has become more widely used since 1945. American abstract artists began to experiment with paints produced for industrial use, car paint for example. Large-scale abstraction demanded a paint which was quick drying, available in brilliant colors and which had great covering power. Water soluble acrylic paints were developed and have become a major medium for artists such as David Hockney (born 1937).

Introduction

Choosing your medium

When contemplating buying painting or drawing materials, remember that their quality is a prime factor. Do not buy a large number of cheap colors but select a few, good quality ones, try them out and gradually expand your palette as you gain in proficiency. There is a large range of commercially produced paints — oil, watercolor and the most recent addition to the artist's repertoire, acrylic. Acrylic has many advantages, it dries quickly and can be used to achieve many different effects. Acrylic mediums should be used with acrylic paints, while acrylic can also be used for priming before painting in oil. Oil paint is still extremely popular, although it takes a long time to dry. Watercolors come in pans, tubes and bottles. Although probably the first painting medium used by children, it is, in fact, a difficult technique to master. Pastel is a less popular medium, but one worth trying out.

Oil paints

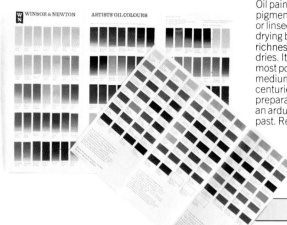

Oil paint, consisting of pigment bound in poppy or linseed oil, is slow drying but retains the richness of color as it dries. It has been the most popular painting medium for over four centuries. The preparation of paint was an arduous task in the past. Renaissance masters, for example, required studio assistants for such work, but the modern artist has a vast range of choice from commercially manufactured paints sold in tubes or tins. Color charts (left) show the many vivid and natural hues available and warn of fugitive pigments, that is those which tend to fade or devalue. Artist's colors are the best quality paint, while the student's range is inferior but cheaper.

Acrylics

The consistency of acrylic paint tends to vary from one brand to another and a manufacturer may produce more than one type. Some tube paints are a thick paste, rather like oil paint but more fluid. Free-flow acrylics are specially constituted to spread evenly on the support and the color dries as a flat tone without brushmarks. These were mainly developed to meet the needs of abstract artists working in pure color and on a large scale. Acrylics can be bought in tubes and jars. It is worth investing in a more expensive brand as this tends to be of higher quality. Cheaper paint may be adequate and could be used at first until you are accustomed to the properties of acrylics. They are fast drying paints and must be handled differently from oil paint as they cannot be so readily blended.

Watercolor

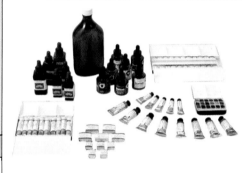

Watercolor paint is available in different forms: the most familiar are the tubes of moist paint and dry cakes or pans. A small box of watercolor pans, which has depressions in the lid for use as a palette, is an economical way of using the paint. The pans are moistened with a wet brush and only the amount of color needed is picked up. The pan dries out again when not in use. Tube paints are of good quality and only a little should be squeezed onto the palette so that nothing is wasted. Liquid watercolor is sold in small bottles, usually with a dropper included. It is best to dilute the paint with distilled water as this cannot affect the quality.

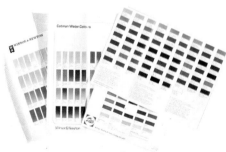

Pastels

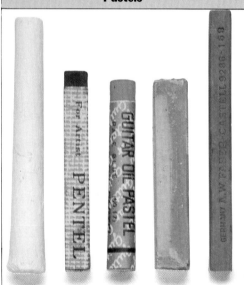

There are several types of pastels and chalks, for example (from left to right) white chalk, square and round section oil pastels, soft gum-bound pastels and a medium soft type. Best quality soft artist's pastels are available in a vast number of hues and tints. They can be bought separately or in boxed sets. Gum-bound pastels are the traditional medium and oil pastels have a quite different character. They are crumbly, rather than powdery and the surface texture of the drawing is greasy. Drawings must be protected with a fixative.

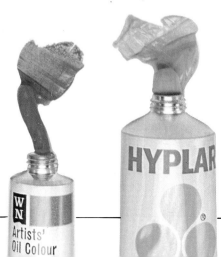

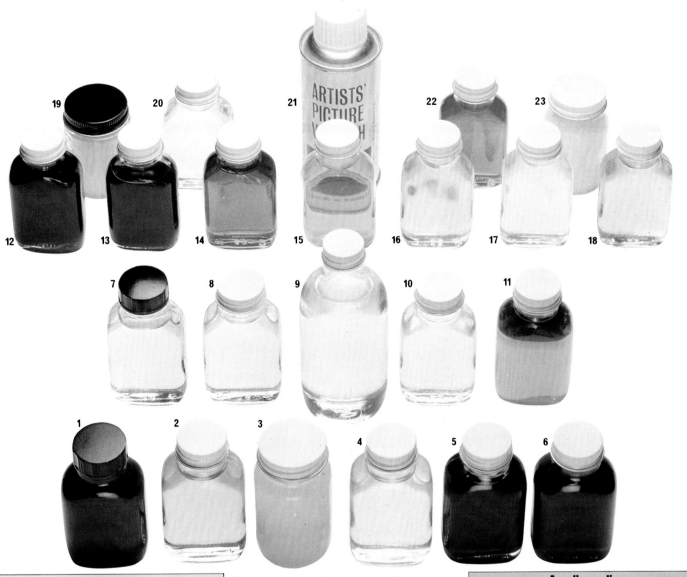

Oils

Linseed oil is the binder most frequently used in manufacturing oil paint. It was in the medium used by the fifteenth century artist Jan van Eyck. He was the first major painter to develop an oil paint that dried successfully, though not too quickly, without exposure to the sun which would cause the paint to crack. Linseed oil is also used as a medium for oil paint, that is to alter the consistency and transparency. The type and amount of oil used affects the drying speed. Poppy oil is an alternative medium, but this retards drying compared to linseed, though it is naturally lighter in color. There are various processes by which linseed oil is refined and modified for different purposes. Raw linseed oil *(below left)* is pressed from steam-heated flax seeds. It is a dark yellow and of poor quality. The finest linseed oil is cold-pressed *(below center)* which has a clear yellow tone and gives the paint greater transparency. However, it is expensive and difficult to obtain. Refined linseed oil *(below right)* is similar but lighter in tone.

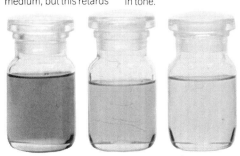

There are a great number of liquid mediums, diluents and varnishes for oil painting *(above)*. To increase the drying speed copal oil mediums *(1,2)* can be added. To thin the paint to a fluid consistency add an oil medium *(3,5,6)*. Opal medium *(4)* is light and transparent to give the paint a matt surface. A diluent is used to thin paint. Turpentine *(9,10)* controls paint and varnish consistency. A cheap alternative to turpentine is turpentine substitute. Commonly known as white spirit, turpentine substitute reduces the quality of color and consistency if used on its own, though it does no harm as the basis of a thin color wash applied directly to the canvas. A thicker petroleum distillate *(11)* may be used as a diluent. White spirit and turpentine also act as solvents to lift paint and clean brushes. A paint remover and solvent *(17)* softens and lifts hardened color, while picture cleaners *(7,8)* remove dirt from a dry painting without attacking the surface. A number of varnishes are made which have different properties according to the time at which they are used. As a general rule, an oil painting should be allowed to dry out for several months before it is finally varnished. Retouching varnish *(22)* protects newly completed work temporarily. Picture varnish in a bottle *(12)* or aerosol spray *(21)* is a clear and quick drying final coating. Crystal damar varnish *(13)*, paper varnish *(14)* and mastic varnish *(15)* give a glossy finish. Some varnishes are made specially heat-resistant *(16)* or weather-resistant *(18,20)*. Wax varnishes *(19,23)* provide a soft sheen on the surface of the finished picture.

Acrylic mediums

Acrylic paints are water soluble but mediums can be added which alter the consistency or affect the nature of the paint surface as it dries. Acrylic primers *(1,2)* should be used to prepare the support before painting. Various mediums are available which give a gloss *(3,5,9,11)* or matt *(4,8)* finish to the dried paint. Some are thin and fluid while others are quite glutinous. Insoluble varnishes *(6,7)* can also be matt or gloss and a soluble gloss varnish *(10)* can be obtained. Water tension breaker *(12)* eases the flow of the paint, while retarder *(13)* slows the drying process. Gel medium *(14)* thickens the paint for impasto effects or heavy glazes.

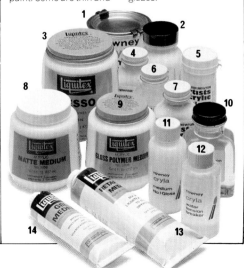

Introduction

Choosing your equipment

Quality is the most important factor in any equipment for painting. Always aim for a small selection of good quality equipment, rather than a large range of cheaper materials. The main types of brush are flat, round and filbert, the best type of bristle depends on the medium used. Hog's hair and sable are the most popular varieties of bristle, while synthetic bristles are becoming increasingly high in quality. Sable brushes are best for watercolor, while both sable and hog's hair are used for oil painting. Choice of palette depends on the medium. Watercolor palettes have recesses to hold the paint while oil painting palettes are flat. Palette knives, rags and sponges also come in handy. For the beginner, a painting kit provides a basic selection of equipment. In addition, soft pencils or charcoal sticks will be needed for the underdrawing. A ruler and putty rubber are also advisable.

Palettes

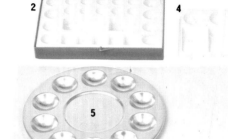

Watercolor should be mixed in a recessed palette. Palette boxes (1,2) are useful, and portable if you work outdoors. Plastic (4) and metal (5) well palettes can be used in the studio. For work in oil and acrylics the traditional wooden thumbhole type (3, 7) is suitable and small dippers can be clipped on to hold mediums. A block of disposable paper palettes (6) saves having to clean them. Palettes can be improvised from ceramic plates, a slab of glass or smooth stone or a shallow tin. Choose a material suited to the medium. Oils, for example, can rot thin plastic palettes.

Priming

To apply a ground to the support use a decorator's brush with a wide head and stiff bristles. Choose a good quality brush or the hair will come out as you apply the paint.

Brush quality

A good brush keeps its shape and is a worthwhile investment. Compare (from left to right) a high quality sable, a round synthetic, and the poor quality sometimes found in paintboxes.

Rags and sponges

Rags, sponges and paper towels are constantly useful when you are painting. With oil paint it is often necessary to clean brushes, mop the palette or wipe paint from the canvas. Paper towels can be used and are more absorbent than some fabrics which you may use as rags. Sponges can be used for cleaning or to apply paint, particularly watercolor and acrylics.

Hog's hair bristle brushes

Hog's hair bristle brushes are usually preferred for oil painting as they are resilient and come in different shapes and sizes which suit all types of work. The illustration (left) shows the three shapes of bristle brushes (from left to right) flat, filbert and round. Flat brushes are extremely versatile, giving a precise stroke if the whole head of the brush is used and finer marks from the tip or side of the bristles. A filbert is similar but the shaped tip softens the brushmark. It combines the qualities of flat and round brushes. Fine round brushes are useful for painting linear detail and small shapes while the larger sizes are excellent for blocking in broad areas of color. Choosing the shape of a brush is largely a matter of personal preference. One type may be found more comfortable but a good collection of brushes should ideally contain several sizes in each shape. Brushes are made in series (below left), the sizes numbered from 1 to 12. Never attempt to adjust a brush by cutting the bristles. The brush is very carefully shaped in manufacture by arrangement of the individual hairs. Buying cheap brushes is a false economy as they will shed hairs and lose shape.

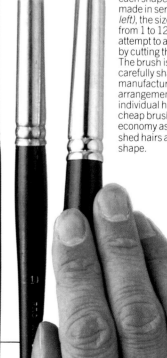

Brushes for watercolor

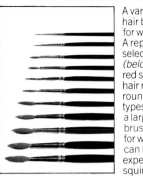

A variety of different soft hair brushes are available for watercolor painting. A representative selection is shown here *(below from left to right):* red sable round, camel hair round, synthetic round, ox hair round, two types of synthetic flat and a large blender. Sable brushes *(left)* are the best for watercolor but they can be very expensive. Ox, camel or squirrel hair are adequate as substitutes and fall within a reasonable price range. Synthetic brushes are less satisfactory but could be used to experiment with different shapes and sizes. Having decided which brushes are needed it will then be worthwhile investing in a range of higher quality. These brushes are sold in series and very fine ones are available numbered 00 and 0.

Mahl stick and palette knives

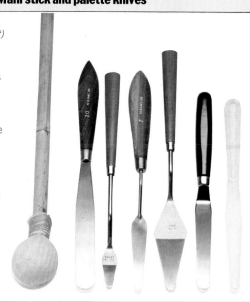

Accessories for painting include *(from left to right)* a mahl stick and palette knives with blades shaped for different purposes. Palette knives can be used to lay paint particularly if a thick, or impasto, effect is required, to mix colors or to scrape back a part of an oil painting which needs correction. Those with rounded, flexible blades are very versatile, while the small pointed blades are set on a curved shaft and are more rigid for precise or detailed work. A mahl stick is a rest for the hand holding the brush. The cushioned end is placed lightly on the canvas to steady the stick.

Drawing materials

Drawing materials which can be used on any type of support include *(from top to bottom)* charcoal pencils, thick, compressed, medium, and thin charcoal sticks and graphite pencils. Charcoal pencils may be more convenient than the messy and brittle sticks. Useful erasers are *(from left to right)* putty, gum and soft rubbers.

Brushes for oil and acrylic

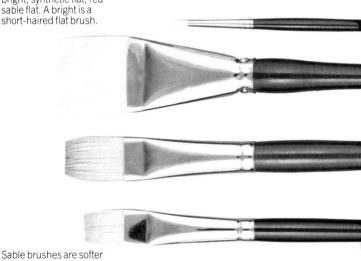

The same type of brushes may be used for oil or acrylic painting. The selection of brushes shown *(right)* forms a useful collection. They are *(from top to bottom)* sable fan, red sable round, small synthetic round, large synthetic flat, hog's hair flat, hog's hair filbert, Russian sable bright, synthetic flat, red sable flat. A bright is a short-haired flat brush.

Sable brushes are softer than bristle and not always found strong enough for oil painting, but they are useful for glazes and details. A fan brush is used to blend colors together. Always clean a brush immediately after use and leave it to dry bristles upwards in a jar. It is very difficult to free them from dried paint.

Painting kits

A basic range of equipment can be bought as a boxed painting kit. There are several different sizes, in plastic or wooden boxes. This is an expensive way to buy materials but it can be very useful if you are not sure what to start with or are short of space for storing equipment. A small kit might contain 10 colors, a medium, two or three brushes and a small palette. A larger size might include two or three oils or mediums, a greater selection of brushes and colors, drawing equipment and canvas board supports. The materials are taken from standard ranges and can be replaced as used, or extra items can be added. Boxes are most often used for working out of doors.

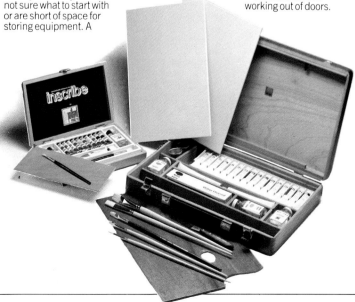

Choosing your support

The most popular modern supports for painting are fabric, paper and specially prepared board. In the past, wood and metal have also been used. The term 'canvas' is generally applied to any fabric support for painting and can be made from linen, cotton, calico, twill or duck, a heavy-weight type of cotton. Canvas has been the most popular type of support for painting in oil since the Renaissance, and, more recently, has been used for acrylic also. Despite its advantages, which include lightness and portability, it requires considerable preparation. It has to be stretched and then primed before painting can begin. As canvas is fairly expensive, a cheaper modern alternative is board. Hardboard can be used, but it requires cradling, which involves putting a batten on the back of the board to keep it straight. Hardboard also needs to be primed. Commercially prepared boards come ready-primed, and some even have a canvas texture. An additional coat of priming is often added before painting begins. For watercolor work, paper is the best surface. This has to be stretched before work can begin. As with equipment, choose the best quality support you can afford as it will give the best results.

The paper surface

Watercolor papers have a right side and a wrong side. The right side generally has a more dense, even grain. This has been carefully prepared for painting and coated with size to lessen the absorbency. On a heavily grained paper it is often quite easy to judge the right side by eye, but this can be more difficult if the paper is smooth and relatively lightweight. If in doubt, hold the paper up to the light and look for the watermark, the name or symbol of the manufacturer which is pressed into the paper. If this can be read you are looking at the right side of the paper. On the wrong side, the mark appears as a mirror image.

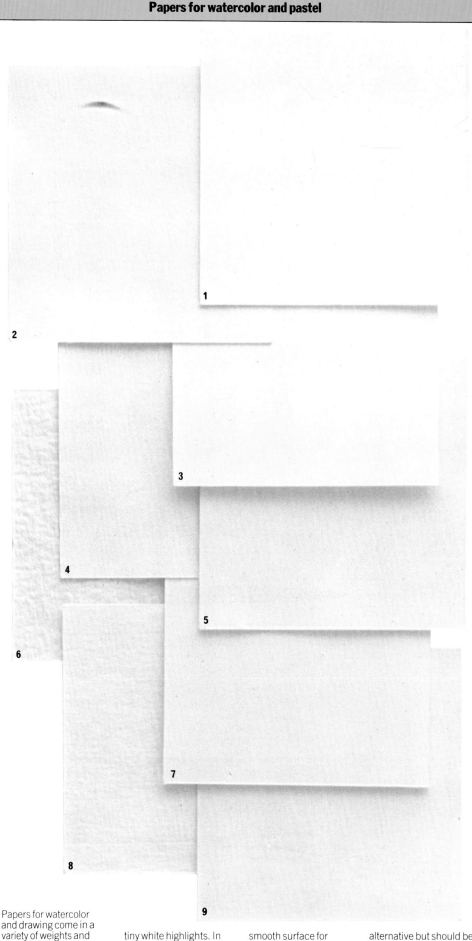

Papers for watercolor and drawing come in a variety of weights and textures. Heavy papers impart their grainy texture to the image and many artists take advantage of this, allowing the grain to create broken color and tiny white highlights. In this case a rough or 'not' (cold pressed) surface should be chosen. The examples here (4,6,8) show different weights and grains. It may be preferable to use a smooth surface for drawing or painting if an even tint is to be laid on the support. Illustrator's boards (1,3,7) are tough and provide a clean, even surface. Cartridge paper (2) is a cheaper alternative but should be stretched before you start work. Hot pressed (5,9) papers are of better quality and are also quite smooth. Papers may be starkly white or a warm, off-white tone.

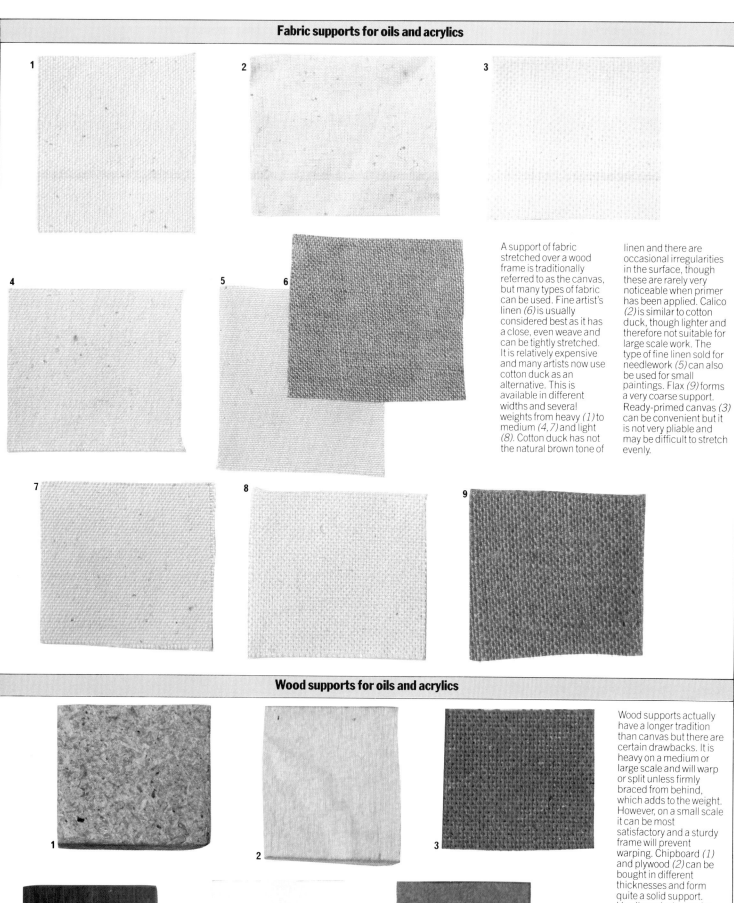

Fabric supports for oils and acrylics

A support of fabric stretched over a wood frame is traditionally referred to as the canvas, but many types of fabric can be used. Fine artist's linen (6) is usually considered best as it has a close, even weave and can be tightly stretched. It is relatively expensive and many artists now use cotton duck as an alternative. This is available in different widths and several weights from heavy (1) to medium (4,7) and light (8). Cotton duck has not the natural brown tone of linen and there are occasional irregularities in the surface, though these are rarely very noticeable when primer has been applied. Calico (2) is similar to cotton duck, though lighter and therefore not suitable for large scale work. The type of fine linen sold for needlework (5) can also be used for small paintings. Flax (9) forms a very coarse support. Ready-primed canvas (3) can be convenient but it is not very pliable and may be difficult to stretch evenly.

Wood supports for oils and acrylics

Wood supports actually have a longer tradition than canvas but there are certain drawbacks. It is heavy on a medium or large scale and will warp or split unless firmly braced from behind, which adds to the weight. However, on a small scale it can be most satisfactory and a sturdy frame will prevent warping. Chipboard (1) and plywood (2) can be bought in different thicknesses and form quite a solid support. Hardboard, chosen for either the smooth side (6) or the rough (3) is lighter but must be braced with a wooden frame. Any well seasoned and prepared wood, for example mahogany (4), can be used. All supports, including card (5), must be primed with a suitable ground for the medium.

17

Preparing your support

A well prepared support will help produce a satisfactory final result, so it is worth taking time and trouble to make sure you have the best possible surface on which to work. When using canvas, stretch it carefully before priming. Paper also requires stretching before watercolor can be applied to it. Board should also be primed before paint is applied. Some boards are already primed, but another coat of priming can also be added. When recreating a painting by another artist, a good reproduction is vital. Try to select one where the color balance seems reasonable. If possible, go and see the original work too. Then scale the picture up using a pencil grid as a guide. Transfer the grid on the reproduction with care to the surface, using either charcoal or pencil. Do not press to hard, or the underdrawing may show through in the finished work. Before starting to paint have your equipment ready and near at hand.

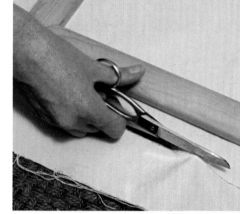

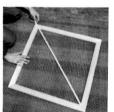

Lengths of wood for stretchers are sold with the ends ready cut (1,3) to form halves of a right-angled joint. Buy two pieces for the width of the painting and two for the length. Make two L-shaped sections by joining a length and a width and put them together to form a rectangle. Wedges (2) are put into the inside corners after the fabric is stretched to tighten the canvas.

1. Ensure each corner of the stretcher forms a right-angle. If the diagonals are equal, the stretcher is square.

2. Lay a piece of canvas flat on the floor and place the stretcher on top. Trim the canvas to size, but allow it to overlap the stretcher by at least 1½in (4cm) on each side.

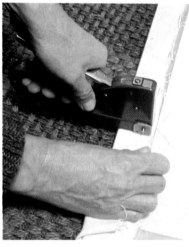

3. Pull the canvas over the stretcher and secure it in the center of each side with a staple. Work across each side from the center outwards, stretching and stapling the fabric. When you have completed one side, move to the opposite side, then work on the other two. This pulls the fabric more evenly.

As you stretch the canvas make sure there are no creases where it may have been pulled awkwardly. Flat headed tacks can be used to secure the fabric rather than staples.

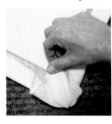

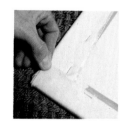

4. Pull the canvas over the corner and place one staple in the center.

5. Fold in each corner so it is smooth and neat and staple them firmly.

Stretching paper

1. Trim the paper to suitable size for the drawing board, leaving a margin of board down each side for the tape.

2. Measure out lengths of brown gummed tape to fit each side of the paper.

Take the tape right to the edge of the board.

3. Immerse the paper completely in clean water, in a shallow dish or bath. Leave it to soak for several minutes.

4. Drain off the paper and lay it flat on the board. Dampen a strip of tape and press it down firmly along one edge.

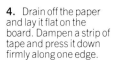

5. Tape each side of the paper to the board in the same way. Do not make the tape too wet or it will not adhere.

6. To secure the tape push in a thumb tack at each corner. Allow the paper to dry naturally. It will split if forced.

Priming

Primer seals the surface of absorbent materials such as fabric or hardboard. In oil painting this is vital and the primer must cover the support effectively, otherwise the oil sinks into the material and eventually rots it away. Acrylic paint contains nothing harmful to the support as it dries quickly to a tough plastic skin. It can be used on canvas, board or paper without primer but an absorbent surface will soak up the first application of color if there is no ground to seal it. If a tinted ground is required, color can be added to a white oil or acrylic primer, or a transparent acrylic emulsion can be used over the natural tone of artist's linen or wood.

Often though, the purpose of priming is to provide a clean, white ground for the colors in the painting. All the major paint manufacturers produce different types of primer. The most common types are oil, acrylic and gesso. Oil paint can be applied over an acrylic primer but water-based paints should never be used on top of an oil-based substance.

Squaring up

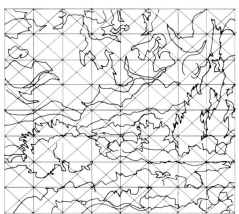
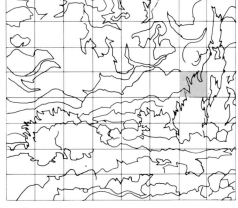

There are two basic ways of squaring up an image. A simple method *(above right)* is to measure out and draw a grid of squares on the picture which is being copied and then scale up the grid on a canvas of the same proportions. The grids must provide an accurate structure for transferring the image by plotting important points and lines. Another method uses measurements from diagonal divisions of the picture *(above left)*. The reproduction is fixed in the top left-hand corner of the canvas. A diagonal is drawn from the corner down to the bottom of the canvas on the right-hand side. This sets the width of the copy. A vertical is drawn up from this point and the second diagonal, from top right to bottom left, can be drawn. A vertical and horizontal division of the picture plane can be put in through the central point where the diagonals cross. This makes smaller rectangles which can then be subdivided in the same way. You may find that this method leaves a narrow strip down the side of your canvas or board where it does not exactly match the proportions of the original. This can be trimmed from a board or hidden with a mount or heavy frame if you are using a stretched canvas. Always try to obtain a support of the right size if possible.

Once a grid has been drawn on the reproduction, transfer the outlines of the image onto the support. Copy the shape of the major forms in each square on the picture in turn.

Preparing for painting

Ideally it should be possible to set up painting equipment where it need not be moved when you are not actually using it. An easel is a valuable item but it is quite possible to work comfortably at a table. The painting area should be in good, even light, whether natural or artificial. Supports which need priming or tinting should be prepared well in advance so the surface is thoroughly dry before painting. Place the reproduction where you can see it clearly without turning away from your painting; for example, pinned to an adjacent wall, or propped up in front of you on the table.

Assemble all the brushes, paint, mediums and other equipment needed for the work. Have a few small, clean jars ready for turpentine and oil, or larger jars for water. Place the palette securely on a flat surface and lay out the colors. If you are using oils you can lay out some of each color, but be cautious with watercolor or acrylic or you may find that the paint has dried on the palette before you come to use it. Rags or paper towels can be kept handy in a box and used for cleaning the brushes and palette or mopping up spills. Old newspapers are good protection from splashes and drips.

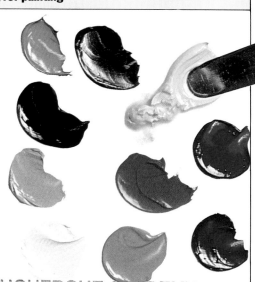

Introduction

Finishing and framing

Framing greatly improves the appearance of a picture and helps to preserve it. Commercial framing can be expensive, but there are many framing kits on the market which provide neat frames more cheaply. It is also possible to make frames yourself, but make sure you have the correct tools and materials. Select a suitable molding. A heavy ornate frame would not complement a delicate watercolor, for instance. Aluminum is a popular fairly recent addition to the types of molding available. It is not always necessary to put glass in front of a frame. This particularly applies to oil paintings, where glass may obscure the texture of the brushwork. Frames require firm backing. Cardboard should never be used because it bends, hardboard is the best material for this. Varnishing a painting can also improve its final appearance. However, before varnishing an oil painting, make sure it is completely dry. This process can take up to six months after the final paint has been applied. Acrylic varnish is available for acrylic works. Watercolors do not require varnishing.

Achieving a craquelure effect

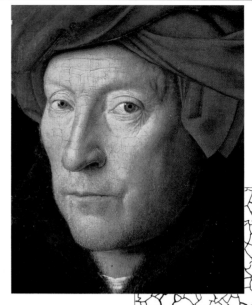

Craquelure is the many hairline cracks which may appear in the surface of an oil painting as it ages. This effect can be simulated on a newly completed painting which is thoroughly dry, using a combination of materials.

1. Using a broad, hog's hair bristle brush, paint a layer of picture varnish over the surface of the finished painting. Allow it to dry for several hours or overnight.

2. Cover the dried varnish with a coat of transparent water-based gum medium. This shrinks as it dries, forming the cracks. Apply a thick coating for coarse effect, a thin coat for fine cracks.

3. When the gum medium is dry, paint on another thin coat of picture varnish. This seals the gum and prevents further cracking or flaking. Be careful not to fill the cracks completely with varnish.

4. To color the cracks, which emphasizes the effect, gently rub in Vandyck brown oil paint with a soft cloth. Rub away excess on the surface. Allow the paint to dry and then apply a final coat of varnish.

Craquelure is an effect which has occurred naturally in many old paintings, due to age, conditions of heat and humidity and shrinkage of the original mediums. The technique used to simulate this appearance depends upon resistance between oil and water. A water-based gum cannot adhere smoothly to an oily varnish base. This only affects the surface and is not a way of 'ageing' the paint.

Types of moldings

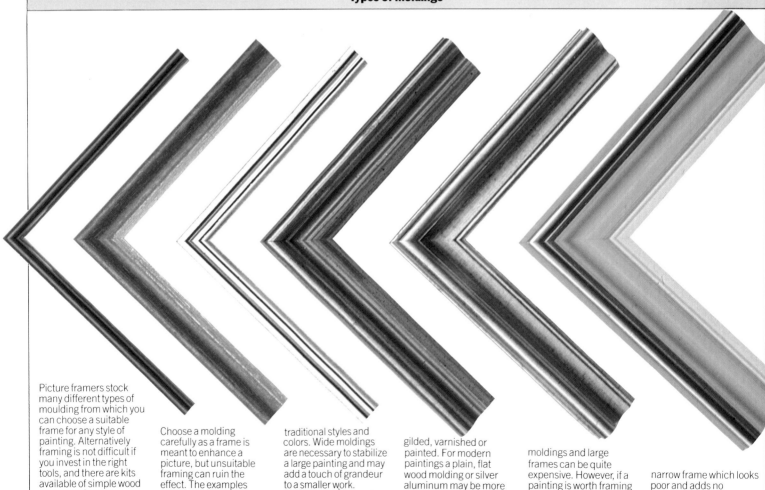

Picture framers stock many different types of moulding from which you can choose a suitable frame for any style of painting. Alternatively framing is not difficult if you invest in the right tools, and there are kits available of simple wood and metal frames.

Choose a molding carefully as a frame is meant to enhance a picture, but unsuitable framing can ruin the effect. The examples shown (above) are traditional styles and colors. Wide moldings are necessary to stabilize a large painting and may add a touch of grandeur to a smaller work. Wooden frames may be gilded, varnished or painted. For modern paintings a plain, flat wood molding or silver aluminum may be more suitable. Ornate moldings and large frames can be quite expensive. However, if a painting is worth framing do not skimp by using a narrow frame which looks poor and adds no support.

Tools for framing

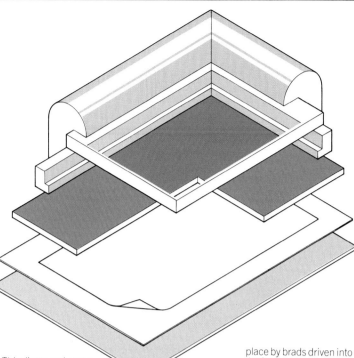

Framing is a specialist task and if you decide to tackle it yourself it is as well not to be too ambitious. For example, do not work on an ornate or expensive molding unless you are absolutely confident. Glass cutting can be tricky, although many people master the technique quickly. Glass suppliers will always cut sheets to size and are accustomed to handling the material, which is obviously potentially dangerous. Oil paintings should not be framed under glass as they take a long time to dry out completely and do not

need the extra surface protection when dry. Canvas board and drawings on paper or card should be fitted with a backing board of hardboard. A stretched canvas simply fits into the frame or can be mounted in a fillet, or inner frame, as well. An important item of equipment for framing is a miter box or clamp. It is worth getting a good one as you must cut the sections of molding perfectly to obtain an accurate right-angled joint at each corner of the frame. To cut and assemble a frame you will need a

suitable size of tenon saw (5), corner clamps (13), a drill (14), a bradawl (19), a pin punch (10), a hammer (9) and a pair of pliers (16,18). Chisels (1), a sturdy pocket knife (2), G-clamps (17) and a file (20) may all be useful. To frame drawings or watercolors which must be mounted on card, you will need pencils (3,4) and a ruler (6), a set square (21), a sharp craft knife (11), a pair of scissors (12) and a roll of adhesive tape (15). Glass cutting tools (7,8) are also available from hardware stores and departments.

Constructing a frame

This diagram shows a type of frame in which the glass is raised from the picture surface. The glass fits into the rebate in the molding, that is the recessed underside of the section. A narrow frame, or fillet, is fitted under the glass. This holds the picture which is further protected here by a card mount. The whole is backed with hardboard or thick card, held in place by brads driven into the frame. A shadow box frame of this type is suitable for watercolors or heavily textured acrylic paintings. The construction of a conventional frame is similar but it would not contain a fillet.

Cutting a miter

 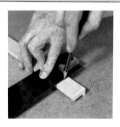 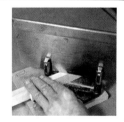

1. Make the first miter cut at one end of the molding. Mark the 45° angle across the section.

2. Turn the molding and mark a vertical line on the flat side, drawn from the outer edge of the miter. This acts as a guide for the saw.

3. Fix the wood in the miter clamp and saw it. Measure the length required along the inside of the molding. Mark and cut the other miter.

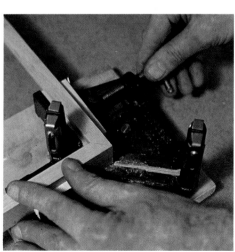

4. Cut four sections for the frame in the same way. Apply wood glue to each end of all four pieces.

5. Fit two sides of the frame, a length and a width, into the miter clamp. Allow the glue to set and then drill the corners and hammer in pins.

Other types of framing

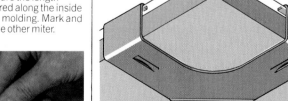

Drawings and watercolors can also be displayed in simple frames, sandwiched between glass and board which are held together with metal clips. Several types of clips may be used.

Spring clamps (top) are designed to secure the glass and board by tension. They are easily fitted but should not be used for framing on a large scale as a big sheet of glass is very heavy.

A double corner clamp (center) provides a slightly stronger fixing. These are placed one at each corner and are secured with stout nylon cords. The cords are looped through the clamps and drawn across the back of the frame to a plate fixed onto the backing board. They are threaded into the plate and tied.

A different type of corner clamp is screwed into the sides of the backing board (bottom) Plywood or chipboard at least ½in (12mm) thick is needed to ensure the screws are firm.

The Paintings

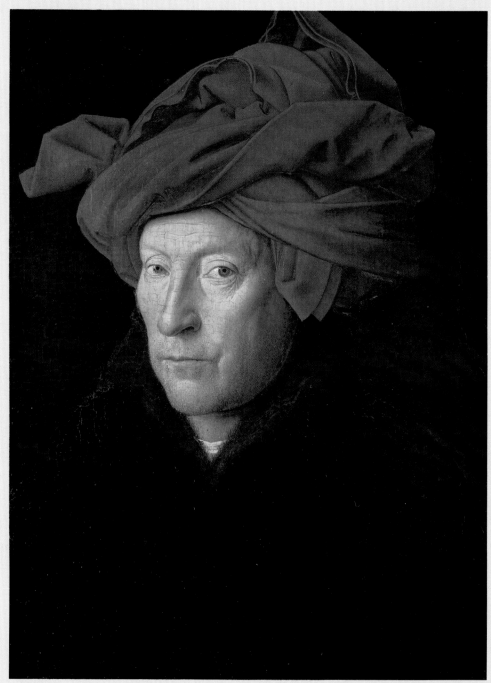

van Eyck

Man in a Turban, oil on panel, 10½ × 7½in (25.7 x 19cm)
This is one of a number of fine portrait studies, some of which relate
directly to van Eyck's more complex figure compositions. As a court
painter, he was required to commemorate notable contemporary figures in
his work, but it is possible that this particular example is a self-portrait.
The rich, glowing colors and subtle tonal range of *Man in a Turban* are
typical of van Eyck's masterly control of oil color. He developed the
potential of this medium.

**Flemish artist
active from 1422, died 1441
Founder of the Flemish school, the
first major painter in oils**

The brothers Hubert and Jan van Eyck have often been credited with the invention of oil painting. This is probably an exaggeration since oil had been in use many years previously. However, Jan van Eyck certainly perfected a technique which formed the foundation of the oil painting which became general in the Flemish school. The brothers' work together includes the large Ghent altarpiece, probably painted in the 1420s. The van Eycks were working during the rule of the Dukes of Burgundy in the Netherlands. After 1422 Jan was attached to the court, traveling to Spain and Portugal in the Duke's service. Jan's paintings reflect the wealth of the court both in the emphasis on rich drapery and furnishings and in the accurate observation of detail and surface texture. The innovation of oil technique made a greater degree of realism possible. Italian painters using the older water-based tempera paint still treated objects in a traditional manner. This involved creating an impression of solidity and three-dimensionality by applying a series of individual strokes. This gave a rather flat effect. However, using oil as the medium gave a transparent paint which could be built up in layers to represent natural effects of light and subtle modeling. Van Eyck also achieved great brilliance and depth with oil varnishes which may well have been his real 'invention'. An example of this is *The Arnolfini Marriage*, painted in 1434, where the painting of the view in the circular mirror shows great virtuosity. The work was also unusual because of the perspective drawing which is well in advance of other painters of the time. Around 1430 van Eyck settled in Bruges where he produced the portraits of the *Man in a Turban* (1433) and *Portrait of the Artist's Wife* (1439), as well as many works of religious subjects. It may be that his early work as a painter on glass led van Eyck to develop the smooth enamel-like surface of his paintings. The new Flemish technique established by van Eyck was introduced into Italy, and was particularly exploited by the Venetian painters. Indeed, it was perhaps Jan van Eyck's extraordinary mastery of a new medium which, over the years, gave rise to the legend that he and his brother actually invented oil painting.

Materials

Color

Van Eyck painted *Man in a Turban* in oils but a similar effect can be achieved using acrylic paint. The advantage with working in acrylics is that the paint dries very quickly unlike oils which can take weeks to dry.

Man in a Turban can be painted using only a few colors. The background's basic color will require burnt sienna (1). Raw sienna (2) is only needed for a thin final glaze. Raw umber (3) glazes make

up a major part of the painting. Payne's gray (4) should be used for the dark glazes. The color of the turban is cadmium red (5). Titanium white (6) is the best paint to use for the highlights. Yellow ochre is also needed.

Brushes

A wide variety of different sized brushes can be used to paint *Man in a Turban*. Pictured here are (from top to bottom) a synthetic 1in (2.5cm) flat, a No 8 sable flat, a No 6 sable flat, a No 1 sable and a No 00 sable. The synthetic flat is the best brush to use for laying in the initial underpainting. Both the sable flats can be used

for blocking in color and for applying glazes over fairly small areas. A No 8 flat bristle brush will be needed for applying the red glaze on the turban. More detailed parts of the image are best painted with a thin No 1 sable. A No 00 sable is needed for the most intricate details.

Support

Good quality hardboard is a useful substitute for the oak panel van Eyck worked on. Choose a piece the same size as the original.

Priming

Prime the support with four coats of acrylic gesso. Between each application, rub down the surface with a sheet of sandpaper.

Other equipment

A number of other items are needed. These include a jar of water; rags on which to wipe your brushes; a ruler and soft pencil for the

squaring up; and a retouching varnish. Water tension breaker or a wetting agent is useful for adding to the paint. It helps achieve even tones.

1 Drawing up the grid and initial sketch

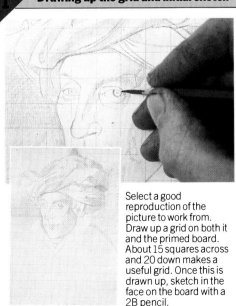

Select a good reproduction of the picture to work from. Draw up a grid on both it and the primed board. About 15 squares across and 20 down makes a useful grid. Once this is drawn up, sketch in the face on the board with a 2B pencil.

2 Painting the ground

Paint the board with a pale underwash. This is because it is much easier to work on a tinted rather than white background. Use a very thin wash of burnt sienna diluted in water. Drag the paint across the board in broad sweeping movements. For best results, use a

synthetic 1in (2.5cm) flat brush. It is important that the color should be laid down as evenly as possible.

3 Applying the first glaze

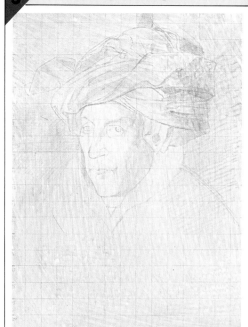

Once the wash has dried, there should only be a hint of color on the board. The pencil under-drawing and the initial grid should still show.

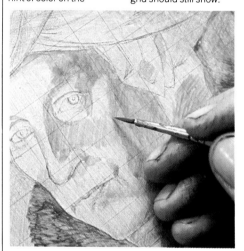

Using a No 1 sable brush, paint in thin glazes of burnt sienna on the reddish parts of the painting such as the face (above and below).

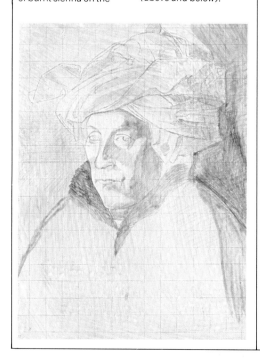

4 Underpainting in dark tones

Apply a second underpainting of thin glazes of raw umber on the face. Use a No 1 sable brush and paint over the burnt sienna already applied. Apply raw umber over the whole background with a No 8 sable. Spread the paint evenly with broad strokes. Use the same color paint to fill in the collar. Work with a No 1 sable brush and keep the brushstrokes small.

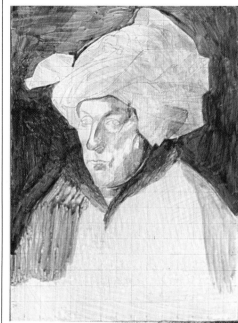

6 Adding highlights

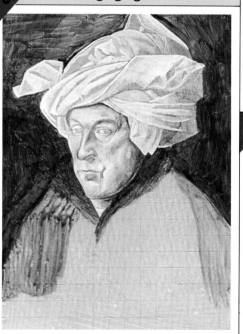

Mix a thin glaze of titanium white for the initial highlights. Paint in the major forms on the turban and the face with a No 1 sable brush. Follow the lines of the folds in the turban. Where the highlights are most prominent, build up several layers of paint.

5 Scumbling the collar

Continue to build up the paint on the collar with pure raw umber. Van Eyck would probably have scumbled his oil paint, so try to create a good scumbled effect. Scumbling involves putting thick, opaque paint over another layer so that some of the paint underneath shows through. This can be done by using the brush in a circular motion or by dabbing the paint on so that it is not smooth.

7 Putting color on the turban

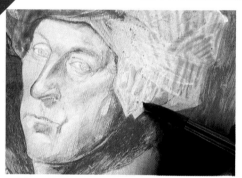

Next, paint in the basic color of the turban. Apply a thin glaze of cadmium red diluted with turpentine. Cover all the white highlights and use a No 8 flat bristle brush, well loaded with the paint. Once the first glaze is dry, put on more coats to build up the color.

8 Building up the flesh tones

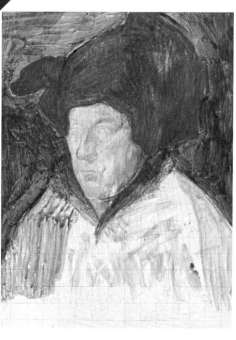

When the color on the turban has been blocked in, add some warmth and tonal variation to the face. Work with a thin glaze of yellow ochre, applied with a No 1 sable brush. Concentrate particularly on the shading on the right-hand side of the face. Build up the glazes gradually.

9 — Defining the darker forms

To paint in the darker parts of the turban, use thin glazes of Payne's gray. Apply delicate, sweeping strokes with a No 1 sable brush. Paint in more than one layer to build up the color and overlap the strokes to strengthen the form. Add most paint where the shadows are darkest.

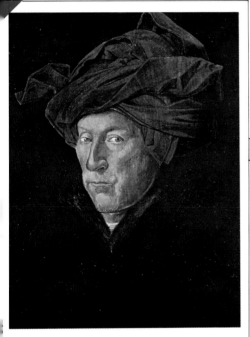

10 — Blocking in the background

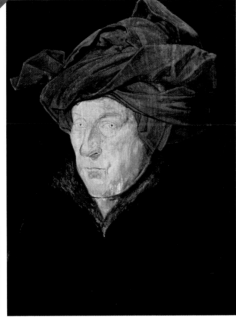

Use Payne's gray and raw umber to make the background darker. Work with a No 8 flat bristle brush and use confident brushstrokes. The coat should merge with the background on the right, but the outline of the left shoulder and the fur collar should remain clearly visible.

11 — Highlighting the face

Paint in the final details with thin glazes of raw umber, raw sienna and burnt sienna. Strengthen the highlights with white. Paint in bristles on the chin with a No 00 sable.

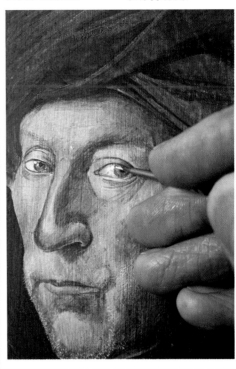

12 — Completing the final details

Once the final details on the face, such as the eyes and highlights, have been completed, the finishing touches can be made to the copy as a whole. Put in a few white lines at the bottom of the neck for the shirt. Give the turban more unity with two more thin glazes. First apply one of cadmium red with a No 8 sable brush. A sable is best for applying glazes as it is smooth and does not leave traces of brushstrokes. Once the red glaze is dry, repeat the process with a pale glaze of Payne's gray to give more depth to the darker parts. To bring out the highlights on the face, paint over the features with a very thin white glaze. Apply it sparingly with a No 6 sable brush. Finally, paint a thin layer of varnish over the painting. This will give it protection and also bring out the translucency of the colors. It is not actually necessary to use a varnish with acrylic paint, but it improves the final result.

The final version

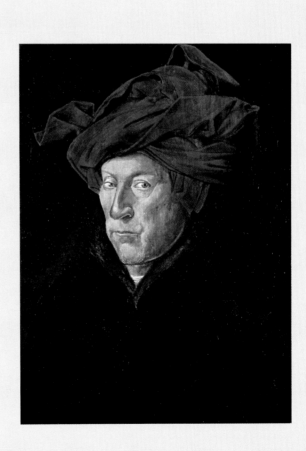

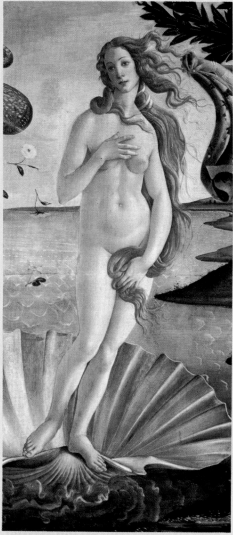

Uffizi, Florence

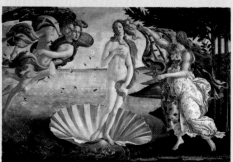

Botticelli

The Birth of Venus (detail), tempera on canvas
This work, representing the classical legend of the birth of Venus, was
commissioned from Botticelli by a member of the Medici family. The clear
colors and decorative style reflect the nature of the medium, but Botticelli
overcame the limitations of the quick drying tempera paint by developing a
technique of blending colors smoothly. Every form has been precisely
drawn and delicately modeled.

The Artist

**Italian artist
born 1445, died 1510
Master of delicate linear design in
tempera and fresco**

The son of a tanner, Botticelli was born in Florence. He began studying literature but soon became a pupil of the painter Filippo Lippi (c1406-1469). Fifteenth century Florence was at the height of its economic and political power and enjoyed a most advanced cultural life. By the time he was 30, Botticelli had become the favorite artist of the influential Medici family who ruled Florence. He carried out decorations for their palaces, of which his *Primavera (Spring)*, painted in the early 1480s, is an outstanding example. In this painting, Christian symbolism is combined with allegory from Greek mythology. In 1481 Botticelli was called to Rome to decorate the Sistine Chapel. He and other masters illustrated the stories of Christ and Moses. In the following year, he was back in Florence and occupied with his favorite themes, classical fables and the Madonna. He painted *The Birth of Venus* around 1485, and the large circular paintings, known as tondos, depicting the Madonna and saints. Botticelli painted in tempera. This was the predominant painting medium before oils became popular with the work of van Eyck in the mid fifteenth century. Tempera paint uses egg yolk as its medium. Unlike oil paint, tempera is opaque, and so an impression of solidity and three-dimensionality has to be created by a series of small brushstrokes. Tempera dries quickly, and so it is difficult to make alterations or corrections. After 1492 Botticelli came under the influence of the influential Italian religious reformer Girolano Savonarola who caused him to abandon his former classical subjects. Botticelli's pictures now illustrated moral, almost 'puritan' themes, and his style became less flowing and lyrical. In his later years, Botticelli's work seems to have declined in popularity. A new generation of painters had created an innovative and more popular style. By his death in 1510, Botticelli had been virtually forgotten, and it was not until the nineteenth century that his paintings were rediscovered and again appreciated. He is now recognized as one of the great exponents of tempera painting. In recent years, tempera has again attracted the attention of artists, who, due to the nature of the medium, use much the same approach as did Botticelli in the fifteenth century.

Materials

Color

Use acrylic paints which are most similar to the media Botticelli used. This was tempera which is made from pigments mixed with egg yolk. The main quality of tempera is that it is very quick drying. Acrylics also have this characteristic. The main colors needed are titanium white *(1)*, burnt sienna *(2)*, raw sienna *(3)*, cerulean blue *(4)*, permanent light green *(5)* and Payne's gray *(6)*. You will also need cobalt blue for the flowers and cadmium red for the lips.

Brushes

A selection of brushes ranging from large flats to very fine rounds can be used to paint this detail from *The Birth of Venus*. Those illustrated are *(from top to bottom)* a 1in (2.5cm) flat synthetic, a No 8 sable flat, a No 6 sable flat, a No 2 sable round and a No 00 sable round. The detailed parts of the composition should be executed with the No 2 or No 00 sable rounds. A No 0 sable round will also be useful.

Support

Use very fine stretched canvas measuring 33⅝ × 15¼in (85.5 × 39cm). Coat the surface with two coats of an acrylic gesso. Ready-prepared primers with an acrylic base are widely available today.

Other equipment

Other basic equipment will be needed. Use a 2B pencil to draw up the grid. Rags or paper towels should be kept handy for wiping brushes on. Use a water tension breaker to make the paint flow easily.

1 Squaring up

Draw up a grid on both the reproduction and the primed canvas. Any number of squares will do providing they are not too big. Then, using the grid for guidance, transfer the picture onto the canvas. Use a soft pencil such as a 2B. Draw in the outline of the figure first. Work loosely, pressing on the surface only lightly. Then draw in the other major forms, such as the shell and the flowers. Fill in shading for the most prominent tonal areas. Smudge the pencil with a finger to achieve an even effect *(above)*. Hold the pencil at a shallow angle.

2 Laying the ground

The next stage is to tint the canvas with a warm color. Mix a very thin wash of burnt sienna with water as the medium and lay it over the whole canvas. It is best to start at the top and work down so that any drips can be easily removed. Use a 1in (2.5cm) synthetic flat brush. As this is quite a large brush, it means that the wash can be completed quickly. Apply the wash with short brushstrokes *(below)*. Do not load the brush too heavily. When the wash is dry it should be barely visible *(right)*.

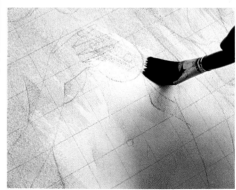

3 Initial painting of the figure

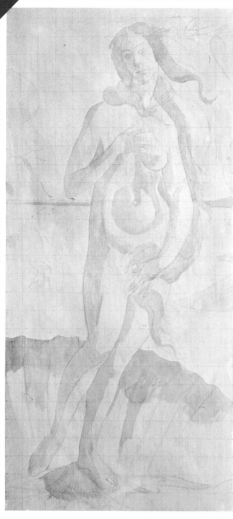

Strengthen the drawing and add some modeling to the figure with a wash of burnt sienna. Paint with a No 6 sable brush. Fill in the bulk of the hair first and then shade in the left part of the face. Refer back to the reproduction to see where the darker shading lies. It is mainly down the left-hand side of the figure, but the top part of the shell should be shaded in all the way round. Add a second wash where the shading is darkest and needs to be built up. Try to keep the wash inside the pencil outlines of the initial sketch (below).

4 Filling in the background

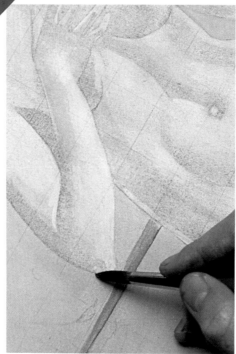

Paint in the background with a broad flat sable brush. Mix a wash of light gray from titanium white, Payne's gray and cerulean blue for the sky. Where the original painting looks mottled, brush a little pure white into the wash. Block in the whole sky even where the hair is going to be (above). Make the color for the sea by adding a touch of permanent light green to the wash used for the sky. It should be slightly darker near the shell. When complete (left), the sea and sky will be similar in color.

6 Building up the flesh tones

Build up the flesh by means of thin glazes. First, cover the whole figure with an almost transparent layer of titanium white. Then mix a darker glaze of raw umber and apply it on top of the white. Use a No 8 sable brush for this work so that no brushstrokes are visible. To give the form more modeling, apply small strokes, gradually building them up one on top of another. Remember to keep the shading on the left of the figure darkest. Ensure that the raw umber does not extend over the outline of the figure and merge into the background or it will make a muddy gray.

5 Adding detail

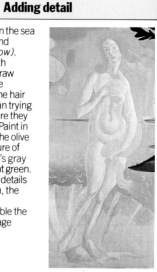

Put in the waves on the sea with a No 8 sable and titanium white (below). Block in the hair with titanium white and raw sienna. Brush in the flowing strands of the hair intuitively rather than trying to copy exactly where they are on the original. Paint in the shore line and the olive branch with a mixture of raw sienna, Payne's gray and permanent light green. Even though all the details are still to be filled in, the painting should be beginning to resemble the original after this stage (right).

7 Further painting of the shell

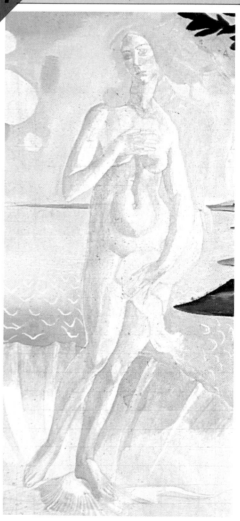

Using the same wash of raw umber, block in the remaining parts of the shell. Blend the paint so that the color merges with the shading already on the canvas and no brushstrokes show.

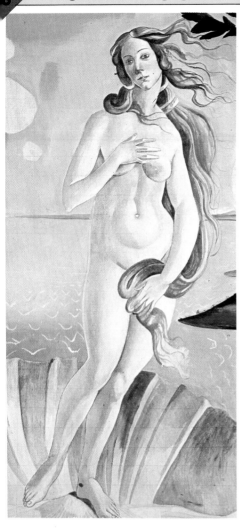

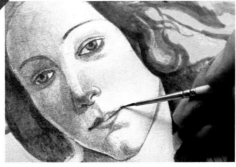

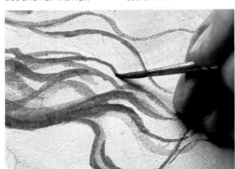

Paint the final detail on the face and hair with raw umber and a very thin sable brush.

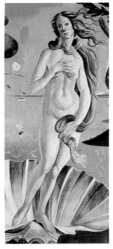

Block in the flowers with white *(left)* and remaining details with gray and cobalt blue. Use white and gray for the rest of the sea *(above left)* and cadmium red for the cloak on the right *(above)*.

With a No 00 sable brush, put in the eyes with burnt sienna. Then apply a weak glaze of cadmium red to the lips to give a hint of color. The hair should be tackled next. Work over the underpainting with a thin wash of burnt sienna and raw umber. Try to copy the way the hair flows in the original as closely as possible. Lay the wash over the shell as well.

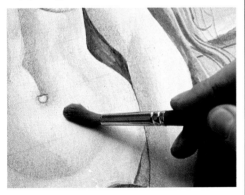

To create a translucent effect, lift off any surplus paint on the figure with a No 8 sable brush. Also, add a few extra highlights with pure titanium white where necessary. Pay particular attention to the area around the navel, the thighs, right arm and right-hand side of the face. Paint in a very thin line around the edge of each finger with a No 0 sable brush.

The final version

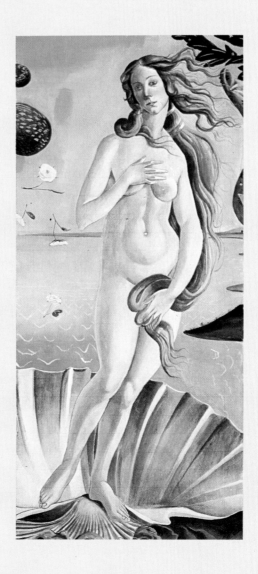

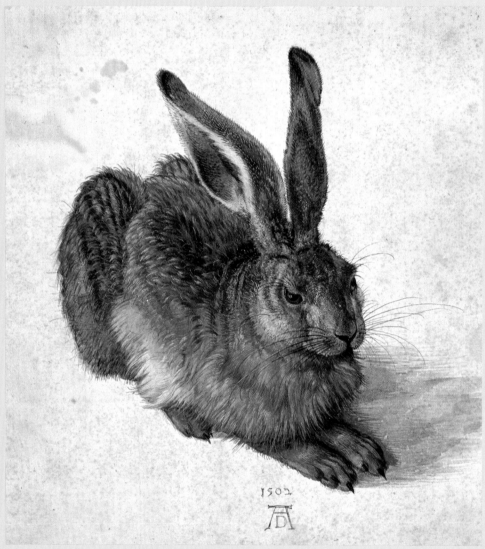

Albertina, Vienna

Dürer

Young Hare, watercolor on paper, 9¾ × 11¾in (23 × 29cm)
This picture, painted from life, is well known from many reproductions.
Dürer used a wide variety of techniques. On his travels he made landscape
and nature studies in watercolor. These were intended as a record for his
future use, but many now stand by themselves as important works of art.
Dürer's subtle use of muted brown and russet tones, applied in a
combination of washes and fine hatching with opaque, white highlights,
creates an accurate and appealing image of the animal.

The Artist

**German artist
born 1471, died 1528
Painter and engraver who spread
Renaissance ideas in Germany**

A scholar, scientist and artist, Dürer is best known for his prints and engravings. He was also instrumental in bringing Renaissance ideas from Italy to Germany and northern Europe. Born in Nuremberg, as a boy he worked with his father, a goldsmith. At the age of 15 he was apprenticed to a painter and engraver. Dürer traveled to Italy on two occasions, visiting northern Italy in 1494 and Venice in 1505 to 1506. While there, he met scholars and painters from whom he learned many new ideas as well as technical skills such as perspective drawing. During his visit to Venice he painted several works which show his mastery of oil painting. In 1512 he was appointed court painter to the Holy Roman Emperor Maximilian. Dürer excelled at woodcuts and copper engravings which he produced in series like the *Apocalypse*, completed in 1498, and single plates like *Adam and Eve* (1504) and *Knight, Death and the Devil* (1513-1514) which are familiar today through reproductions. Dürer's paintings combine German and Italian influences, and he himself placed great emphasis on fine coloring. In several self-portraits Dürer shows himself as handsome and a man of fashion. He was reputedly vain and did not regard himself as a mere craftsman. During his travels he made exquisite watercolors of landscape and natural objects. His print workshop, in his home town of Nuremberg, trained craftsmen to new, high standards in the techniques which he had perfected. Dürer wrote a number of treatises on measurement, fortifications, human proportion and artistic theory, as well as an outline for a painting manual. He corresponded with leading figures of the Reformation and took an active part in promoting the movement. In spite of his connections and travels abroad, Dürer's work retains an essentially individual character. His style was most influential at home, where traditions of sharp observation of nature and detailed linear drawing persisted. Dürer was the greatest German Renaissance artist and was largely responsible for spreading Renaissance ideals to northern Europe. His early training as an engraver shines through in the great precision of his works, whether woodcuts, engravings, drawings or paintings.

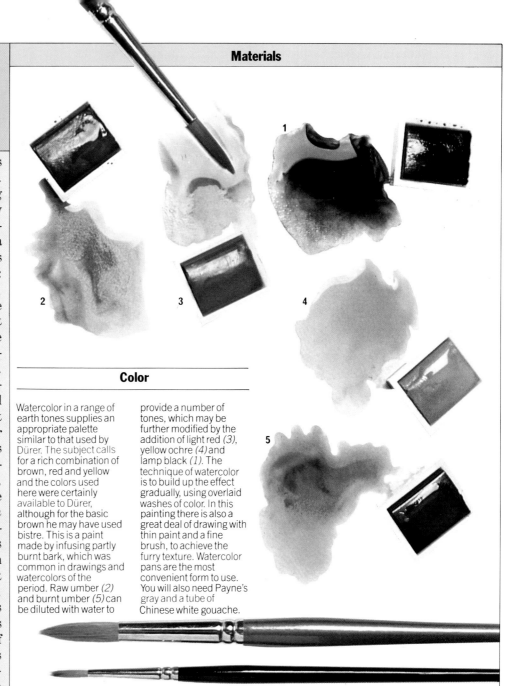

Color

Watercolor in a range of earth tones supplies an appropriate palette similar to that used by Dürer. The subject calls for a rich combination of brown, red and yellow and the colors used here were certainly available to Dürer, although for the basic brown he may have used bistre. This is a paint made by infusing partly burnt bark, which was common in drawings and watercolors of the period. Raw umber *(2)* and burnt umber *(5)* can be diluted with water to provide a number of tones, which may be further modified by the addition of light red *(3)*, yellow ochre *(4)* and lamp black *(1)*. The technique of watercolor is to build up the effect gradually, using overlaid washes of color. In this painting there is also a great deal of drawing with thin paint and a fine brush, to achieve the furry texture. Watercolor pans are the most convenient form to use. You will also need Payne's gray and a tube of Chinese white gouache.

Brushes

Round sable brushes are the most versatile tools for watercolor painting. The sizes used here are *(top to bottom)* No 10, No 2 and No 0. The No 10 brush is used to lay in broad areas of wash, while the two smaller sizes have fine points for detail and texture in the fur and features of the hare. It may prove more convenient to wet the color with a larger brush and then pick up paint on the small brush once it is already damp. Always clean brushes thoroughly.

Other equipment

Graphite, which is the material used for the 'lead' of a pencil, was also used in Dürer's time, though not in the wood-encased form of modern pencils. Use a 2H pencil to make a fine, gray line. The initial drawing should not be obtrusive as it must be covered by the thin paint.

Support

Choose a sheet of handmade, white 'not' paper. This is one of the most popular supports for watercolor painting as it has quite a rough surface, which means that it will take both large washes and fine detailed work. Select a fine quality, fairly thick paper that has already been sized on one side. Before beginning work, stretch the paper. Trim the paper so that it will fit onto a drawing board, leaving a margin round the edge. Soak the paper in clean water and then let it drain off. Put it on the board and stick it down with gummed tape, making sure the paper is flat. Then let the paper dry naturally.

Mediums

Water is the only substance required as a medium or diluent for watercolor. Tap water will do, but distilled water is ideal as it contains no impurities which may affect the quality of the paint as it is applied. Keep the water clean, changing it frequently as you work so colors are not reduced.

Tinting the support

Hold the paper up to the light so that the watermark is the right way round to see which side is sized. Then tint the paper with a thin gray wash.

2 Initial drawing

Once the wash is completely dry, draw in a rough outline of the hare. Use a 2H pencil so that it is just a light sketch, and do not press too hard. The drawing action should flow quite freely. To make sure that the hare is in proportion, keep referring back to the reproduction. Also, try to assess where different parts of the body are in relation to each other by visualizing straight lines and the angles between them. For example, the tip of the left ear and the nose should be in line with each other. This is a useful aid when drawing to scale.

3 Matching washes

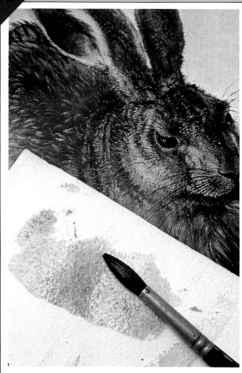

Before starting to paint, experiment with the colors to create washes as similar as possible to the original ones. Use raw and burnt umber, lamp black, light red and yellow ochre. Add more or less water depending on the intensity of color required.

4 Laying the first wash

Mix a very pale wash of raw umber and light red. Using a No 10 sable brush, cover all the main areas of the body and then leave it to dry out thoroughly.

5 Painting the outline

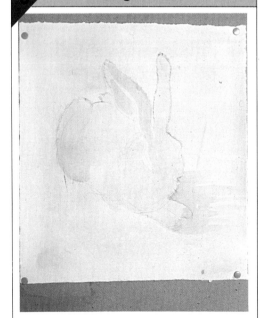

Use a darker wash of raw umber to outline the main parts of the hare. With a No 0 sable brush, work with brisk, short strokes to give the impression of fur. Pay particular attention to the ears, the haunches and the chest at this stage. Make sure that the original pencil marks are well covered and do not show through.

6 Putting in the main forms

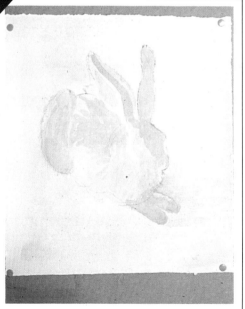

Create a slightly darker wash than before, using raw umber, light red and a touch of black. Fill out the larger areas of the body with a No 10 sable brush. The right ear, back and haunches should be painted with fairly large brushstrokes. Bring the wash down over the forehead to cover the center of the muzzle as well. The paws should also be filled in. They should be painted with a darker shade of the same color on the toes. Finally, paint in some shadow on the background to the right of the hare. Use horizontal strokes.

7 Filling in the body

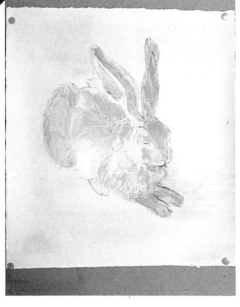

Mix a darker wash from raw umber, light red and lamp black. With a thin brush, such as a No 0 sable, paint in thin lines to outline the major forms in the body. These should include the folds on the back of the neck, the eyes and nose, haunches and front paws. Define the ears and eyebrows as well.

8 Building up the fur

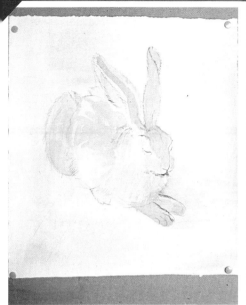

Change to a No 2 sable brush for filling in the body. Use just pure umber, light red and a little water. Do not load the brush too heavily. Start by painting in the shaded, darker parts of the ears. Note that the right ear should be darker than the left. Then paint in the face, paws and major shaded areas of the body. Try to paint in the direction the fur naturally grows and use quite short strokes.

9 Further building up of the fur

Continue to build up the main parts of the body. Work with a No 0 sable brush and burnt umber. Paint in the back left foot and the top of the hare's left haunch. Build up the fur on the back of the animal and on its chest and other haunch. Keep the brushstrokes separate as far as possible, so they look like fur.

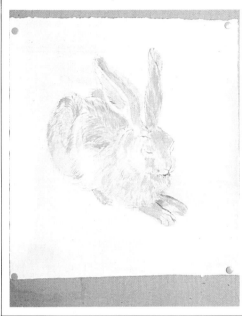

10 Adding definition

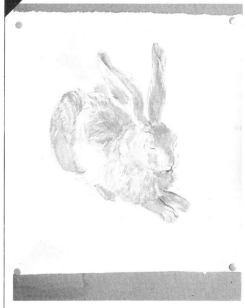

Using a No 2 sable brush, paint in the larger areas of fur. Mix together a fairly dark wash of burnt umber and lamp black. Concentrate on the lower half of the left haunch, blending the brushstrokes to make an area of flat color. Use the same paint to give an impression of thicker fur on the hare's chest and back as well.

11 Developing the fur

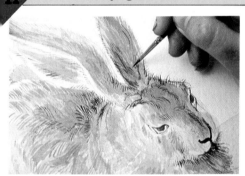

The next stage is to add some definition (below). Work with a No 0 sable brush loaded with lamp black and burnt umber. Fill in the eyes and add the first lines to the mouth. Then define the digits of the feet and draw in the claws. Using very short strokes, paint in darker fur on the shaded parts of the body and on the ears (above).

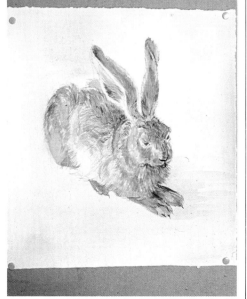

12 Adding areas of tone

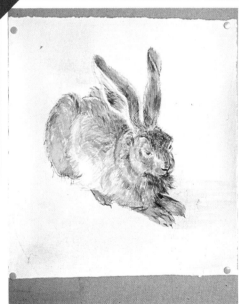

Once the basic lines are drawn in, carry on putting in others beside them. Use only short strokes and try to keep the brush at right-angles to the paper. Put in some more fur on the face, especially the cheeks. Add a number of strokes to the chest so that the hare's coat looks quite bushy.

13 Defining details

With a No 0 sable brush, paint in warm tonal areas on the back and the side of the body. Work with a diluted mixture of light red.

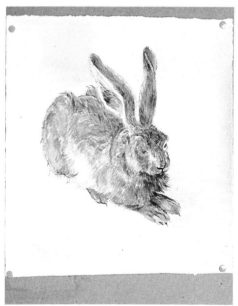

14 Developing details further

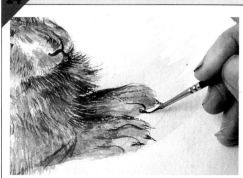

Now use lamp black and a No 0 sable brush to define the details, such as the claws, clearly.

15 Working on the legs

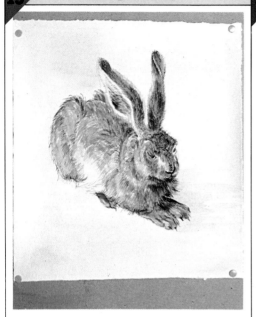

Follow up the initial work on the details by deepening the color. Continue to work with lamp black and a No 0 sable brush. This is the best brush to use for very fine lines as it is so thin. Go over the lines again so that each line is very dark and well defined. Ensure that the paint is not too liquid or it will be difficult to work with. Paint very carefully, keeping a steady hand.

16 Adding form and detail

Make a pale wash from light red, raw umber and lamp black. Then paint in the outline of the front leg. Put in cross-hatching to make the line furry. Add detail to the haunches as well.

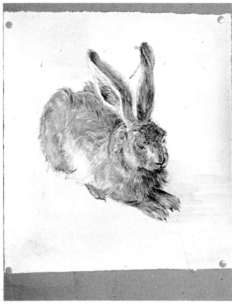

17 Putting in shading

Change to working with a No 2 sable brush to paint in the side, nose, ears and patches of the back. Use a wash of lamp black diluted with plenty of water to create a pale gray. Work with quite a wet brush and use short strokes. Lay the wash over the brushstrokes already on the paper, but do not let the colors merge.

Use the same pale gray wash and a No 0 sable brush to paint in the hare's whiskers and eyebrows. Start on the face and paint each whisker with one confident brushstroke. Work with just the tip of the brush on the paper and drag the paint lightly.

18 Developing highlights

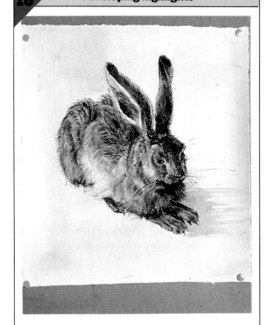

When the pale gray wash has dried, mix up a new wash of light red and raw umber. Now paint over the areas of gray to make the coat look more realistic and give a much warmer color. Work carefully and use a No 2 sable brush.

19 Adding final definition

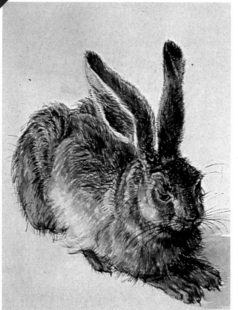

Using the same mixture of light red and raw umber, gradually build up the fur a bit more. A very thin brush, such as a No 0 sable, is best for this stage. Begin at the top and fill in short brushstrokes along the edges of the ears. It is much better to work with many thin strokes rather than a few thick ones. After the shading on the fur has been built up, add some color to the shadow to the right of the body. Only use a hint of paint and work with small dabs.

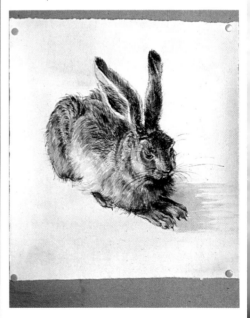

As well as putting in the whiskers, extend some of the lines on the haunches and back of the animal to give a more furry impression. Use a No 2 sable brush for this but then change back to a No 0 sable for the ears. Using very short strokes, put in dark brown dashes to outline the ears and also give some shading to the inner ear as well. Once the gray wash has been applied, the hare should look much darker all over.

| 20 | **Blending the colors** | 21 | **Putting in shadow** | 22 | **Completing shading** |

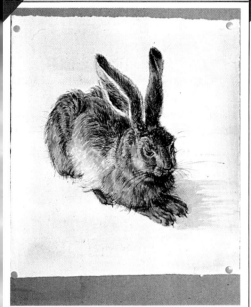

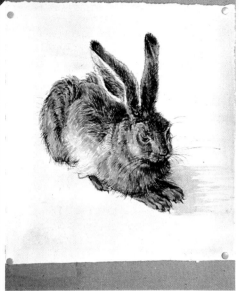

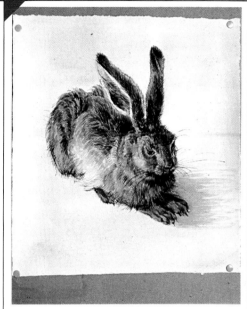

Bring out the warm highlights on the body, such as on the back and parts of the ears and haunches, with a light wash. Mix this from light red and yellow ochre. Work with a No 2 sable brush. Lay down the color in flat areas so that no brushstrokes are visible. Blend the paint with the shades of raw umber and gray that already make up the fur. Add a touch of color to the cheeks, the front paws and parts of the chest.

Add the final touches to the darkest lines of fur with a No 0 sable brush. Work with a mixture of lamp black and burnt umber. Paint over the existing lines rather than make new ones.

Using a wash of pale lamp black, increase the shading to the right of the hare. Work from side to side to build up an area of even color. Blend the strokes together and use a No 2 sable.

The final version

| 23 | **Adding highlights** |

Finally, add the highlights with a No 0 sable brush and pure Chinese white. The right ear should be left without any highlights but a generous amount should be applied to the rest of the body. The outline of the left ear should be painted in and the highlight on the side of the hare should also be increased. Lightly paint over some of the whiskers on the left-hand side. Use small groups of brushstrokes placed close to each other to add highlights to the fur. Also paint the face to the left of the nose with tiny dots. Lastly, paint in the whites of the eyes.

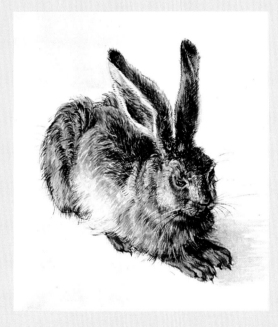

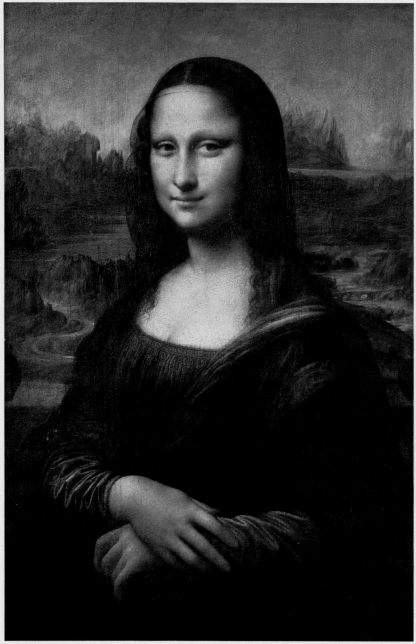

The Louvre, Paris (photo — Bridgeman Art Library)

Leonardo

Mona Lisa, oil on panel, 30 x 20in (77 x 53cm)
This is arguably the world's most famous painting. Leonardo was a tireless
experimenter and technician and this portrait is evidence of his inquisitive
mind, both in his rendering of the individual character of the model through
her secretive smile, and the innovative pictorial effects which he developed
in the new medium of oil painting. Working in thin, semi-opaque layers of
color over a gray or violet underpainting, he created softened outlines and
subtle half-tones.

The Artist

**Italian artist
born 1452, died 1519
Next to Michelangelo, the most
famous Renaissance artist**

The great artists of the Italian Renaissance each reveal different aspects of genius. In the case of Leonardo da Vinci, this was expressed in scientific as well as in artistic terms. He was a passionate investigator of the laws of nature. His early training was as a painter in the workshop of the Florentine artist Andrea del Verrocchio (1435-1488), where sculpture, furniture, ornaments and armor as well as paintings were made. In 1472, Leonardo was made a master craftsman of the painters' guild. His passion for research is revealed in his many notebooks, often written in his idiosyncratic 'mirror' writing. He studied the appearance of things not simply as subjects of art, but in order to understand the structure and function of nature. He made drawings of inventions which could only be realized centuries later, including one of a flying machine. Leonardo's fondness for experiment led him to try new methods of painting, which, however, were not always successful. For example, this can be seen in the gradual decay of his Florentine wall painting *The Battle of Anghiari,* painted in 1504 and 1505, or in the 'curdled' surfaces of some of his paintings resulting from excessive oil in the paint. In 1483 Leonardo was employed by the Duke of Milan. Between 1475 and 1478 he painted *The Last Supper* which was remarkable for its psychological interpretation of the subject. In his major paintings, he created new effects of atmosphere and light, and used soft outlines to increase the illusion of figures in space. The *Mona Lisa,* painted around 1502, and *The Virgin of the Rocks,* painted around 1508, are good examples. Although Leonardo would have had access to most of the pigments available, he chose to use a rather muted palette in which color played a secondary role to the subtle modeling of form and organization of light and shade. Leonardo also worked as a military engineer and made designs for a large equestrian monument. The diversity of his interests and the legendary slow speed at which he worked caused him to complete few of his projects. When approaching old age, he was invited by the king to live in France where he was able to pursue his scientific studies quietly until his death in 1519. Leonardo is one of the world's best known artists.

Materials

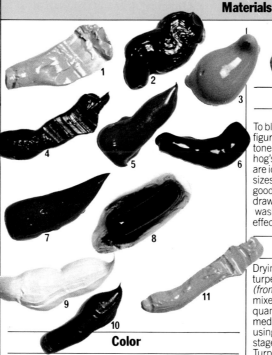

Brushes

To block in the form of the figure and background tone quickly and loosely hog's hair bristle brushes are ideal. Flat brushes in sizes 4, 6 and 8 give a good range of marks for drawing and broad washes of color. A softer effect is achieved with a round No 6 sable brush, and No 4 and 2 sables can be used for fine detail. A fine stippling brush of soft hair is useful for adding texture and a sable fan brush is needed for laying in and blending thick paint and color glazes.

Color

The painting is initially blocked in with a combination of lamp black *(10)* and the dark earth colors terre verte *(4),* burnt umber *(2)* and raw umber *(8).* Cobalt blue *(7)* is used in both the sky and the background. The clothing and flesh tones are given color with glazes and areas of opaque Naples yellow *(1),* yellow ochre *(3),* Venetian red *(5),* carmine *(6)* and cadmium yellow light *(11).* Flake white *(9),* the common form of white paint in Leonardo's time, is needed to give the color mixtures opacity and for highlights and all the pale tones.

Mediums

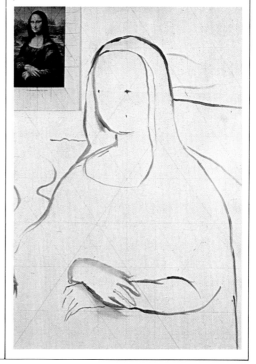

Drying varnish, pure turpentine and linseed oil *(from left to right)* can be mixed in varying quantities to make mediums for the paint, using the varnish in later stages of the work. Turpentine alone is a diluent which preserves the rich color of the paint.

Support

Leonardo painted the *Mona Lisa* on wooden paneling. A reasonable alternative to painting on wood is to use an oil prepared heavyweight board with a fine grain. Choose an unprimed board.

Priming

Prime the board with a ready-made oil-based white primer, slightly tinted with raw umber oil paint for a softer effect. This practice was invented by Leonardo. Put on the primer evenly to cover the board well.

Squaring up

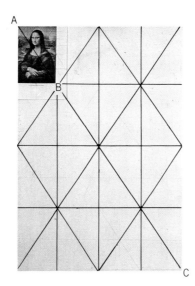

It is essential that the squaring up process is executed carefully or the final copy will not be in proportion. Fix a reproduction of the painting, such as a postcard, to the top left corner of the primed board. Draw the diagonal AB *(above)* across the picture. Now extend this onto the board to make the line BC. Use a ruler to get the line straight and do not use too hard a pencil or the grid lines will show through the finished copy. Draw in the other diagonal, the horizontals and verticals on both the picture and the board until the grid is complete. It should have at least 16 sections.

Initial outlining

Once the grid on the board is completed, paint in the outline of the figure, her left arm, and hands. Also, suggest parts of the background. Always refer back to the squares on the postcard to check that the lines painted on the board are in the right position. Work in raw umber oil paint diluted in a medium made up of equal parts of pure turpentine, linseed oil and a drying varnish. Use a No 6 sable brush for a thin, fine line and paint with confident, sweeping strokes.

3 Blocking in main areas

Using the same mixture of raw umber diluted in the medium, work the main areas of tonality in the hair and the dress. A No 7 hog's hair brush is best for filling in these larger areas. Do not paint in the flesh parts yet. Fairly large brushstrokes can be applied at this stage.

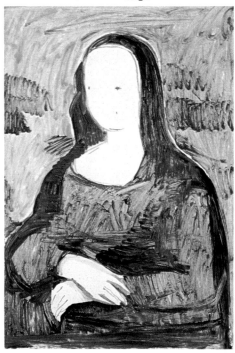

4 Defining light and shade

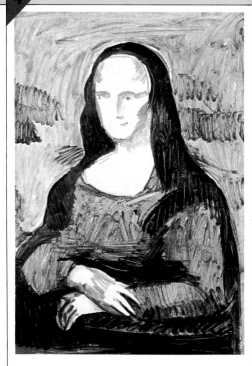

The next stage is to define the darker, shaded areas further. Continue to paint in raw umber with a No 6 sable brush. Ignore the background and concentrate fully on the figure. Use fairly short brushstrokes to build up strong areas of shadow gradually. Then sketch in the facial features with pale raw umber. Do not worry if any mistakes are made as these can be rectified later. This shading is only to give a first hint of color to the flesh. Lightly shade in parts of the hands as well.

5 Softening flesh tones

Continue to work on the face and hands with raw and burnt umber and black. For a soft effect, use Leonardo's technique of smudging the paint with a piece of rag *(above left)*. Only a pale suggestion of the features should remain visible *(above and below)*.

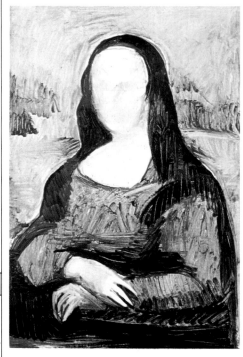

6 Building up the body

Use a No 6 sable brush to build up the body even further with lamp black and raw and burnt umber. Concentrate especially on the hair and the clothes at the bottom of the picture where the shading is so dark it is almost black.

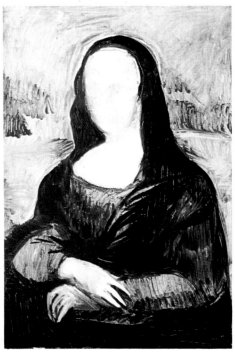

7 Adding detail to hands and sleeves

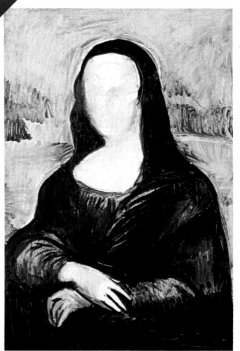

Change to a stipple marten brush No 4, which is slightly thinner than a sable No 6, to work on the hands and sleeves. The aim is just to add some more color at this stage and not to complete the final touches as this needs to be done later on. Use short brushstrokes and then use the same softening technique as applied on the face to smudge the paint. Make sure that the bit of rag is clean and has not been used before. Add definition to the fingers as well.

8 Adding initial landscape detail

Paint with the No 4 stipple marten brush to darken the landscape, hands and neck. Use terre verte, lamp black and raw umber.

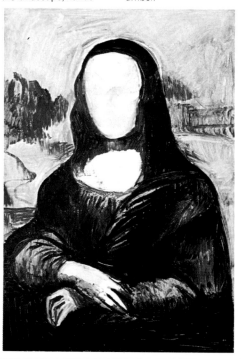

9 Working on face and hands

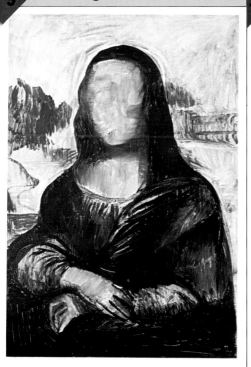

Change to a fan brush to paint the face and hands a darker color *(above)*. Make a thin grayish glaze out of terre verte, raw umber and Naples yellow. Use short brushstrokes and add a darker glaze to the shaded parts of the hands *(right)*.

10 Painting in sky

Mix together cobalt blue, raw umber and terre verte or burnt umber to make a gray-blue. Use a hog's hair filbert to paint in the sky and most of the background. Do not paint over the umber shading to the left of the head.

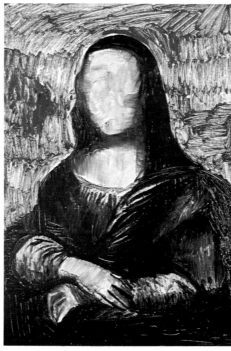

11 Filling in background

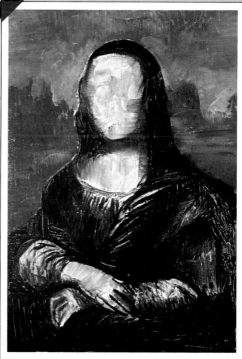

Change back to a fan brush to give more body to the background. Brush on the paint quite thickly and use little strokes *(below)*. The sky should now be the same color as the land and all the background should be quite blurred *(above)*.

12 Adding detail to dress

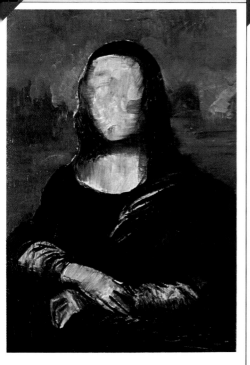

Again using a fan brush, paint the bodice and neck using a thick mixture of lamp black and terre verte *(above)*. Apply the same color to increase the shading on the lower parts of both arms *(left)*. Use a gentle dabbing motion.

13 Blending background

Next, draw a fan brush across the background in a sweeping movement to lift off some of the paint and blend it further *(right)*. Then use a No 2 marten stippler to go around the edge of the head and sleeves *(below)*.

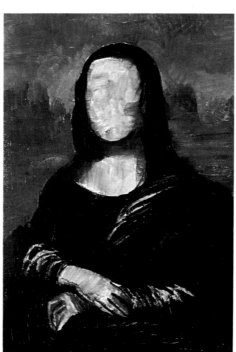

14 Adding initial highlights

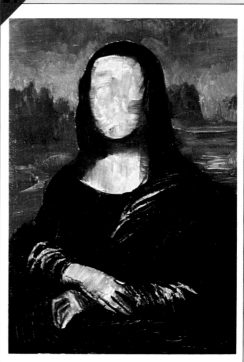

With a mixture of raw umber, light red, Naples yellow and flake white, highlight the clothes and parts of the background.

Highlighting folds and flesh

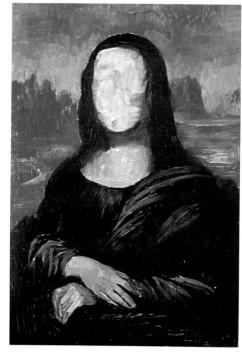

Finish blending the highlights on the clothes to give a good impression of the folds (right). Model the hands with the same highlight mixture as before. Use both a No 4 stipple marten brush (above and below) and a fan brush (bottom).

Using a No 4 stipple marten brush, paint in the flesh above the neckline of the dress (above). Mix the color from light red, raw umber, Naples yellow and flake white. Blend the paint into the shadows and darker areas next to the hair.

Painting the features

Before putting in the facial features, scrape back the paint very gently so that the pencil lines of the grid show through from underneath. These will act as guidelines so lightly paint them in with raw umber and a thin brush. Strictly adhering to his theory of classical proportion, Leonardo painted the face as follows. The imaginary center of the head runs through the eyes. The bottom of the nose lies on a line halfway between the center of the eyes and the chin. The shading underneath the lower lip is halfway between the center of the eyes and the chin. The area of forehead between the head string and the top of the head takes up ⅛ of the whole head. Finally, the corners of the mouth are in line with the center of the eyes. Using a sable No 4, paint the features in with raw umber (below right) following the above guidelines closely. Refer back to the original picture for extra help. Then paint out the grid lines with a flesh color (below left).

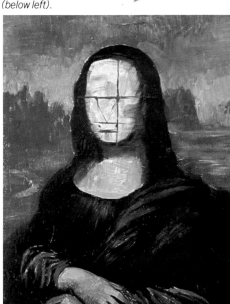

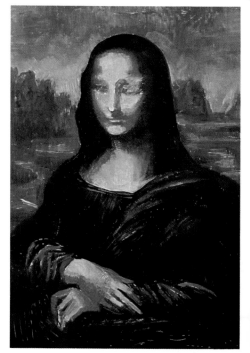

Building up flesh tones

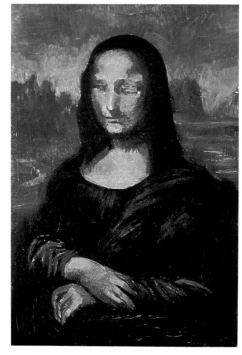

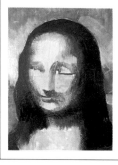

Once the features are roughly in position, paint in the flesh. Create the color by mixing flake white, light red, Naples yellow and raw umber well diluted in the medium. Begin by shading in the temples and cheek bones with raw umber (left top).

Continue to paint in a dark color all around the edge of the face (left center). Draw the paint inwards blending the colors with a fan brush (left bottom). The shading should make the features more defined (above).

Applying glazes

Mix up a thin glaze of raw umber well diluted with the medium. Using a No 6 sable round, paint the glaze over the background (above). Then use the same glaze to darken the forehead (below). Draw the paint in the hair down onto the flesh with the tip of the brush. Keep the brush-strokes as short as possible. Apply the glaze over the whole of the face to give a soft effect (right). The flesh tones should be well blended.

19 | Adding facial detail
20 | Completing facial detail
21 | Shading the jaw

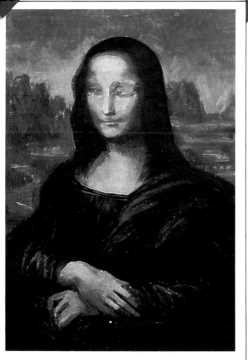

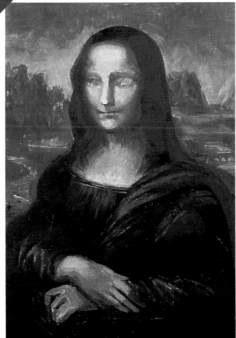

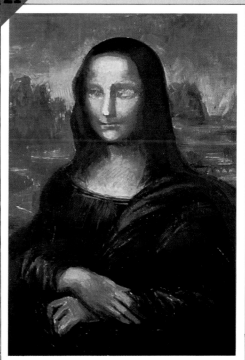

To complete the flesh coloring on the face, use a very small brush such as a No 1 sable. Apply the same colored paint made up from raw umber, burnt umber, Naples yellow and just a little hint of flake white. The brushstrokes should be minute and barely visible.

First add the color to the face *(above left)*. Then put the finishing touches on the other flesh parts *(above center)*. Lastly, blend the shading along the jaw bones *(above right)*. The final coloring on the face should be extremely pale.

The final version

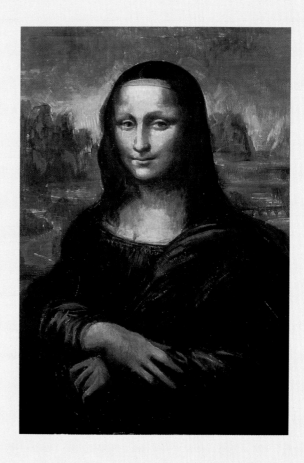

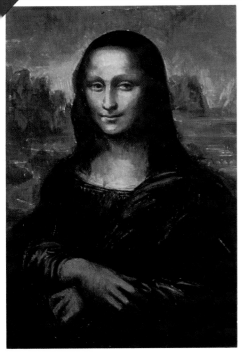

To complete the picture, put a dab of flake white in the whites of the eyes. Finally, paint in the very thin line of the head string *(right)* and also the eyeballs. Work with a No 1 sable brush and raw umber to define the features *(above)*.

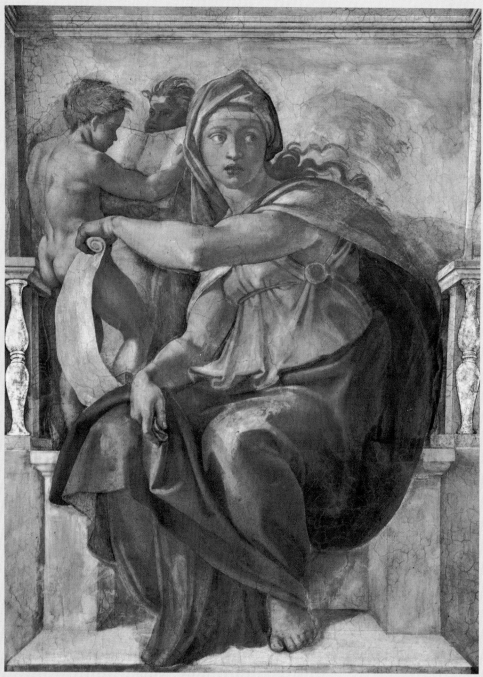

Sistine Chapel, Vatican (photo — Scala)

Michelangelo

Delphic Sibyl (detail from Sistine Chapel ceiling, Rome), fresco
Michelangelo's monumental effort in painting the Sistine Chapel ceiling
produced an outstanding example of the art of fresco, a technique
perfected in sixteenth century Italy. This image is a small detail from the
many religious scenes. The work was painted in wet color on fresh plaster,
the two fusing together as the plaster dried. Michelangelo prepared large
drawings, known as cartoons, to transfer the design to the ceiling. Fresco
leaves little room for alterations or corrections.

The Artist

Italian artist
born 1475, died 1564
Painter and sculptor, leading figure in the Renaissance

Leonardo da Vinci (1452-1519) and Michelangelo Buonarotti are regarded as the major figures in that extraordinary flowering of artistic talent, the Renaissance. Michelangelo was some 23 years younger than Leonardo. Michelangelo's life and works are well known through the comprehensive biography by his friend and admirer Vasari which was published in his book *Lives of the Artists* in 1550. Michelangelo was born near Florence and began his career as an apprentice to the respected painter Domenico Ghirlandaio (1449-1494), but soon entered the workshop of the sculptor Bertoldo. Michelangelo copied antique classical sculptures which were then being enthusiastically excavated in Italy. His skill attracted the attention of Lorenzo de' Medici, the ruler of Florence, in whose palace Michelangelo lived. Michelangelo became interested in the ideas of humanism which stemmed from interest in classical art and philosophy combined with Christian belief and scientific investigation. His prodigious talents in sculpture and painting, together with his researches into anatomy, led him to evolve a new form of expression. Michelangelo treated the human figure as the vehicle for conveying human emotions, studying movement and introducing a new type of composition based on diagonal stresses and clear perspective. This can be seen in the figures he painted for the Sistine Chapel in Rome, where he decorated the ceiling and altar walls with Biblical subjects. This was perhaps Michelangelo's most daunting task. The huge fresco took four years to complete; the work began in 1508 and was finished in 1512. The complex arrangements of figures show a wealth of detail. The painting itself had to be done with the artist lying on his back on scaffolding. As well as painting and sculpture, Michelangelo designed memorials for Popes Julius II and Clement VII and worked as an architect in Rome and Florence. After 1534 he lived exclusively in Rome, chiefly occupied with papal commissions. He inevitably attracted criticism because of his robust portrayal of nude figures. Michelangelo's talents also extended into literature. Like his paintings and sculpture, his *Sonnets* demonstrate his belief in beauty as the goal of human existence.

Support

The original painting was executed in fresco, a technique which is impractical for many reasons. The paint was applied to fresh plaster, a small section at a time, and for a good result ideal drying conditions were necessary, which is why fresco flourished in Italy. As a simple solution, a smooth board and acrylic paints have been used for this copy. A ready-primed and stiffened canvas board can be used but the surface must be pure white if the fresco effect is to be successfully imitated. A sheet of hardboard cut to size, in this case 28 × 20in (70 × 50cm), provides a suitable surface when primed with two coats of acrylic primer. Hardboard must be battened at the back to prevent warping.

Mediums

Acrylic paint can be thinned with water only to make loose washes of color. Add less water in later stages and make use of the paint texture.

Color

Since Michelangelo was primarily a sculptor he was concerned with the modeling of form, an effect largely dependent upon the tonal scale, rather than the colors, in a painting. However, with a limited range of color he was able to achieve a subtle representation of his subjects. At the time there were few bright colors and they were often extremely expensive. Vivid blues, for example, were used sparingly for this reason. The palette, of acrylic paint, consists mainly of earth colors — burnt umber (1), raw umber (2), terre verte (3), yellow ochre (5) and Venetian red (7). Lamp black (4) and flake white (6) are used to increase the tonal range and cobalt blue (8) to add richness to the drapery.

Other equipment

Use charcoal for squaring up and the preliminary drawing. It can be easily rubbed down with a soft rag if corrections are necessary. Rags are useful for blotting the paint and wiping brushes. Acrylic paints are water soluble and easy to use so brushes and water are the only vital materials.

Brushes

Round sable brushes *(top to bottom)* Nos 2, 3 and 10 cover the range of marks used in this image. Lay in broad washes of thin paint with the No 10 brush and add details of particular features with the two fine sizes.

1. Drawing the figures

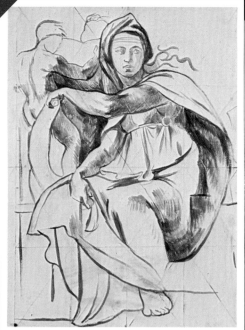

Draw a grid based on diagonal divisions of the picture area over the reproduction. Scale up the grid on canvas using charcoal and a long ruler to draw the lines. Transfer the outline of the figure to the canvas, putting in the basic shapes of limbs and drapery. Mix a dark greenish-brown from raw umber, terre verte and a little black. Dilute the paint with water and using a No 3 sable brush, reinforce the lines of the figures. Start to block in shadows and dark tones with finely cross-hatched strokes and thin washes of paint on the limbs and drapery.

2. Overpainting with flesh tone

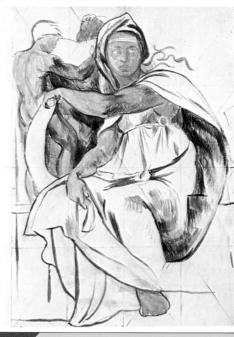

Acrylic paint dries in a short time, especially when applied thinly, so it lends itself to a technique of building up form by overpainting layers of color. When you have established the basic divisions of light and shade, this can be overpainted with a flesh tone. Mix white and light red, thinning the paint with water until it is still viscous but fairly transparent. With a sable brush, paint across the dark tones and bare areas of the board, modifying the tonal structure in the underpainting. As shown in the detail (above) the flesh tone covers the cross-hatching but is not opaque so does not obliterate the modeling in the figures.

3. Coloring the drapery

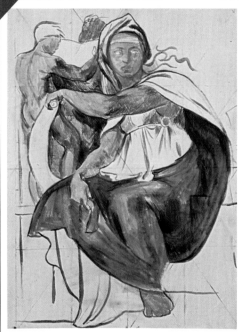

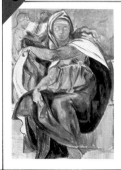

Add yellow ochre and a little raw umber to a quantity of light red. Dilute the color and, using the No 10 sable brush, lay in the broad area of drapery across the form of the central figure. Apply the paint initially as a thin wash and gradually build more density of tone over the dark underpainting. Follow the outlines carefully.

4. Putting in middle tones

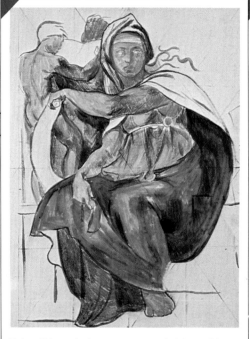

Make a thin wash of raw umber and terre verte. Paint the dress of the main figure with a light tone over the body and slightly darker color in the bottom of the skirt. Use the direction of the brushmarks to suggest the rhythm of the drapery over underlying solid forms. When working with color washes, clean the brush thoroughly before moving from one tone to another, otherwise the colors gradually become similar in tone and hue and the forms less distinct.

5. Underpainting the background

Develop tones in the background with raw umber and black. Lay in a darker shadow in the area between the figures, keeping the paint fairly transparent as before. Loosely block in a light wash of color over the whole background area. Then build up dark tone to the right of the figure, emphasizing the outline and throwing the form into relief against the background plane. Again use the No 10 sable brush, which is large enough to cover the surface area quickly.

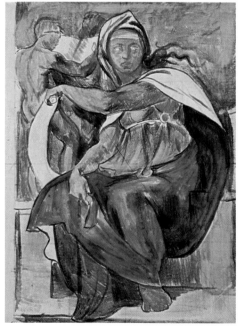

6. Reworking the drawing

Draw with the brush, in a mixture of raw umber and black, developing detail in the composition. Reinforce the modeling of the drapery, darkening the shadows and using linear marks to indicate the fluid lines of skirt and cloak. Use slightly thicker paint than in the initial washes, so the paint surface becomes more active and definite.

7. Highlighting the flesh tones

Brush in highlights on the curves of arms and face. Make a pale pink from flake white tinted with light red and lay it over the flesh toned wash. Use the same tone on the leg and back of the figure in the background. Apply the paint sparingly at this stage. Block in the hair with a thin wash of Venetian red.

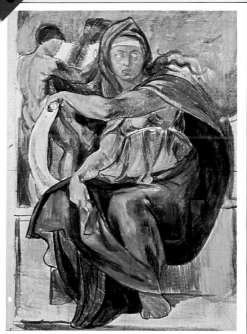

Mix cobalt blue and lamp black to make a middle toned blue-gray. Paint in the drapery over the head and left shoulder of the figure. Follow the curving shape with the brushmarks.

With flake white, thinned moderately with water, brush in highlights on the flesh and drapery. Note that highlights on the arm are put in with separate brushstrokes, creating an effect similar to hatching, whereas the scroll held by the figure and the light tone to the right of the head are painted with a solid but semi-transparent layer of color. Lighten also the curves of folds in the drapery, for example over the knee where the fabric falls directly over the form.

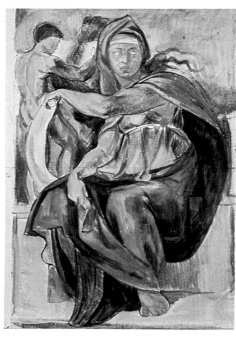

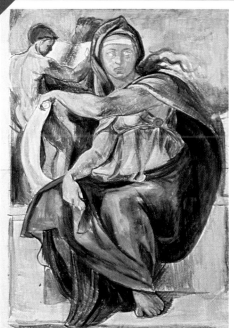

Rework the dark tones, drawing around the forms and developing the shadow areas. Use small hatched marks to build up the tone, working over and across the washes of the underpainting. Overlay this with broad brushmarks, using raw umber and black applied with the No 10 round sable brush.

11 **Completing the details**

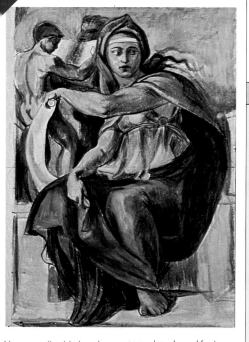

Use a small sable brush to draw in details of the face, outlining eyes, nose and mouth in raw umber. Add definition to the modeling with small areas of hatching (*below*). Outline the arms, hands and feet more precisely to add emphasis to the muscular forms and characteristic shapes. Work over the whole image adjusting the tonal balance.

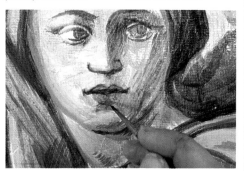

The final version

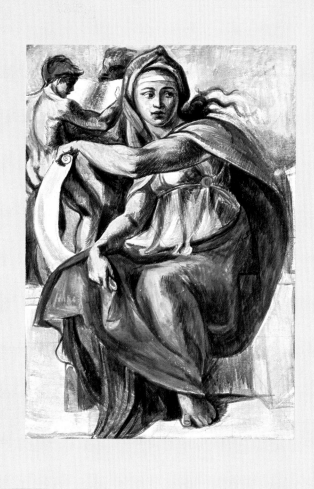

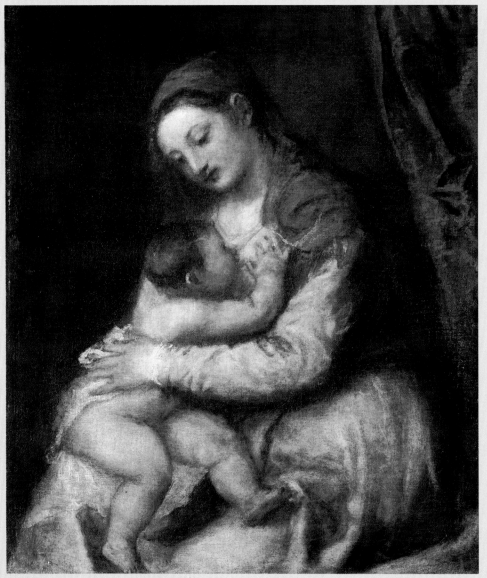

Mother and Child, oil on canvas, 29⅔ x 24⅞in (75.6 x 63.2cm)
Titian was a keenly observant and technically sophisticated painter, so was fully capable of rendering a wide variation in the thoughts and moods of his subjects. His subtle commentary behind the images can range from satire to sympathy. Like other Venetian painters of the time, he tried to develop the qualities of color, tone and texture in his work, achieving superimposed warm and cool tints and delicate modeling with transitional tones. His later works are full of rich color and expressive brushwork.

The Artist

**Italian painter
born c1487, died 1576
Venetian artist, one of the first to
work mainly on canvas**

Titian was the leading artist of the Venetian School. His career lasted for more than 70 years. Over this period his style altered greatly, changing from the detailed approach of his early pieces to the loose blocks of color in his later works. He was born in Cadore in northern Italy and was sent to study with the Venetian artist Giovanni Bellini (c1430-1516). At that time Venice was an independent republic and was a very important maritime power and commercial trading center. The wealth of Venice's more important citizens was often reflected in lavish works of art which they commissioned. The use of canvas as a support for painting became popular in Venice partly because the city's wet and salty atmosphere was not suited to work on wood or in fresco. Canvas also had the advantage that it could be rolled up and transported easily. Venetian artists were influenced by the oil painting techniques developed from the work of van Eyck (active 1422-1441). Early in his career, Titian worked in fresco, but soon turned his attention to large-scale pieces on canvas. He gradually began to develop an individual style of painting which was based on the broad effects of color, light and shade rather than detailed drawing. Unlike his contemporaries, Titian worked the composition directly in paint rather than doing detailed underdrawing. Titian held several court appointments during his long career, including painter to the republic of Venice from 1516 and, from 1533, court painter to the Holy Roman Emperor Charles V. Titian became particularly well known for his portraits. In his later years, the great demand for his portraits forced Titian to employ assistants and to work not from life but from other paintings and, in some instances, even from medals. However, despite these drawbacks, Titian's portraits have both character and vitality. The importance of Venice as a commercial center and port gave artists access to a wider range of pigments than was available elsewhere in Italy. One feature of Titian's early work was his use of a wide range of colors. In his later works, however, Titian used a more muted palette, conveying the effect of light playing over surfaces giving the blurred contours and blended tones of these works.

Materials

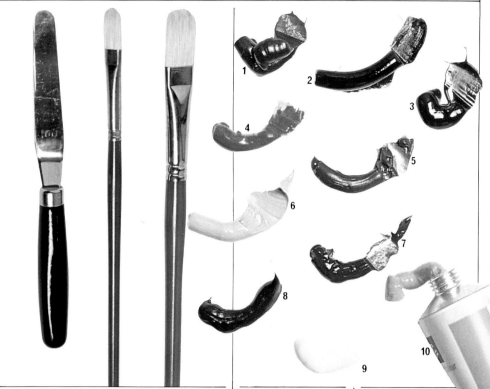

Brushes

Very few brushes are required for this fairly loose style of painting. All that you need are (from left to right) a palette knife with a flexible, rounded blade; a No 6 hog's hair filbert and a No 8 hog's hair filbert.

Mediums

Linseed oil (left) and turpentine (center) should be used in roughly equal proportions. A quick drying varnish (right) is also necessary.

Support

Titian painted on canvas so a use a stretched canvas support. Medium weight cotton duck measuring 24 × 20in (61 × 51cm) is suitable. Prime it with an oil-based primer tinted with a little burnt umber which is what Titian used. After the first coat has been applied, let it dry thoroughly. Then put on a second coat.

Color

A fairly extensive palette is required for this work. The colors are raw umber (1), lamp black (2), madder carmine (3), Venetian red (4), terre verte (5), Naples yellow (6), cobalt blue (7), burnt umber (8), flake white (9) and cadmium yellow (10). Yellow ochre will be a useful addition to the palette for the highlights and the flesh tones.

1 · Blocking in the background

Paint in the basic outline of the two figures following a roughly triangular form. Use a No 8 round filbert hog's hair brush and burnt umber. Work very freely, applying the paint in broad, sweeping brushstrokes. Put in a line for the left-hand side of the mother's head and the shadow under her left arm.

Continue to work with the same brush and paint. Put in outlines for the child's head and legs, and the mother's arm. Then mix up a much paler wash of burnt

2 · Initial painting of the figures

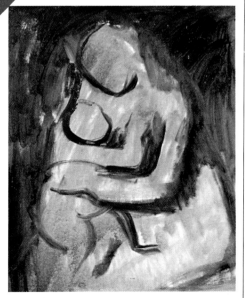

umber and block in the whole of the remaining area. Blend the dark line of the underside of the arm into the wash using short brushstrokes.

49

<table>
<tr>
<td>

3 **Defining the figures**

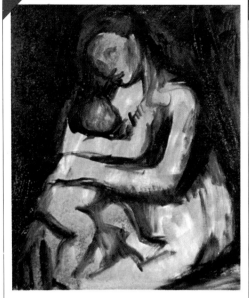

Add some definition to the figures with a mixture of both raw and burnt umber and black. Use a No 4 round hog's hair filbert. Fill in the faces with a light wash, making it darker where the hair is. Suggest the features on the mother's face, and also put in the child's ear. Work up the darkest areas of shadow in the crook of the mother's arm. Paint over the darkest parts of the background.

</td>
<td>

4 **Painting in the cloth by the child**

Paint in the pale cloth surrounding the child with thick flake white. Apply the paint with a No 4 hog's hair brush. Mix the white in with the umber on the canvas to form a slightly cream color. Build up several layers of paint.

</td>
<td>

5 **Blocking in the areas of color**

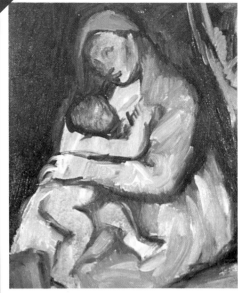

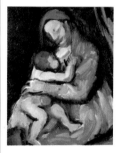

Block in all the major areas of color (above). Use a mixture of raw umber, cadmium yellow and terre verte for the hair and the drapery on the right of the picture. Paint in the dress with cobalt blue and white. Fill in the flesh tones with Naples yellow and Venetian red, letting the underpainting show through. Blend the flesh with a finger (left).

</td>
</tr>
<tr>
<td>

6 **Reworking the dress**

Rework the modeling of the dress with some more cobalt blue and white (above). Use a palette knife to achieve a smooth surface. Titian often abandoned painting with brushes when he was putting in the final touches on a painting. Instead, he used a knife or his fingers to blend the paint and, in particular, bring out the highlights. Put one layer of paint down on another, smearing it with the knife. This gives an even, smooth texture which cannot be achieved so easily with a brush. Use pure cobalt blue for the darker parts of the dress and add some more white for the highlights. Once the work on the dress is completed, adjust the tones on the face of the mother (below). Use a No 8 hog's hair brush to rub the flesh colored paint into the canvas. This brings out the texture of the support which is a feature of Titian's technique.

</td>
<td colspan="1">

7 **Building up the flesh**

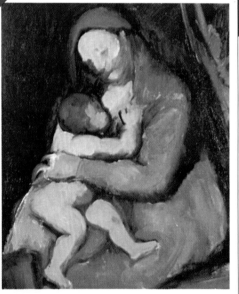

Carry on building up the flesh with a mixture of flake white, yellow ochre and Venetian red (above). Then add highlights to the drapes on the right of the picture and the hair of both the mother and child (above). For this, use a palette of cadmium yellow, yellow ochre, Venetian red and flake white. Drag a heavily loaded No 4 hog's hair brush over the surface, bringing out the texture of the support. The paint should be diluted with only a small amount of the medium so that it lies quite thickly. Refer back to the original reproduction to see exactly where the lightest parts of the hair should be, and paint them in accordingly.

</td>
<td>

8 **Highlighting the dress**

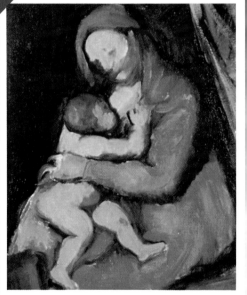

Put in some additional highlights on the clothes, again using cobalt blue and flake white. Use heavy paint without any medium and a No 4 hog's hair brush.

</td>
</tr>
</table>

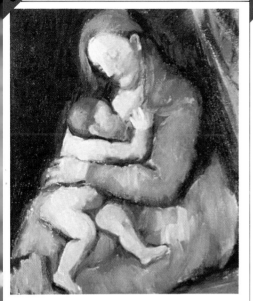

Define the features of both the faces and the hands. Mix the medium with flake white, yellow ochre, Naples yellow, madder carmine and Venetian red. Emphasize the rosy cheeks.

Return to the dress once more with the palette knife. Titian always left parts of a painting and went back to them with a fresh eye at a later stage. Smear flake white on top of the blue to bring out the modeling.

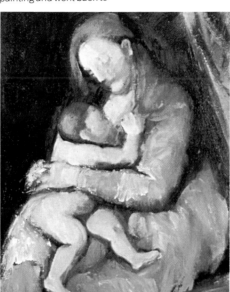

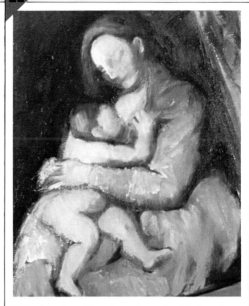

With a thin glaze of burnt umber, redefine the darker lines on the painting. Apply it also to the mother's hair and shoulder. Then put in a series of short strokes on the child's head.

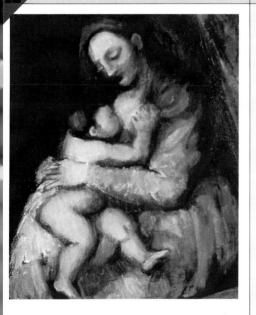

Add further highlights to the flesh and dress with pure flake white and a No 4 hog's hair brush (above). Use a finger to smudge the paint so that it is blended well (left). This is a technique that Titian frequently employed.

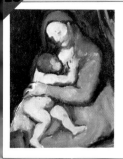

Finally, varnish the painting. However, before doing this, make sure that the oil paint has dried completely. This will take at least one week, and it may easily take 6 weeks or so. Test the dryness of the surface by touching it. One coat of quick-drying varnish should be sufficient.

The final version

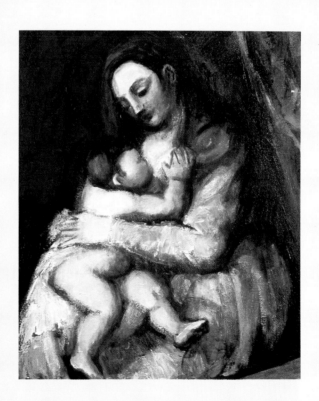

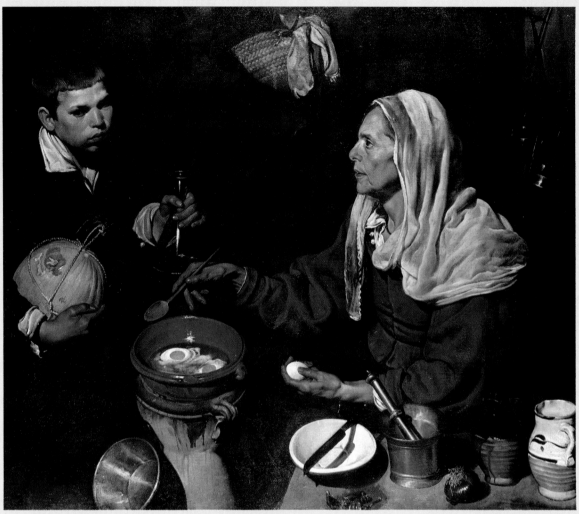

The National Gallery of Scotland (photo — Bridgeman Art Library)

Velazquez

Old Woman Cooking Eggs, oil on canvas, 39 × 46in (99 × 117cm)
The term genre painting describes scenes which show ordinary people
engaged in their day to day activities. Cooking, eating and drinking were
particularly popular subjects among seventeenth century Spanish
painters, including Velazquez. The other aspect of this picture which is
typical of his work is the use of stark contrasts of light and shade, or
chiaroscuro. This gives the forms a heavily modeled effect and sharpens
the painting's focus.

**Spanish artist
born 1599, died 1660
Spanish court painter of portraits
and domestic scenes**

Diego Rodriguez de Silva Velazquez was a Spaniard whose family came from Portugal. He was born in Seville, and while very young began to study painting. His principal teacher was the artist Pacheco (1564-1654), who was later to write an account of the painter's methods. In 1618 Velazquez married Pacheco's daughter and became a member of the painters' Guild of St Luke. His early paintings show scenes of daily life in which his interest in naturalistic effects and strong light and shade are evident. Velazquez visited Madrid in 1622 in order to see the collections of paintings there. During this visit he painted the portrait of the poet Gongora. This gained him an introduction to the royal court. A year later the Spanish king, Philip IV, became his patron, and from that time allowed no painter other than Velazquez to paint his portrait. This privilege and the other court appointments which he received assured Velazquez of his position in the royal household. Although this restricted him in his choice of subject matter, the close association with the king over a long period resulted in a series of portraits of Philip IV, as well as portraits of members of the royal family. In 1648 Velazquez visited Italy on behalf of the king. There he painted the portrait of Pope Innocent X, and the *Rokeby Venus* (c1649) which is his only nude. Velazquez achieved a great reputation and was particularly admired by painters of the nineteenth century who saw his economy of brushwork and simple designs as confirmation of their own efforts. However, the impression of spontaneity in Velazquez' work is in fact the result of careful thought and experiment. Indeed, many of Velazquez' works show that he made alterations during the painting. He also tended to wipe his brush clean on the canvas, leaving traces which he subsequently painted over. It is likely that Velazquez used fairly fluid paint mixed with linseed oil, while the smooth brushstrokes show that Velazquez preferred to use soft hair brushes rather than the coarse bristle variety chosen by some of his contemporaries. Velazquez has had a great influence on many important, later artists, including his fellow Spaniard Francisco de Goya (1746-1828), and, later, the French painter Edouard Manet (1832-1883).

Materials

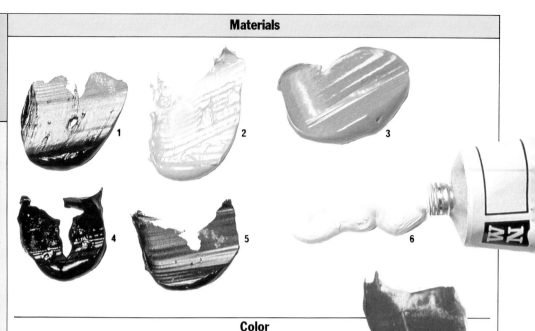

Color

Oil paint should be used to imitate fully the rich tones of the original painting. The color scheme is composed of the earth tones. The board is initially tinted with burnt umber (1) and the composition sketched in with ivory black (4). The figures can then be modeled in color with Naples yellow (2), yellow ochre (3) and light red (7). Raw umber (5) is mixed in to create shadows and dark tones. Highlights and pale tones are added with flake white (6). Use Venetian red for warm tones.

Support

Choose hardboard or canvas board about 20 × 24in (50 × 61cm).

Priming

A hardboard support must be well primed and the primer allowed to dry out thoroughly. Use two coats of white oil primer, brushed on evenly but not too thickly. Canvas boards are usually ready-primed but you may like to cover the surface with a coat of oil primer as this may give a better base for the tinted ground of the painting.

Brushes

The brushes needed are (from top to bottom) flat hog's hair bristle Nos 6 and 4, and fine, round sable brushes Nos 4, 2, 1 and 0. These enable you to block in the color and apply detail.

Other equipment

Use turpentine and linseed oil as mediums. Have rags handy for wiping brushes.

1 Squaring up and blocking in

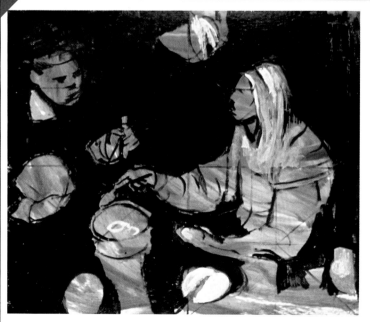

Apply a dilute wash of burnt umber to the whole area. This provides the warm undertone of the painting. Then draw in a grid on the reproduction you are using. Draw in a grid on the board using the same proportions. Sketch in the main outlines of the composition with a dilute mixture of ivory black using a small sable brush. A No 2 is suitable. Next, indicate the main areas of tone and contrast in black and flake white. Use broad strokes applied with a No 4 hog's hair brush. Do not worry about detail at this stage, as the general shapes can be refined later.

2 Establishing color

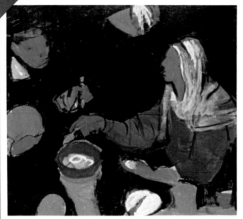

Block in the main areas of color in the composition. Use Venetian red for the woman's dress, and burnt umber for the initial folds and shadows. Paint the flesh in Naples yellow, mixed with a little light red. Use Naples yellow for the bowl in the boy's hand and Venetian red for the pan with the eggs. Use a No 4 hog's hair brush to establish these general areas of the painting.

3 Initial shading

Begin to add the shading. Apply a mixture of burnt umber and white to the main areas of shadow. Paint the folds in the woman's headdress with long strokes. For the shading on the pots and pans, use raw umber. A medium sized brush, such as a sable No 4, is best for this stage of the work.

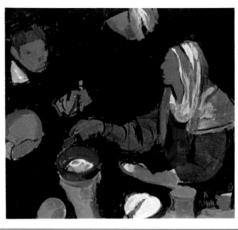

4 Modeling flesh

Next begin to model the flesh areas. Use a smaller sable brush, such as a No 2, so that more detail can be achieved. Model the flesh gradually using a mixture of burnt umber with a little white, concentrating on the shadowy areas of the faces and necks.

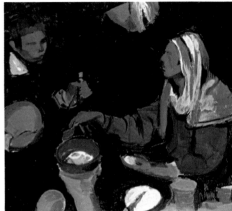

5 Working initial detail

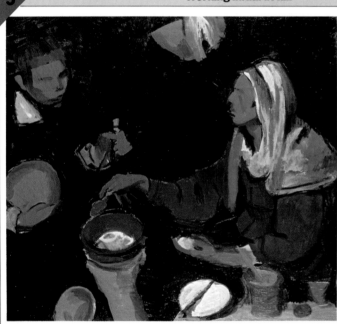

The process of building up modeling and shading should always be gradual. Velazquez achieved a smooth effect by blending his brushwork well and modulating the color changes subtly. This can only be achieved by patiently building up the layers and color changes in the shadows. Work mainly with raw umber, especially in the flesh and garments, although a little burnt umber should also be used for working up the detail of the yellow bowl in the boy's hand. Always check the colors and tones you are using carefully against those in the reproduction.

6 Adding first highlights

Add highlights to the flesh using a small sable brush, such as a sable No 2, which is suitable for detailed work. The highlights should be in yellow ochre and Naples yellow. Build up the highlights gradually to achieve a subtle effect.

7 Checking outlines

Now that the main areas of the composition have been established, recheck the initial drawing and make adjustments where necessary in black and raw umber. Use a fine, No 1 sable brush. Look at all the parts of the work. Add, for instance, a strengthening black line along the boy's hand.

8 Establishing flesh details

Add further modeling to the flesh areas with a fine sable brush. A No 2 is best for this purpose. Mix raw sienna and Naples yellow, and strengthen the main features of the faces and the shadows on the hands. Concentrate, for example, on the boy's eyes.

9 Working up general detail

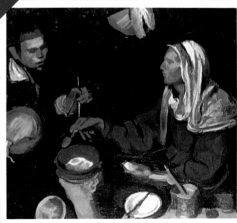

Next add similar detail to the utensils and drapery still using the sable No 2. Build up the modeling in the bowls and add the egg yolks with yellow ochre, white and a touch of raw umber. Add highlights to the white plate with raw umber and white, paying attention to the curve of the rim. Add detail to the beaker with umber and white.

10 Developing forms

lighten the tones. For facial highlights, use a mixture of Naples yellow and white (*left*). Use the same mixture to add small highlights to the bowl in the foreground (*below*).

For the subtle details, use a sable No 1. All the main areas of the composition should be worked over, adding highlights and modeling. Use the same pigments as in the previous steps, with some extra white to

11 Strengthening drapery

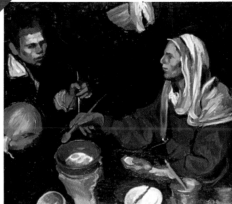

The next area to be worked over is the drapery. Strengthen the tones with a mixture of light red, Venetian red and flake white. A larger brush, such as a hog's hair No 4, should be used for the longer, sweeping strokes.

12 Adding flesh detail

Work up the detail in the old woman's face with a No 2 sable. Use burnt umber for the line by the mouth, and a mixture of light red, raw umber and white for the cheek tones. Keep referring to the original to make sure what you do is accurate.

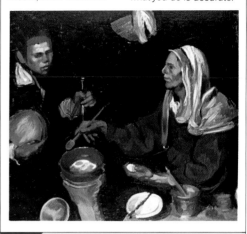

13 Finishing background

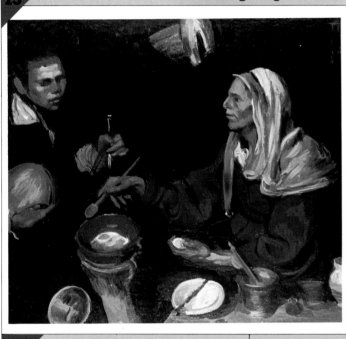

The background requires relatively little attention. However, check that the background tones are rich and even. Use a hog's hair No 6 to achieve smooth blending. A fluid paint is best for this stage, so use a mixture of black and burnt umber diluted in a little linseed oil and turpentine. Add the shadow of the knife on the plate in the same dilute paint, with a No 1 sable brush (*below*).

14 Adding final highlights

Now the final highlights should be added. Use a very pale mixture of white with just a touch of Naples yellow for the fingernails of the old woman and the boy, the end of the woman's sleeve and so on. Using a very fine brush, such as a sable No 00, add the trimming on the old woman's scarf with one bold flourish. Check other areas to see where more detail is needed.

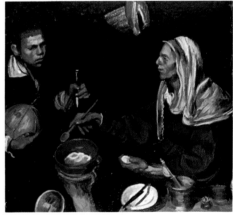

15 Checking details

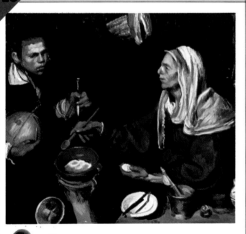

Finally, stand well back from the picture and look at it carefully. Compare your work with the reproduction which you have copied. Look at the balance of the tones and at the detail. Be critical with yourself.

The final version

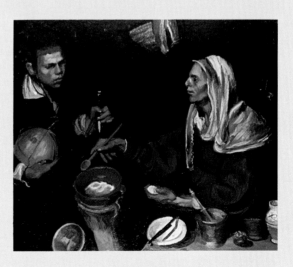

Rubens

Portrait of Susanna Lunden, oil on panel, 31 x 21½in (79 x 55cm)
Rubens' sister-in-law, Susanna Lunden, was the model for this portrait.
The work is characteristic of his rich style. Although large compositions
were often partly executed by Rubens' studio assistants, the portraits are
the personal expression of the master's skill and sympathy with subject
and medium. Rubens used a limited color range, but, by combining
opaque, light tones and dark, translucent shadows he achieved a wide
spectrum of color.

The Artist

Dutch artist
born 1577, died 1640
Painter and diplomat whose works
include many sensitive portraits

Rubens' family came from the prosperous Flemish city of Antwerp, but Rubens was born at Siegen in Germany. He studied for six years with two Flemish painters, at the same time gaining a thorough knowledge of the classics and of the major European languages. In 1598 he became an independent master of the Antwerp painters' guild, and he then set out for Italy. He was employed by the Duke of Mantua, for whom, in 1603, he traveled to Spain on the first of several diplomatic missions. His duties included making copies of great paintings by Italian masters, including Titian (c1487-1576) and Michelangelo (1475-1564). In 1608, just after his mother's death, Rubens returned to Antwerp. Here he received a new appointment to the Governors of the Netherlands. In 1609 he married Isabella Brandt and established a studio where large commissions were carried out with the help of collaborators. His technique was based on the skillful division of labor. He prepared sketches for the patrons' approval, which were enlarged by assistants under his supervision, and finished by Rubens. It was only in this way he could meet the demands on his time. Sometimes a patron specified that certain figures should be Rubens' own work. He completed a large number of commissions between 1609 and 1621, then visited Paris in 1622. Rubens made journeys in the combined role of diplomat and painter to Holland, Spain and England where he was knighted by King Charles I. Between 1620 and 1625 Rubens completed the famous *Portrait of Susanna Lunden née Fourment*, using a wood panel as the base, primed with an unusual streaky light brown ground, instead of the more popular, Italian-influenced solid dark brown. The shadows in the picture are thin and translucent over the ground, but Rubens painted the flesh and highlighting thickly and opaquely, building on the ground. The result is a solid and sensual portrait. After his second marriage in 1630 to Hélène Fourment, Rubens painted many portraits and nudes on a smaller scale. He continued drawing, painting and designing with speed and fluency, imparting vitality to religious, mythological and historical subjects. The basis of his genius was the luminosity and opulence of his colors.

Materials

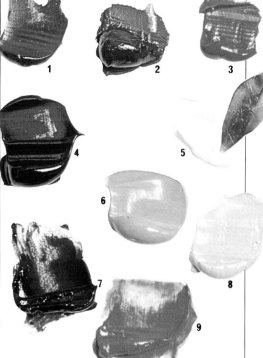

Brushes

Using three sizes of filbert hog's hair bristle brushes *(from top to bottom)* No 8, No 6 and No 4 and a fine sable brush, such as a round No 2, you will be able to work on broad areas of color and details. The shaped tip of a filbert brush softens the brushstroke, but if you find it difficult to control, use flat brushes. When using a sable brush on canvas many artists prefer the long-handled type, to avoid resting the hand on the canvas.

Support

There are two basic options available when you wish to work on canvas. You can buy one ready-stretched and primed, to the right scale and proportions. This copy is made on a canvas 26 × 20in (65 × 50cm). Alternatively, cover a wooden stretcher with cotton duck or linen and give it two coats of primer.

Other equipment

Keep plenty of rags or paper towels to hand for cleaning and wiping.

Mediums

It is known that Rubens used a special medium to encourage the paint to dry more quickly but it is not clear from documentary evidence precisely how it was made. If speed is an important factor in your work modern equivalents can be found. A drying oil or medium containing cobalt drier or copal varnish will serve the same purpose. Turpentine and linseed oil are also required for mixing a medium to thin the paint.

Color

A feature of this painting is the particularly vivid blue used in the background. Ultramarine *(7)* was an expensive color in Rubens' time but as he was a wealthy man it can be fairly assumed that he used the real thing. Modern processes of paint production have reduced this disparity in price between different color. Raw umber *(1)*, burnt umber *(2)*, light red *(3)*, yellow ochre *(6)* and Naples yellow *(8)* are all used in this painting, with lamp black *(4)* and flake white *(5)* to enhance shadows and highlights. Cadmium scarlet *(9)* has been substituted for the vermilion probably used in the original. In addition, a touch of carmine is needed to add warm color in the face.

1 Squaring up and tinting the canvas

Draw a light grid on the reproduction, putting in both main diagonals and the diagonals in each quarter of the rectangle. Tint the canvas with a light wash of raw umber diluted with turpentine, applied loosely with rags. On the canvas, draw a grid proportionate to the first, using charcoal.

2 Brushing in the figure

With a filbert No 4 hog's hair brush, sketch in the main lines of the figure with diluted raw umber paint. Build up the shapes with a series of fluid brushstrokes. Lay in areas of solid color with burnt umber to show the darkest tones. This drawing should establish the general form.

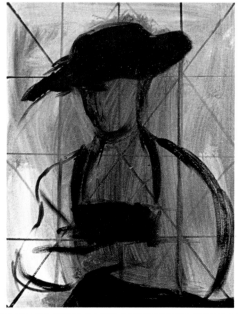

3 Emphasizing the dark tones

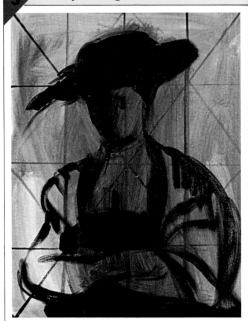

Using burnt umber and a filbert No 4 hog's hair brush, emphasize the basic tonal structure and roughly indicate shadows on the face and folds in the dress. At this stage, you can exaggerate the tonal balance and correct it later.

4 Laying in background color

Mix French ultramarine and flake white and brush color into the background, following the contours of hat, head and shoulders. Use vigorous brushstrokes with a light touch, so the warm tone of the tinted ground and underpainting breaks through the blue, modifying the tone and texture. The pale color used here makes the figure stand out in relief from the picture plane. Use a No 6 brush to work into curves and angles.

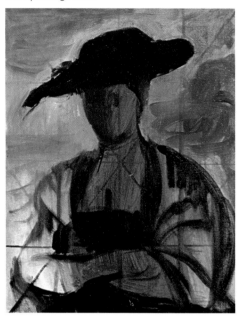

5 Establishing extreme tones

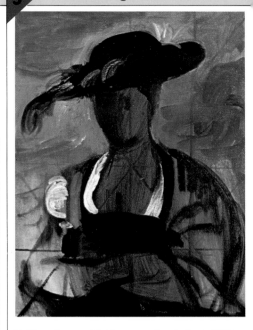

Set the extremes of light and dark by working on the dress and hat with lamp black and flake white. Add drying medium to the paint as these areas will be reworked at a later stage. Work loosely in white to indicate a soft texture.

6 Applying local color

Color the dress with cadmium scarlet, using a filbert No 4 hog's hair brush. Use raw umber and flake white to soften the heavy shadows, applying the paint in thin glazes. To make the glaze, add turpentine and linseed oil to the paint, mixing well until it has a thin, runny consistency and is slightly translucent. Brush it lightly over the surface.

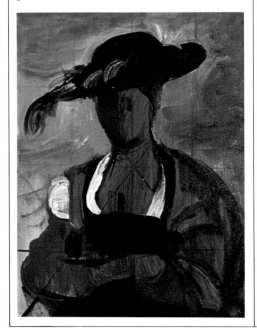

7 Laying in flesh tones

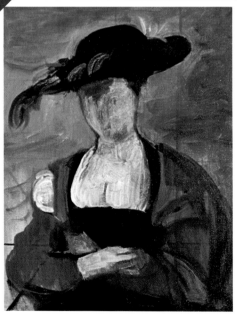

Mix a light flesh tone with flake white, Naples yellow and cadmium scarlet. Add linseed oil to give the paint transparency and turpentine to dilute it slightly. Scumble the color into the flesh areas, that is move the brush lightly over the surface in all directions to form an active translucent layer over the underpainting. Build up the lightest tone with broad strokes of thicker paint following the direction of the form.

8 Modeling shadows

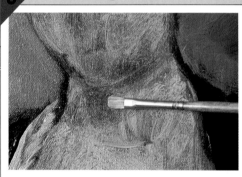

Clean the No 6 filbert brush with turpentine and wipe the bristles dry with a rag. With the tip of the brush, gently remove areas of flesh color to reveal the underpainting. In this way, model the form of the neck, face and chest using the color of the underpainting as shadow. Wipe paint from the brush continually as you work or the bristles will clog and smear.

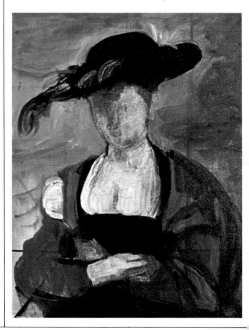

9 Building up flesh tones

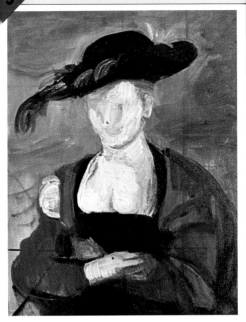

Build up the flesh tones with deliberate strokes, crossing the brush-strokes in the transparent layer to give the color more opacity. Use a mixture of flake white and Naples yellow to lighten the cast shadows and add scarlet for other areas.

10 Marking highlights

Put in highlights on the clothing with the No 4 brush. Add white to cadmium scarlet to show the curve of folds in the sleeves, and raw umber mixed with white for the shawl. Study the picture carefully and then paint with confident gestures.

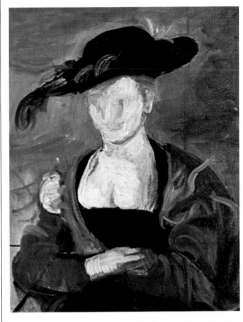

11 Adjusting the outline

Make a vivid light blue with French ultramarine and white, of a tone darker than that initially used to paint the sky. Work around the head and hat, adjusting the outlines. Lay the paint quite thickly with a filbert No 4 hog's hair brush. Establish the contour of head and hair. Check that the angle and shape of the hat are correct in relation to the width of the head and vertical emphasis of the face.

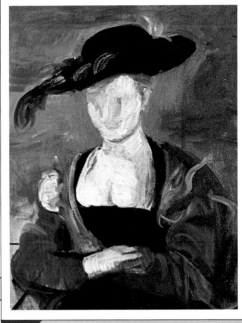

12 Blending flesh tones

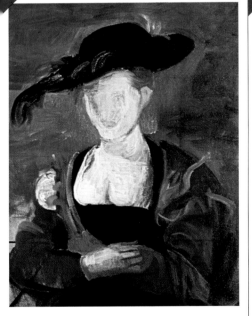

Develop the form in head and hands with flesh tones. Use light colors tending to yellow in shadowed areas, giving them a warm cast by mixing in yellow ochre, and contrast these with pale pinks for the high tones. Use burnt umber and white to put in the hair. Paint with a round No 4 hog's hair. Blend the brushstrokes gently with a fan brush (below) to soften the color.

13 Drawing in the features

Rework the shadows in face and hands with transparent raw umber. Mix the paint with drying medium and apply it with a round No 2 sable brush in feathery strokes across the surface. With the same brush and paint, draw in the lines of eyes, nose and mouth, not in detail but to define the basic structure of the features. Lay a glaze of umber over the hair to darken the color.

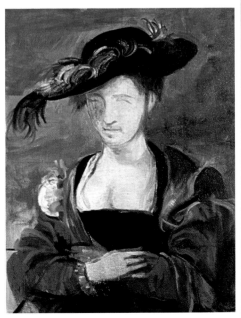

14 Shaping the eyes

Continue to work on the facial features, drawing in the whole shape of each eye. You may find it easier to work in a series of short brushstrokes than to make a continuous line which may become lost in the still wet paint beneath. It is important to be accurate in drawing this sort of fine detail. If you make an obvious error, lift the paint gently with a rag and rework the line to adjust the overall shape.

15 Developing the clothes

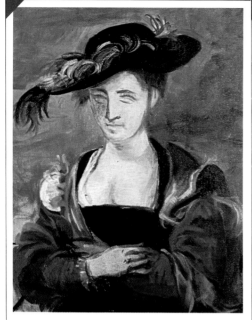

Build up richer color and texture in the dress, working with the No 4 hog's hair brush. Mix white or black with light red and cadmium scarlet to make the light and dark tones in the sleeves. Use the brushstrokes to give the direction of each curving fold. Strengthen shadows in the shawl with burnt umber and enhance the highlights with raw umber and white. Work in bold, vigorous strokes and blend the colors together with the tip of the brush to soften the lines.

16 Adding highlights

Work on the eyes and hands in more detail. Put in the whites of the eyes and highlights on the lids. Strengthen the lines of eyes and nose with raw umber, using the No 2 sable brush. Emphasize light tones in the hands and blend the colors.

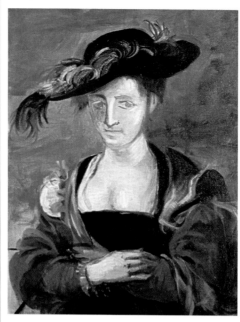

17 Adjusting the tones

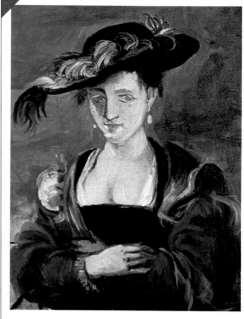

Adjust the background tones, mixing raw umber with ultramarine and white. Bring up the light tones down the left-hand side of face, neck and chest. Mix plenty of white with small amounts of Naples yellow and cadmium red to make the flesh tone. Lay the paint thickly and use the fan brush in light, feathery strokes for blending. Use the filbert No 4 brush to dab in the white earrings. With the No 2 sable brush define the shape of the mouth, using cadmium scarlet and raw umber.

18 Modeling the form and glazing

Rework shadows in the face and neck with raw umber, giving greater definition to the shapes of nose, mouth and chin. At this stage the light flesh tones should be adjusted at the same time as shadow areas, so the form begins to appear more fully modeled. Darken the color of the eyes and judge the tones for shadows in the eyelids in relation to the extremes of light and dark already established. The method of painting used here is relatively free and it is vital to check by eye continually to make sure that you are working towards a correct balance of tone. The final effect will depend upon well-judged modeling of form and careful analysis of color at every stage. To invest the colors with warmth and luminosity, lay a glaze over the whole figure. Mix yellow ochre with a little raw umber and add turpentine so the color is fluid. Brush the glaze lightly over the surface with a filbert No 4 bristle brush.

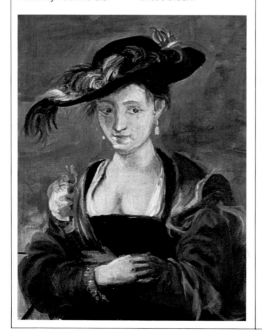

19 Lightening the tones

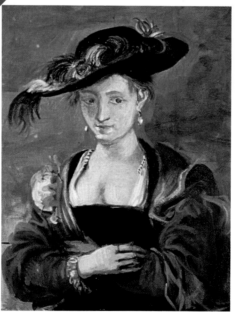

Brush in lighter flesh tones on the head and neck, mixing very small amounts of cadmium scarlet and Naples yellow into white paint. Use a light touch when working over shadow areas, so the raw umber beneath shows through to modify the tone. Follow the direction of the form in making the brushmarks and use a fan brush to blend colors. Rework the background in a lighter tone of blue to balance the lightness of the flesh. Sharpen details of the clothing, such as the cuff and neckline of the dress, using black, white and raw umber. Put in highlights with strokes of pure white.

20 Laying pink glazes in the face

Mix a light glaze of cadmium red, white and Naples yellow in drying medium and turpentine. Brush the glaze onto the cheeks and chin to give the skin a vibrant pink. It may be advisable to let the painting dry out for a day before applying this glazing, or the color may be deadened by picking up the paint layers underneath. Work on the shape of the mouth with a No 2 sable brush. Darken the line between the lips with raw umber, and a little burnt umber at the darkest points. Mix the pink from carmine and flake white, adding linseed oil and turpentine to give it transparency. Work over the shape of the lips with the pink glaze. Define the shape clearly but keep the tone subtle or the mouth will seem too prominent.

Enrich the reds in the sleeves, working over the folds to even the texture and imitate the glowing color of the original. Strengthen the contrast of dark and light in the hair, laying a glaze of burnt umber and mixing in white for the lights in the separate strands. With the No 2 sable brush draw the woman's ring, using white for highlight, yellow ochre to suggest gold and burnt umber to shade the band.

With a filbert No 4 hog's hair bristle brush, dab in black to show the stone in the ring and blend it into the white and gold. Finish the earrings in detail, painting the gold hoops in the same way as the ring and the pearl pendants in white and gray. Check tones and colors over the whole work and make any necessary adjustments.

The final version

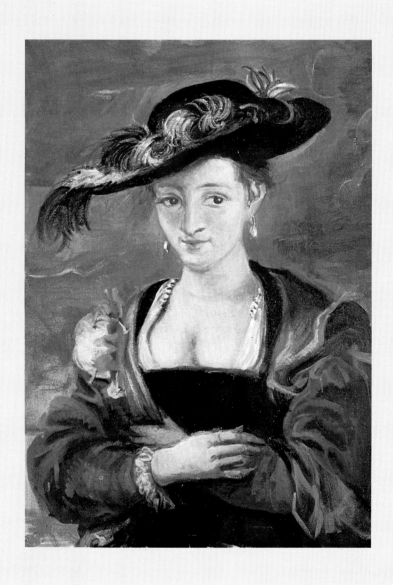

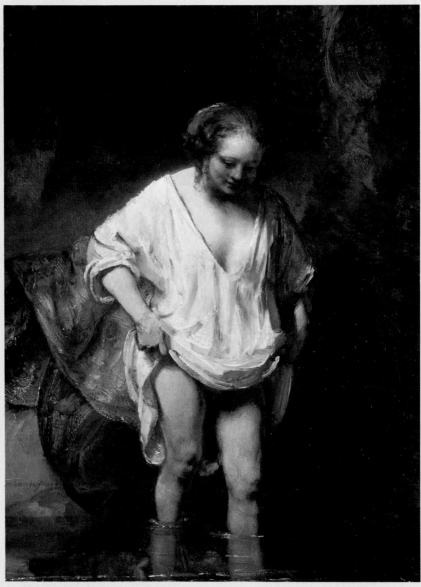

Rembrandt

A Woman Bathing in a Stream, oil on oak panel, 24¼×18½in (62×47cm)
One of the striking features of Rembrandt's work is his obvious enjoyment
of the media he used in paintings, drawings and prints. In all his oil
paintings, the colors and textures are rich and satisfying. Heavy impasto
and fluid glazes are combined in a display of vigorous brushwork. The
model here was Rembrandt's mistress after the death of his wife Saskia.
Both women frequently featured in his works, he also painted many
self-portraits.

The Artist

Dutch artist
born 1606, died 1669
Leading Dutch seventeenth century painter, draftsman and etcher

Rembrandt was born at Leiden in the Netherlands. He attended university there but left after a few months to study painting. Rembrandt's earliest dated work, *The Angel and the Prophet Balaam* (1626) has glossy colors, animated gestures and realistic facial expressions. He painted religious and historical subjects and some self-portraits, until he moved to Amsterdam in 1632. Here his reputation was quickly enhanced by a commission for *The Anatomy Lesson of Dr Tulp*. Rembrandt rapidly became Amsterdam's leading portraitist. He married in 1634, and his wife Saskia modeled for many portraits and drawings. Rembrandt was successful and the family lived in some style. In the early 1640s he painted the unusual and now famous group portrait known as *The Night Watch*, making full use of his mastery of *chiaroscuro*. This Italian term means tonal shading and refers to the strong effect in a painting of gradations between brightness and darkness. However, in 1642 Rembrandt's wife died leaving him to care for his young son. Although he received important commissions, he began to paint more for himself, concentrating on the portrayal of inner life and character rather than appearances and actions. An example of this trend is *The Holy Family* (1645). He also produced some exquisite landscape drawings and etchings. By 1656 Rembrandt was bankrupt, but his painting continued to be prolific. His techniques evolved far beyond contemporary fashions. He had abandoned the smooth surfaces of conventional Dutch painting early on in his life. His own brushstrokes were often thick, but always precise. He composed many of his pictures by mapping out shapes in generalized tones over the brown ground, then he worked in complex layers, building up his pictures with delicate glazes that allowed light actually to permeate his backgrounds. Highlights were added in thick strokes at the end. Rembrandt took great interest in the physical qualities and capabilities of his medium. His excellent craftsmanship and extensive knowledge of materials allowed him to employ highly individual methods. Rembrandt is widely acknowledged as being one of the world's most important artists.

Materials

Color

The range of color used in the original is quite limited but careful use of golden and orange tones gives the image a considerable richness. These are all mixed from yellow ochre (2), Naples yellow (3) and cadmium red (4). Light red is useful in addition to enhance the warm tones. Shadows and even the darkest tones are brushed in with raw umber (1) and burnt umber (6). These add depth and intensity to the background and modeling of the figure. Oil paint is the most suitable medium for a copy of the painting as acrylic does not have the vibrancy and texture of the original oil. Flake white (5) is heavily used in the highlights and broad sweep of drapery around the figure.

Support

The original painting is on oak panel but a simpler modern equivalent would be a sheet of hardboard, cut to the same size as the original. A prepared canvas board is also suitable and can be found in most art shops. Choose one of suitable proportions for the image. A sturdy frame on the finished picture prevents warping.

Priming

Hardboard should be evenly coated with oil primer, applied with a decorator's brush. Use two coats of primer to build up a flat white surface. Priming is necessary both to provide a tooth for the paint and to seal the board to prevent the oils from rotting it. Canvas board can be used without primer.

Mediums

The mediums used here to improve the flow of the oil paint are *(from left to right)* a heavy synthetic drying medium, linseed oil and pure turpentine. Rembrandt used a varnish medium to give fluidity to the paint but modern equivalents to traditional recipes can prove very expensive. However, the synthetic mediums which have been developed quite recently provide the necessary properties. Turpentine is used to thin the paint and to clean brushes. Linseed oil also gives fluidity to the paint and may be mixed with the other mediums.

Other equipment

Hog's hair filbert brushes are most frequently used in this painting. No 8, No 6 and No 4 is a good range of sizes, enabling you to block in the overall tones and develop linear rhythm in the composition. To correct and rework the drawing of the figure a round No 4 bristle brush encourages a loose, sketchy stroke in describing the rounded forms. To imitate the rich texture of the paint surface, typical of Rembrandt's confident style, the bright colors should be laid with a palette knife. Choose the type with a rounded, flexible blade which can be drawn swiftly across the canvas to lay paint or scrape it off where necessary. As the name implies, the knife is also useful for mixing colors on the palette. You will also need a No 2 sable brush for details.

1 Squaring up

Draw the main diagonals on the reproduction and use the crossing point to bisect the image vertically and horizontally. Continue to square up the picture by drawing diagonal and straight lines to make a grid as shown. Pin the reproduction in the top left-hand corner of the board. Then, using a No 4 filbert brush and a long stick or ruler, extend the lines across the board to plot the proportions.

2 Blocking in dark tones

Mix copal varnish with linseed oil to make a thick medium and use this to dilute some burnt umber paint. With a filbert No 8 hog's hair brush, block in broadly an overall impression of the image, copying the main areas of light and dark. Work with vigorous brushstrokes, and do not feel restricted to absolute accuracy at this stage. The purpose of blocking in is simply to obtain a general feeling of the shape of the figure and the dark background surrounding it. Dilute the paint further with medium and turpentine to brush in mid tones, leaving the white canvas to stand as the areas of highlight. Note here how the strokes of the brush emphasize a strong vertical axis on which is placed the rounded, heavy form of the body and clothing of the figure, shown as the lightest area.

3 Putting in the warm colors

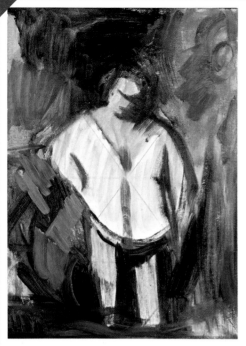

Use a smaller hog's hair brush, the No 6 filbert, to lay areas of color into the background. Mix Naples yellow into yellow ochre for the middle tone to the left of the figure. The warm color is mainly light red, with a little cadmium scarlet added in the foreground to give it extra richness. Again, the intention here is to break down gradually the broad area of the picture plane, so identify general shapes in each color and do not worry about precision at this early stage.

4 Reworking the figure

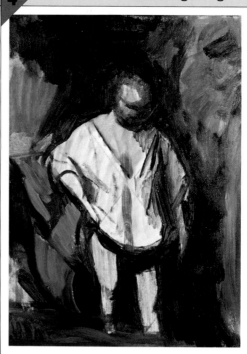

Rework the dark tones in a mixture of black and burnt umber. Draw into the shapes in the figure and background with a filbert No 4 hog's hair bristle brush, defining the shapes more clearly and strengthening the areas of dense dark color. Dilute the paint with turpentine and linseed oil and loosely scrub in the shadows down the right-hand side of the figure. This allows the three-dimensional forms in the image to start to emerge and establishes the basic attitude of the figure.

5 Adding the flesh tones

Put in the lightest areas of flesh tone on the head and shoulders, lower arms and legs of the figure. Use a large amount of flake white and add in small dabs of Naples yellow, raw umber and cadmium red to make a pale beige tone. Mix in some of the varnish medium so the paint is thick but can be worked freely. To create shadows on the legs, brush in raw umber and blend it gently with the flesh color. Follow the general direction of each form with the brush-marks. This initial application of color over the form *(left)* provides a basis on which highlights can later be added.

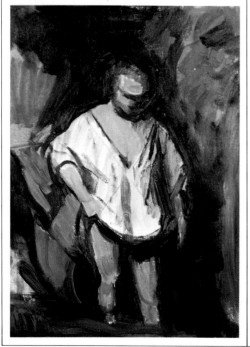

6 Painting in the whites

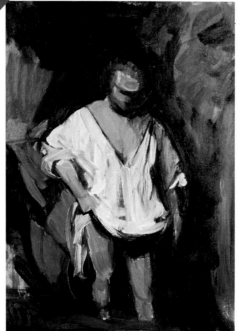

Clean out the No 8 brush carefully and use this to brush in the folds of the loose undergarment worn by the figure. Load the brush with pure flake white, undiluted by any medium, and lay in broad, heavy strokes. Try to develop the rhythm of the brushmarks which are apparent in the original. Pick out the highlight on the model's left sleeve with the No 6 hog's hair brush. You will inevitably lift a little of the dark colors from the previous layer of underpainting, but careful handling of the brush can put this to advantage, if it is used to indicate shadows or a change of direction in the form *(below)*. The rich texture of heavily laid brushmarks is characteristic of Rembrandt's technique.

7 Lightening the flesh tones

Lighten the flesh tones, working with a mixture of light red, Naples yellow and white. Apply the paint on the legs with horizontal strokes of the brush to emphasize the roundness of the limbs.

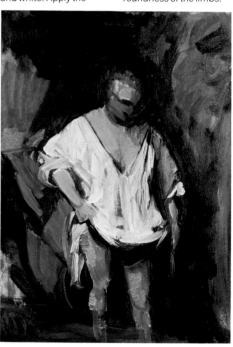

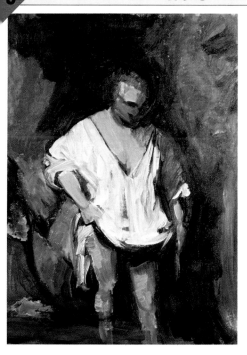

Heighten the colors in background to give more definition to the shapes. Use yellow ochre and light red as before, mixing in a little white to give the paint opacity. Apply the color thickly with the end of a palette knife, pasting on a heavy layer and drawing it across the surface with the tip of the knife (below). To bring up the warm tone in the left foreground, mix cadmium red into the light red and brush it in.

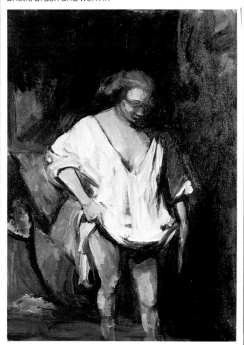

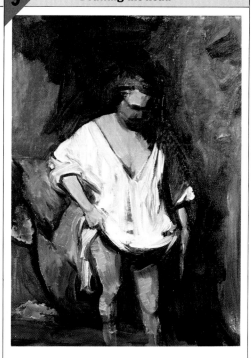

Dilute burnt umber with turpentine and linseed oil. With a round No 4 hog's hair brush draw into the shape of the head. Take care to establish the lines of the features and main areas of shadow correctly. Block in the light area on the forehead with a pale flesh tone and rework the chest.

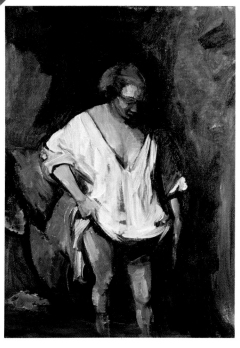

Mix a number of pale flesh tones using white, light red, Naples yellow and a little raw umber for shading. Make at least three different hues, one with a light yellow cast for highlights, a warmer pink tone and a mid tone. Apply the paint with a palette knife, blending the tones with the tip (above). Soften the shadow areas and lay in fresh highlights to model the basic form. Build up the hair with yellow ochre and Naples yellow. Draw into the shape of the head with burnt umber on a fine No 2 sable brush.

Enrich the dark colors in the background with black and burnt umber. Add oil and varnish medium to the paint to give it surface luster and block in heavy areas behind the figure at the head and down the right-hand side of the painting. Use a No 8 bristle brush and work in broad horizontal strokes to fill and overlay the previous layer. With the No 4 brush, reinforce linear marks showing the lines of the dress and limbs. Blot the brush and use feathery strokes at each top corner, giving an effect of broken color over the red background.

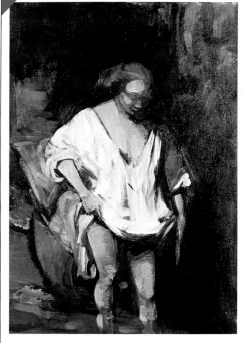

Gradually rework the flesh tones, mixing the colors as before. Make a careful study of the original to identify the basic form and tonal structure of each part of the composition. It is important to achieve a correct interpretation of early stages in the painting if you wish to imitate the richness of Rembrandt's technique. A combination of opaque and glazed color, that is areas of thin, transparent paint, contribute to the vitality of the finished work. Oil paint dries slowly, so it is always possible to scrape it off and rework a section of the image if necessary.

13 Brightening the colors

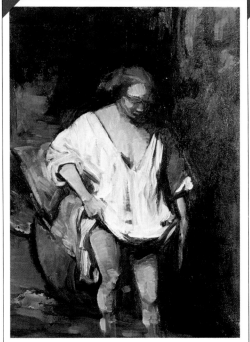

Work on the foreground and to the left of the figure with a palette knife, putting in touches of warm, vibrant color. Use yellow ochre, light red and Naples yellow and drag the color across the surface. Indicate the reflection of the figure in the foreground.

14 Darkening the background

Reinforce the dark tones surrounding the figure. Use burnt umber, diluted with turpentine and linseed oil. Brush over the shadow on the sleeve with a No 6 hog's hair filbert and add a little black to increase the depth of tone as you work outwards into the background. For these broader areas of tone, you may prefer to work with the No 8 brush, returning to the smaller sizes for particular forms and details. While painting in the background tones study the outline of the figure and make adjustments to the shapes if necessary. Assess the form continually, and check by eye against the original.

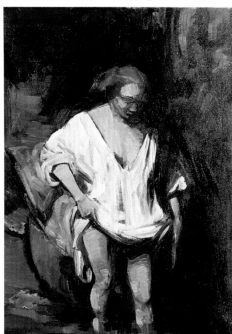

15 Glazing the shadows

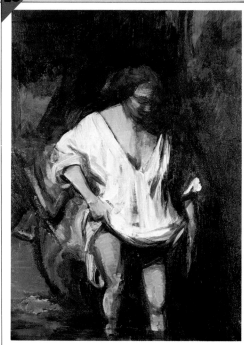

Mix burnt umber and yellow ochre with linseed oil and varnish to make a glaze of warm brown. Dilute it with turpentine, but keep the glaze thick enough to be easily controlled with the brush. With a No 6 hog's hair filbert, lay the transparent color on shadow areas in the flesh tones and foreground.

16 Modeling the figure

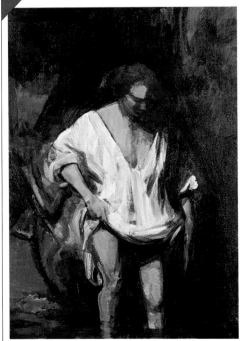

Having established the dark tones on the legs, arms and head, continue to model the forms in the figure, working with pale flesh tones. Make a warm, deep pink from light red, Naples yellow and flake white, and use this for the mid tone which shows the swell of muscles in the model's right arm. Mix in more yellow and white to create a light flesh tone and work over the curves of legs and arm, using the No 4 bristle brush. Put in a heavy patch of light pink on forehead and cheekbone to show highlights in the modeling of the head.

17 Defining the shape of the head

Work on the head in more detail, softening the shadows and lightening the tones of skin and hair. Since this is a small area of the painting, you will need the No 4 bristle brush and the No 2 sable to achieve delicacy in the brushwork. Apply the paint sparingly so the effect of the dark underpainting contributes to the modeling. Note that there is a yellow cast to the flesh tones which gives an effect of glowing light falling on the figure. The precise coloring will depend upon the quality of the original which you are copying and this tends to vary.

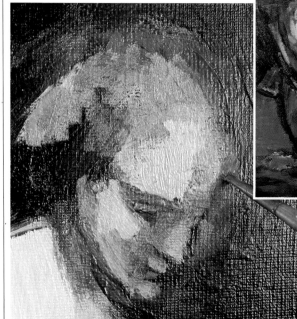

Follow the direction of the form with each stroke of the brush. This detail (left) shows how the line of the jaw and the curve of forehead and cheekbone are marked by the direction of the brushstroke, as well as the color. The umber shows through as heavy shadow.

Scumble brighter color into the foreground and background. Enrich the warm tones with a mixture of light red and cadmium red. Use yellow ochre, white and light red in the background and to the left of the figure. Wipe excess paint from the brush and draw it across the surface to leave strokes of broken color. Work around the figure with a further dark glaze of burnt umber *(right)*, so the image takes on a lively contrast of tones. To enhance this effect, pick out highlights in the flesh tones and across the whole image, using the appropriate colors as before *(far right)*.

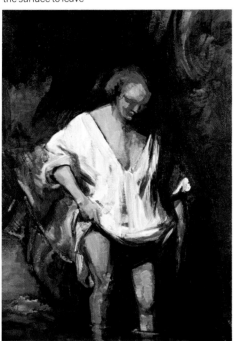

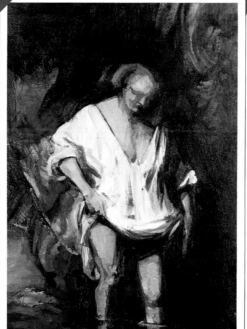

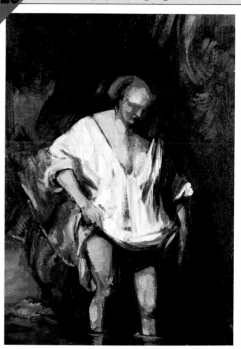

The final version

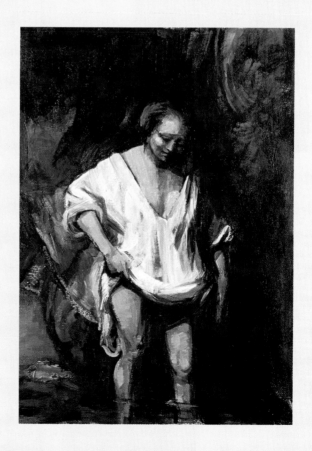

Draw in the facial features and darken shadows with burnt umber. Give more weight to the color in the whole head with yellow ochre in the hair and shadows around the eyes. Use pink flesh tones in the forehead and cheeks and blend the colors lightly to achieve the final form.

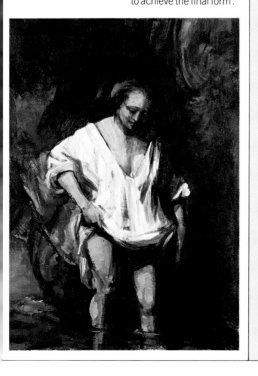

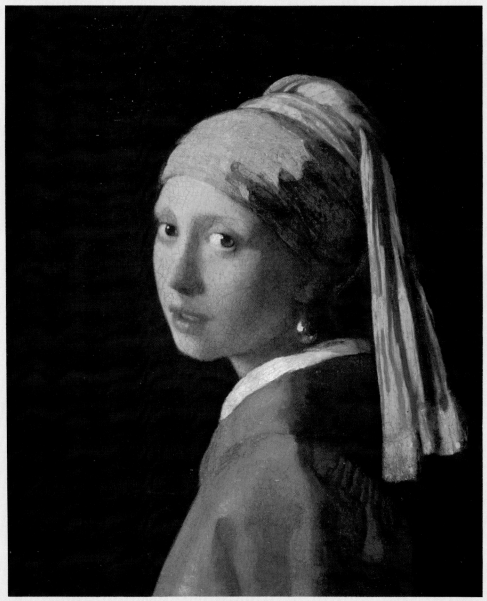

Mauritshaus. The Hague

Vermeer

Head of a Girl with Pearl Earring, oil on canvas, 18¼ × 15¾in (46 × 40cm)
Vermeer explored the appearance of his subjects with great care, using
smooth glazes to build up areas of color and subtly merged tones. The
colors are highlighted with minute dots of paint, generously distributed
to create an impression of soft radiance. This well known painting takes a
closer view of the subject than other works by Vermeer, enabling him to
refine the delicate features and subtle coloring.

The Artist

**Dutch artist
born 1632, died 1675
Painter of delicate, sensitive
portraits and interior scenes**

Vermeer was born at Delft in Holland, the son of a silk merchant who was also a picture dealer. As a result, Vermeer was familiar with works of art from childhood. In 1653 he married Catherina Bolnes, and, having completed his apprenticeship, was admitted to the painters' guild in the same year. In the early seventeenth century, Dutch painters were turning away from religious and historical subjects and becoming increasingly interested in representing appearances as exactly as possible, experimenting with optical instruments as aids to drawing. The subjects of these paintings were often scenes of daily life. Some of Vermeer's early work illustrates this trend. *The Girl Asleep at a Table* (1657) contains many features of genre painting which he frequently used – an indoor setting, a single figure, still life objects and furniture. Only the bright sunlight from a side window is missing, and this appears the following year in *Soldier with a Laughing Girl*. Vermeer often placed figures by a bright window. His paintings are convincing not only because of accurate observation and astonishing skill, but also because he chose arrangements of objects and lighting which emphasize the impression of depth in space. He varied the degree of focus so that not all areas are equally sharply defined. His unusual understanding of perspective and naturalistic style may have been aided by a camera obscura, an instrument which projects a reduced image of a scene on to a flat surface, using an arrangement of lenses and mirrors. Such devices were widely used in the sixteenth and seventeenth centuries. Vermeer was also very aware of the effects and uses of light in a painting. He used a variety of techniques to capture them, ranging from thin layers of glazes to thick, opaque paint. Visible brushwork and texture are minimal in most of his paintings. *Head of a Girl* (c1665) is typical of his sensitive portraits. However, despite his skill, neither Vermeer's work nor his life became widely known until the mid nineteenth century. The small number of paintings which he executed during his life may account for this. After his death, his widow was obliged to sell many of his works to help solve the financial problems with which she had been left.

Materials

Color

The painting is initially established with a ground and underpainting in burnt sienna *(1)* and raw umber *(4)*. The basic flesh tone is mixed from flake white *(3)*, yellow ochre *(7)* and cadmium red *(8)*. Payne's gray *(5)* is used to darken the tones in the background and shadows on the figure. Cobalt blue *(2)* and cobalt violet *(6)* provide the soft, pearly color of the turban. The heightened tonal contrast is due to careful placing of colors as no black is used in the background.

Brushes

It is advisable to keep a delicate portrait such as this to a small scale, so synthetic bristle brushes in sizes 4 round and 6 flat can be used for blocking in. Round sable brushes Nos 00, 2, 6 and 8 cater for details and washes of thinned color.

Support

Use a very small canvas, made from cotton duck stretched on a wooden stretcher. The example here is only 9 × 7½in (23 × 19cm).

Priming

Cover the canvas with a few even coats of gesso primer, letting each dry before applying the next.

Mediums

Use white spirit to thin the paint in the underpainting and for cleaning brushes. Dilute the paint with pure gum turpentine as a rule.

Squaring up

1

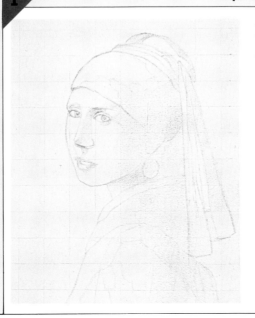

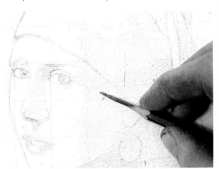

Square up the primed canvas and the reproduction to be copied. Transfer the image to the canvas with a soft pencil (*left*). Put in the outlines first and then suggest some of the tones by shading the darker areas of the face. Hold the pencil so that the length of the lead lies flat on the surface (*below*). Do not press too hard, either for the shading or for the more detailed features. Refer back to the original frequently as you work to check that the drawn image is as accurate as possible.

2 Laying a wash

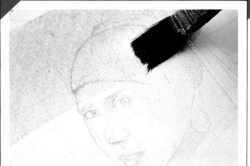

Lay a thin ground wash of burnt sienna diluted with white spirit. Work from the top to the bottom with a fairly wide brush (*above*). Keep the wash even with no visible brushmarks.

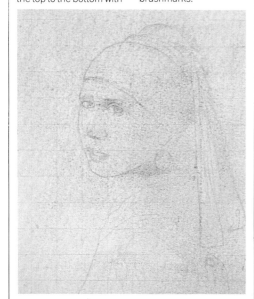

3 Blocking in the underpainting

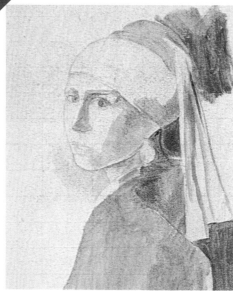

Use burnt sienna and raw umber diluted so that it is quite pale for the initial underpainting (*left*). Follow the lines of the drawing underneath the ground wash. Paint raw umber onto the right cheekbone with a No 6 sable brush (*below*). This will show through later to give a warm reddish effect. Block in the paler garments with raw umber as well. Paint in the more shaded parts of the composition with burnt sienna. Take care not to put any underpainting at all on the areas which will be very light in the finished painting.

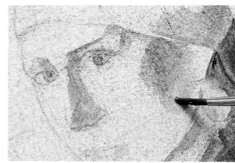

4 Painting the head

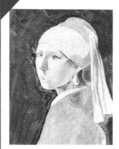

Apply a mixture of flake white with a hint of yellow ochre and cadmium red to the face. Put white on the collar and headdress as well. Work with a soft brush to model the features. Add a little burnt sienna and raw umber to strengthen the darks. The flesh color will be modified with a wash later.

5 Modeling the face

Build up the modeling on the face with light glazes of burnt sienna and raw umber. Work with quite a dry No 6 sable brush. Blend the paint on the right cheek to create warm tones. Increase the shading on the side of the nose and take the color up onto both eyelids. Put a touch of burnt sienna and raw umber on the earring as well.

6 Filling in the background

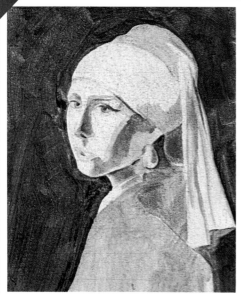

Block in the background with a wash of burnt umber. Work freely with a large brush. Any visible brushstrokes will be concealed later. Using thin washes of burnt umber still, build up the darks in the face. Put in the first paint on the eyes and add more shading to the side of the nose. Paint over the raw umber on the cheek and extend the shadow down to the chin. Use an extremely thin wash to fill in the area around the eyes. For the very fine lines work with a thin brush such as a No 00 sable. Use slightly more burnt sienna and less of the medium to paint in the darker lines on the upper lids and the headdress.

7 Defining the mouth

Using cadmium red mixed with a little Payne's gray and burnt sienna fill in the mouth. Build up the color with small delicate strokes made with a No 2 sable brush (*left*). Blend the red into the flesh tones around the upper and lower lips on the right-hand side. To create a softened effect, work with a finger rather than a brush to smudge the paint.

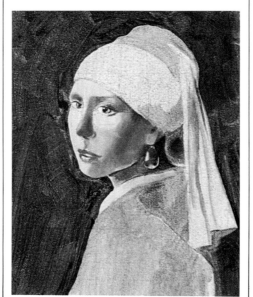

8 Working on details

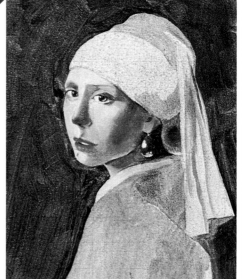

Add more definition to both the eyes and the earring. Mix up a very deep color on your palette from burnt sienna with touches of Payne's gray and cobalt blue. Fill in the pupils and the iris with a No 00 sable brush. Then add a dab of flake white to each eye and fill in the whites. Use the paint quite thickly so that it lies in a solid mass. Add more color to the pearl earring with raw umber and burnt sienna. Lay one glaze over another, so that the paint remains darkest on the right. Put in the highlights to give an impression of solidity. Use pure flake white with very little medium. Also put some white on the teeth.

Block in the clothing with combinations of yellow ochre, burnt sienna, raw umber, flake white and Payne's gray. If the tones are not exactly matched with those of the original, it does not matter too much as the final wash will unify the different colors. Block in the main part of the headdress with cobalt violet and a touch of cobalt blue and white.

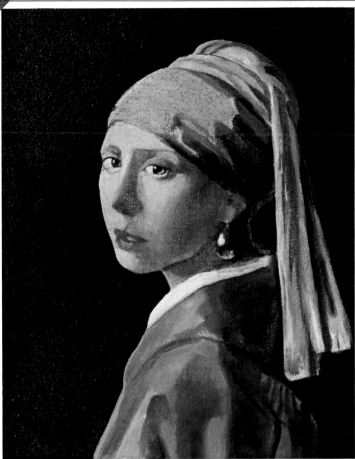

Paint in the background with a mixture of Payne's gray and raw umber. Build up a smooth texture to form an even block of solid color with no brushmarks showing. Refer back to the original you are working from and note how Vermeer works the background. The corner of the left eye almost merges into it. The background color is also present at the back of the neck and on the right-hand side of the headdress. Dilute the paint with turpentine and build up thin glazes overlapping each other to achieve the same effect. Using thin glazes of just Payne's gray build up the modeling in the clothing. Work up the glazes to heighten the underpainting and follow the lines of the folds in the material. Then put a thin glaze over the shaded parts of the face and neck. The brown part of the headdress will also be improved if it is glazed.

Finishing details

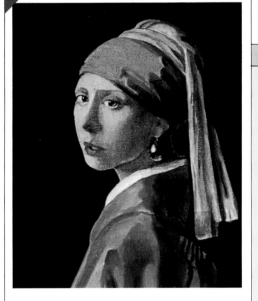

To complete the painting, add the final detail to the clothing. With a thin brush paint in the dark lines of Payne's gray and burnt sienna at the top of the sleeve *(below)*. Once the oil paint is completely dry, give the painting a coat of varnish. Use any type suitable for oils. Here a retouching varnish has been put on.

The final version

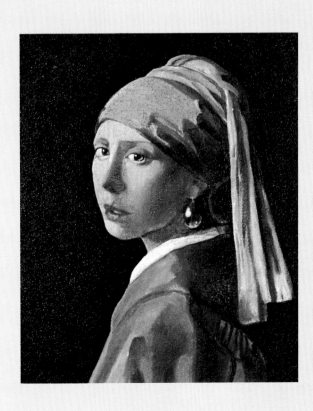

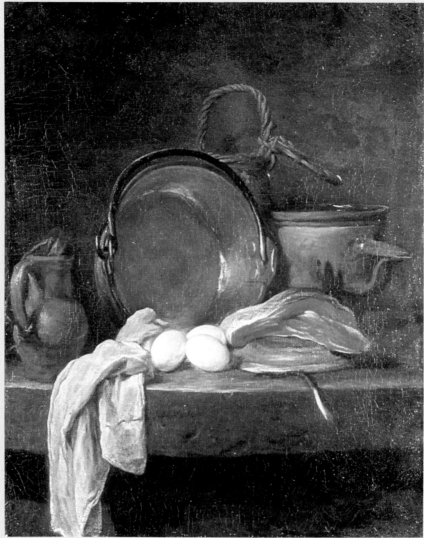

The National Gallery of Scotland

Chardin

Still Life: The Kitchen Table, oil on canvas, 16 × 12¾in (40.6 × 32.4cm)
Chardin was known as the 'French Rembrandt'. He was influenced by
Dutch artists and painted many still lifes and domestic scenes. This
painting is typical of his warm, harmonious colors and simple but
delicately balanced compositions. His technique can be seen from his
sketches and unfinished works. A contemporary described how Chardin
spent a long time over his paintings, laying one color over another with
hardly any mixing of the paint layers, to obtain the clear, glowing tones.

The Artist

**French painter
born 1699, died 1779
Major eighteenth century painter of
still life and genre subjects**

Chardin, one of the great masters of still life painting, came to the genre almost by mistake. His father, a craftsman and cabinet maker, thought to improve his son's prospects by enrolling him at the Academy of St Luke in Paris, which catered more for craft skills than the fine arts. As a result, the training which Chardin received was more suited to craftsmen or decorators than to aspiring artists who, for the most part, attended the newly constituted Académie Royale. Chardin's master taught drawing from memory without the use of models. The extremely limited facilities of the school obliged Chardin to take up still life painting. He is said to have regretted this limitation. To help develop his technique, Chardin began to work directly from nature. However, despite the limited opportunities of his education, in 1728 Chardin submitted work to the Académie and became a member in the same year. He remained an active member of the Académie throughout his life, and was its treasurer for 20 years. Until 1737 he was occupied with painting a variety of still lifes, but he had also begun a series of paintings of people in interiors. Many of these interior scenes, known as genre paintings, are similar in atmosphere to work by Vermeer (1632-1675). Chardin also adopted Vermeer's practice of showing the head in silhouette against a warm, light-colored ground. Chardin hoped this new type of work would appeal to more fashionable patrons than purchased his still lifes. Although Chardin's work was valued by collectors, it was rather on account of its craftsmanship than for the originality of his compositions. By several accounts – including his own – he worked slowly and his methods were meticulous. The paintings were built up in successive layers of semi-opaque color and thin glazes. These contribute to the richness of texture in the objects shown. Chardin's understated, almost austere compositions were to influence a wide range of painters in later centuries, including the two nineteenth century Realist artists, Gustave Courbet (1819-1877) and Jean François Millet (1814-1875). Later the works of Paul Cézanne (1839-1906), another masterly still life painter, also acknowledged the influence of the meticulous eighteenth century artist.

Materials

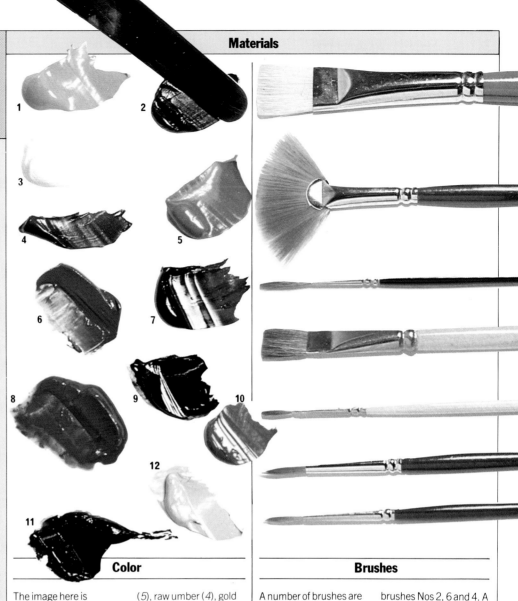

Color

The image here is created in oils with subtle mixtures of earth tones, varied with touches of cadmium red (10) and ultramarine (7). The basic colors are yellow ochre (1), Vandyke brown (2), raw sienna (5), raw umber (4), gold ochre (6), light red (8), burnt umber (11) and Naples yellow (12). Lamp black (9) is added to dark tones and flake white (3) used for highlights. Terre verte will also be needed.

Brushes

A number of brushes are needed including (from top to bottom) a broad hog's hair flat brush for tinting the ground, a fan brush for blending, a No 1 sable writer which has a long tip, a No 8 flat sable and round sable brushes Nos 2, 6 and 4. A round synthetic bristle brush of medium size, for example a No 6, is useful for putting in linear highlights. Brushes with soft hair, sable or synthetic, are the best for laying in glazes.

Priming

Apply four thin coats of liquid gesso primer, letting each dry out thoroughly.

Support

Stretch up a canvas of fine artists' linen. The copy here is made the same size as the original.

Mediums

Pure turpentine is used to dilute the paint and a thick glaze medium added in later stages.

Other equipment

Keep a supply of rags or paper towels to hand as you are painting to wipe brushes and canvas.

1 Tinting the canvas and drawing up the outlines

Cover the primed canvas with a light brown tone, brushing on an even layer of white primer tinted with burnt umber. Draw a grid on your reproduction of the painting and scale up the grid onto the canvas, marking the grid lines faintly on the tinted primer with a fine brush and white paint. Use a long ruler or straight length of wood to guide the brush. Start to draw the outlines of each object in burnt umber diluted with turpentine. For this use a No 1 sable script brush, which is specially made for fine lettering.

2 Completing the drawing

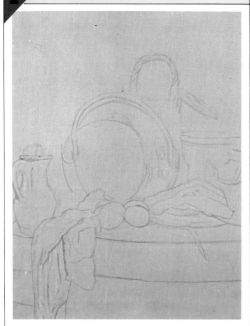

Draw up the objects as accurately as possible and in some detail. The thin lines of burnt umber will be easily covered when you start to work up the painting as a whole, but it is important to have a clear layout of the composition and the main features of each object as a basis for the copy. Check that the shapes are correct against the original and make any alterations.

5 Developing the underpainting

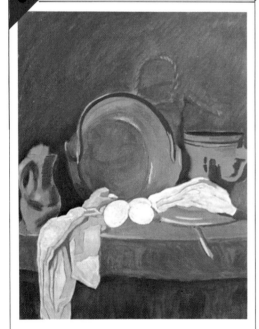

Continue working on the basic tonal structure, using mixtures of burnt umber, terre verte and white for a neutral middle tone. Add gold ochre to the color to create a warmer tone in the bottom of the large pan,

and yellow ochre for the flat plane of the shelf in the foreground. Reinforce the darkest tones, in burnt umber and ultramarine. Scumble the shape of the basket lightly with terre verte mixed with Vandyke brown, using swift, sketchy brushstrokes. Darken the background tone at the left-hand side of the picture with the same mixture. Keep the paint thin and fluid by adding plenty of turpentine and blend the colors roughly together. Brush in a little light red on the jug and pot.

3 Laying in dark tones

Loosely wash in the dark tones on the objects and in the background. Mix raw umber with a small amount of black, add a touch of white and dilute the paint with turpentine. Spread the color with a flat No 5 hog's hair brush, following the outlines to establish the tones.

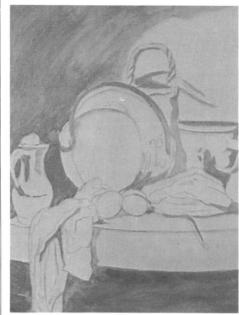

6 Putting in color

Start to apply local color. Paint in the flesh of the salmon with a mixture of cadmium red, Naples yellow and white (below), glazing in the shadows with terre verte and burnt sienna. Mix green-grays for the skin and the leek and reddish grays for the shadows in the plate. Put in dark shadows with Vandyke brown and black.

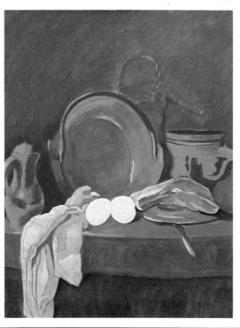

4 Working up the highlights

Put in the lightest tones in well diluted white, assessing broad areas and highlights. Use a round No 6 synthetic brush for fine details and the No 5 bristle for solid shapes, such as the eggs.

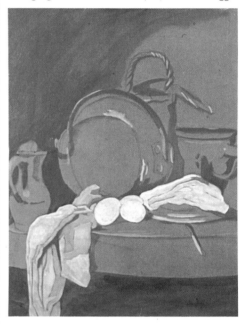

7 Applying tonal glazes

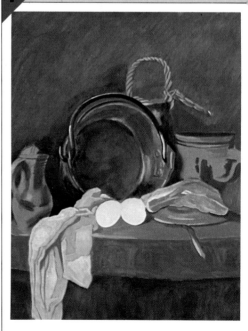

Strengthen the tones in the pan and basket. Work in a dark green-gray made from terre verte, black, white and ultramarine and draw in the shadow details with a No 6 sable brush. Add plenty of glaze medium to the inside of the pan. Overlay thin glazes of terre verte, Vandyke brown and raw umber. Brush in stiff white paint to form pale tones and highlights.

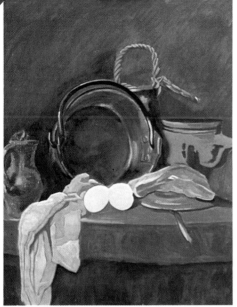

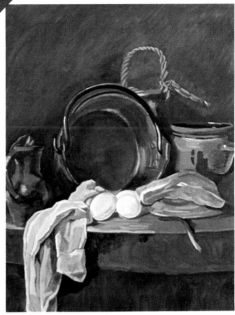

Model the form of the jug, first applying the dark tones, light red mixed with black, and adding more light red and white to develop the light colors. Put in pure white highlights and blend the colors gently with a soft fan brush. The full subtlety of the color depends upon transparency in the paint, so continue to add plenty of glaze medium to each mixture.

Work on the details of folds in the white cloth, mixing a number of mid tones for the shadows with white, terre verte, black and ultramarine in varying proportions. Add yellow ochre and, with the No 2 sable brush, develop the shape of the basket handle, softening the tones by dabbing gently with a rag. This also removes excess paint.

Work over the whole image strengthening the tonal contrasts in the warm and cool colors.

The final version

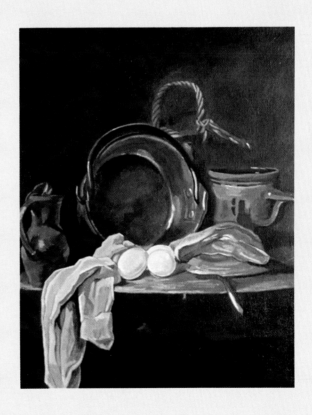

11 Correcting the image

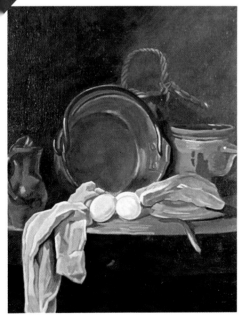

The painting is now almost finished, but it is always advisable in the final stages to stand back and cast a critical eye over your work. The shapes must be quite accurate and the tones and colors carefully identified and copied, otherwise the objects will not look convincing. Check the colors against the original, and make any adjustments to the tone by overlaying glazes and enhancing the highlights. There is a subtle exchange in this painting between the cool tones, created with terre verte and raw umber, and those which are warm and glowing, which are mainly those containing light red and yellow ochre.

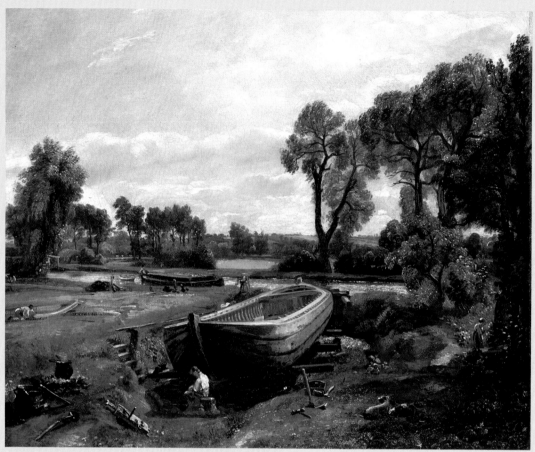

Victoria and Albert Museum, London (photo — Bridgeman Art Library)

Constable

Boatbuilding near Flatford Mill, oil on canvas, 19 × 24in (48 × 61cm)
Constable valued traditional painting techniques and he adapted them to
working mainly out of doors. To convey atmosphere and distance, he built
up thin layers of color into a composite effect. Color mixtures are rare in
his work since they would have destroyed the luminosity he aimed to
achieve. Reproductions of the landscape paintings tend to disguise
Constable's remarkable command of his medium. The paint texture is rich
and the brushwork is fluid and economical.

The Artist

**British painter
born 1776, died 1837
Landscape painter with an assured
and masterly personal technique**

The major English landscape painters of the nineteenth century were J. M. W. Turner (1775-1851) and Constable. They both introduced new ways of painting nature. Constable was born and brought up in Suffolk, and it was this countryside, he said, which made him a painter. The landscape around his early home remained an influence on him throughout his life. Constable felt that the best way to master painting technique was to copy works by the Old Masters. He particularly studied the Dutch tradition of landscape painting in which the coloring was dominated by golden brown tones and which had mainly been painted in the studio. However, he soon felt it was necessary to break with this tradition and paint from nature directly out of doors, using only natural light. He began to introduce brighter colors – especially greens – into his paintings. This new direction was not appreciated by the public which still preferred the dark tones associated with works by the Old Masters. However, when Constable exhibited *The Hay Wain* at the Paris Salon in 1824, it was an immediate success, and he was awarded a gold medal for the picture, which was greatly admired by Delacroix (1798-1863) and other important French artists. In fact, Constable's influence was greater in France than in Britain. For instance, in the late 1840s, when the French painters of the Barbizon School were trying to establish a new style of landscape painting, they followed Constable's example of natural, informal composition. Constable made freely painted full-size studies for his large-scale paintings which included much detail. These sketches are much admired nowadays, but during Constable's lifetime artists were required to make large finished works from their sketches. It seems likely that some of this work may have been done in the studio. He made a particular study of the changes of light and weather which are most characteristic of England, especially East Anglia. Constable's work expresses his love of nature and he regarded painting as a science which 'should be pursued as an enquiry into the laws of nature'. Although their approaches were very different, Constable and Turner added new dimensions to the genre of landscape painting.

Materials

Color

Acrylic paint is used here to imitate the oil of the original. The effect is not exactly the same as oil colors have greater density, but acrylics are easier to use, being water soluble. They also dry more quickly, which enables you to overpaint without delay. The colors needed are yellow ochre (1), viridian (2), burnt umber (3), cadmium yellow (4), alizarin crimson (5), cadmium red (6), raw umber (7) and monastral blue (8). Burnt sienna is used to tint the ground.

Mediums

Acrylic paint is thinned for areas of wash or flat color with water only. Various mediums are available which alter the consistency or surface finish of the paint. Thin glazes of color are created here by mixing acrylic gloss medium with the paint. This is clear when dry.

Support

This painting can be conveniently made to the same size as the original, 19 × 24in (48 × 61cm). Find a suitable stretcher and cover it with artist's linen. Tack or staple the linen to the back of the wood. If you cannot easily stretch the canvas yourself buy one ready-made and primed or use a canvas board of a suitable size.

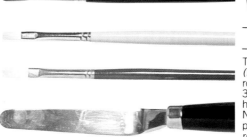

Equipment

The brushes needed are *(from top to bottom)* round sable brushes Nos 3 and 4, a flat No 2 hog's hair bristle brush and a No 6 hog's hair filbert. A palette knife with a rounded blade is used for the underpainting. Generally, hog's hair brushes are best for broad areas, and sables are best for details. A larger bristle brush could be used in the early stages.

1 Tinting the ground

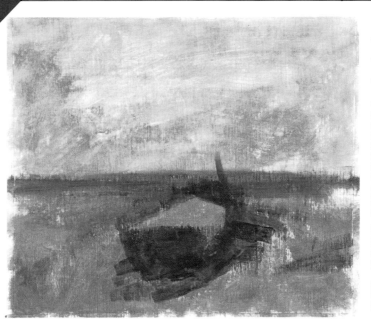

Mix a rich brown from burnt sienna and half the quantity of burnt umber. Dilute the color with water and apply it liberally to the support with a flat No 6 hog's hair bristle brush. Scrub color loosely across the surface to form a warm ground for the painting. It need not be even, but you may find it useful to keep the tone lighter in the area of sky than in the foreground. Divide the canvas simply by putting the horizon line as a broad band of raw umber. Then roughly draw with the brush to establish the basic shape of the boat and brush in dark tones solidly with raw umber. These shapes are only a general guide and can be developed as the painting progresses.

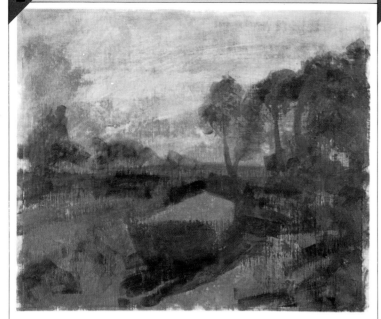

Block in the basic masses of the trees and areas of dark tone. Use raw umber thinned with water to sketch in the forms. Apply heavy strokes of burnt umber, using the No 6 bristle brush, to emphasize shadows and solid shapes, such as the tree trunks and bushes. Work over the tinted ground with thin and broken layers of warm color.

Add rich, warm tones in the foreground with raw umber and burnt sienna, mixed and spread with a palette knife to increase the paint texture. Make a quantity of light gray-blue from monastral blue, white and black and thin it with water. Cover the sky with loosely brushed paint, at the same time redefining the trees and horizon line.

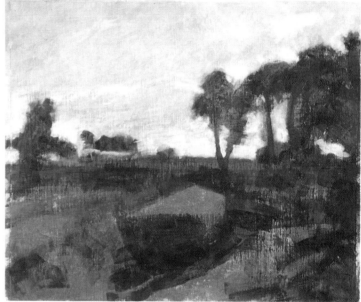

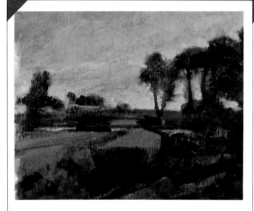

Start to apply color in the middle ground of the painting. Put in the light tone of the fields and river bank with a mixture of cadmium yellow, burnt umber, white and yellow ochre, using a No 6 filbert brush. With a round No 4 sable brush, put in fine bands of light blue, the same color as in the sky, to represent the river which cuts through the middle of the painting. Put in the river barge with a solid wedge of black.

Work on the shape of the boat, using a No 4 sable brush for each of the stages. First lay a glowing pink glaze over the inside of the boat. Mix cadmium red and a little cadmium yellow with plenty of gloss medium and apply the paint thinly. Define the whole shape more clearly, drawing with the brush in a light tone mixed from burnt sienna, yellow ochre and white. Leave blocks of underpainting free to show the shadows.

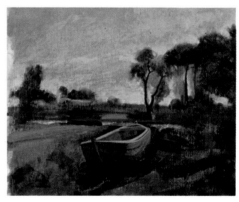

Continue work on the detail of the boat. Glaze over the shadows with raw umber in gloss medium. Emphasize highlights and draw in the ribs. Suggest the chocks beneath the boat with small marks in thin, gray paint.

Add linear detail to the trees on both sides of the painting, drawing in burnt umber with the No 4 sable. Strengthen dark tones and shapes.

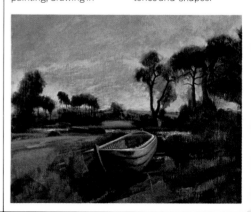

7 Modeling tones in the foreground

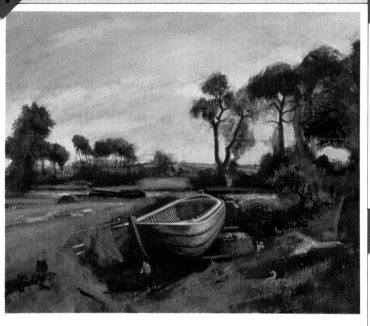

Model the light and dark tones in the foreground, concentrating on the details and highlights of individual forms. Mix a light brown from white, burnt sienna and raw umber and scumble it loosely, with circular movements of the brush, over the underpainting to each side of the boat. With pure white, draw in lines and flecks of paint with a No 3 sable brush to mark the position of the figure, the steps and pathway and the dog playing in the foreground to the right. Emphasize dark tones in the hollow around the boat with black and draw the shape of the cauldron and patch of dark shadow on the left of the picture.

8 Putting in the foliage

Mix a mid toned green from monastral blue and yellow ochre. Dab in the foliage of trees and bushes with a No 4 sable. Again, use the dark underpainting to vary the tone, building up the green more thickly to achieve the correct color, drawing it lightly over the brown to indicate shadows. Add more yellow ochre and a little burnt sienna to the greens on the right of the image and white to create pale tones and highlights.

9 Defining the figures and foreground detail

Lighten the tone of the sky directly above the horizon and around the trees. Gradually develop detail in the foreground, for example the flames under the cauldron, with cadmium red, yellow and white. Study each form carefully to identify the color and the type of brushmark in the original. Although Constable's paintings can appear very detailed, forms can often be described adequately with only a few strokes.

The final version

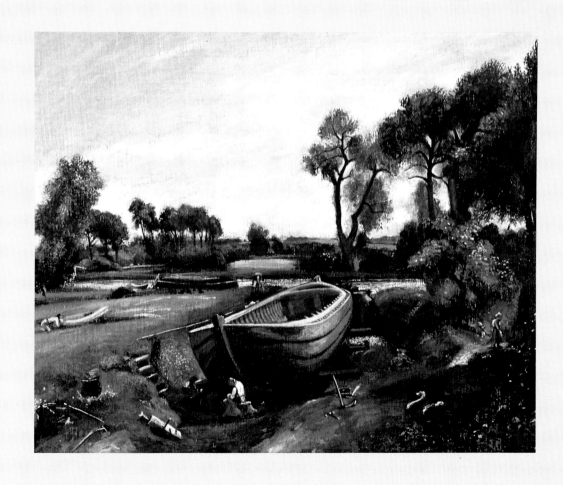

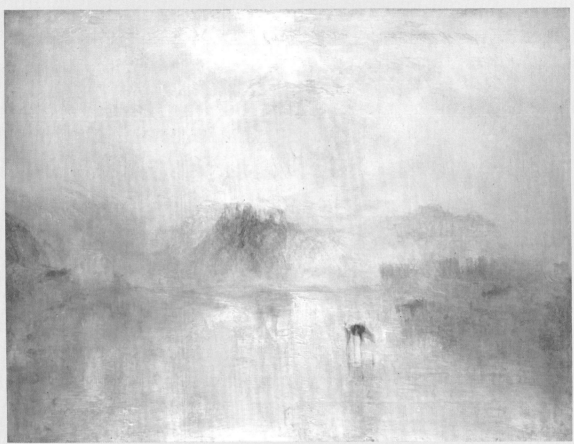

The Tate Gallery, London

Norham Castle, oil on canvas, 35¾ × 48in (90.5 × 122cm)
This painting is a theme recreated from watercolor sketches. It was made
many years after Turner's last visit to Norham Castle. This enabled him to
combine the freshness of his early vision with the expertise gained from
years of experience in painting. Turner liked to conceal his painting
methods and it is difficult to classify him because of his technical virtuosity.
His habit of repainting pictures on the day before exhibition suggests
reliance on final varnishes to unify color effects.

The Artist

British painter
born 1775, died 1851
Innovative landscape painter in oils and watercolors

Turner was born in London where his father was a barber. He was first apprenticed to an architectural draftsman and then, when only 14 years old, was admitted to the Royal Academy Schools. His training was conventional and did not suggest that he would revolutionize the art of landscape painting. He was one of the first painters to realize the beauty of the English seacoast, and this became one of his principal themes. Like other English watercolorists, he made studies from nature and spent many years building up a vast collection of watercolors which show his skill in rendering atmosphere. In fact, he made the study of light and aerial perspective the chief subject of his work. This was unusual in an age when other artists were painting pictures of romantic or historical subjects. Turner's oil paintings, like *Calais Pier* (1803), were often condemned as being unfinished, although he received support from important artists of the time such as the portrait painter Sir Thomas Lawrence (1769-1830). Turner's preoccupation with watercolor led him to adopt a palette of increasingly light colors, and his technique in oils anticipates the use of white grounds and bright effects by the Impressionists. It was the magic and poetry of light which caused the influential critic John Ruskin to champion Turner in his book *Modern Painters* of 1843. Turner tended to lay one color over another on the canvas, rather than mixing pigments together on the palette. His technique combined the use of soft, subtle tones with thickly applied paint. Turner not only observed nature closely but also attached symbolic meaning to its phenomena, even writing long and rather obscure titles and verses which were intended to explain his pictures. Particularly in his later works, Turner's primary aim was to express in purely pictorial terms the impression of light, atmosphere and space. His huge collection of pictures was left to the nation to be displayed publicly. This wish was not carried out until nearly a century after his death. Turner and his fellow countryman Constable (1776-1837) show very different approaches to landscape painting. Turner's work, however, in some ways prefigures the work of both the Impressionists and modern abstract artists.

Materials

Brushes

A range of brushes are used here *(from top to bottom)* a No 5 hog's hair flat, a No 14 hog's hair flat, a No 7 filbert bristle brush, flat hog's hair Nos 1, 4 and 3, and Nos 1 and 4 round sables. Use a fan brush for blending colors. The No 5 brush is widely used for blocking in the color and shaping forms while the No 14 enables you to cover broad areas quickly. A good range of bristle brushes will be invaluable, though the actual sizes and shapes may be a matter of preference. Use sables for details.

Support

A stretched canvas, using fine artist's linen as the fabric, is the support for this painting. The dimensions are 18½ × 25in (47 × 64cm). Always be sure to imitate the proportions of the original.

Color

The overall tone of this painting is fairly light so plenty of flake white *(8)* is needed to tint the color mixtures. Prussian blue *(4)* is the basic color in the sky, sea and the distant shape of hills and castle, later modified with cobalt blue *(7)*. Warm tones are created by adding burnt sienna *(2)* and alizarin crimson *(6)*. Chrome yellow *(1)* and Naples yellow *(5)* give the shimmering effect of sun in the sky and on the water. A useful addition to the palette is raw umber, a neutral earth tone which can be used to darken the colors and tone down the vivid character of the predominant Prussian blue. Turner's oil painting was inspired by earlier sketches in watercolor so use oils to imitate the subtle coloration of the original.

Priming

A gesso ground gives a clean, smooth surface for the painting and protects the fabric of the canvas. Use a liquid acrylic gesso primer, built up gradually in four thin coats. Tint the ground with a mixture of Prussian blue, crimson, yellow and a large amount of flake white.

Other equipment

Highlights are applied thickly so a palette knife with a trowel-shaped blade is needed to spread the color. Added texture is given by scraping into the paint with the wooden end of a brush. Keep rags to hand for wiping knife and brushes and to lift the paint surface.

1 | Painting the underdrawing

Draw in the major outlines of the picture with paint that is slightly darker than the whitish ground. Mix the paint from raw umber, Prussian blue, white and turpentine. Use a No 1 sable brush which will give a very fine line. Hold the brush at an angle of about 45° *(above)* and do not load it too heavily with paint. The lines will act as a guide showing where the different areas of color should lie and they will not actually be visible in the final painting. Most of the drawing should be in the foreground *(right)*.

2 Initial underpainting

Work with a No 14 hog's hair flat brush to block in most of the painting with a dark gray made from equal amounts of Prussian blue, alizarin crimson and chrome yellow, with just a touch of flake white. Lay down an area of flat color over the whole canvas, leaving just the sun and the reflection of sunlight on the water unpainted.

3 Blocking in the sun

Next, fill in the unpainted, lighter areas of the picture with off-white. Use mainly flake white mixed with a little chrome yellow. Work with a No 5 flat bristle brush. Apply the paint in fairly small strokes trying to keep roughly within the outlines.

4 Strengthening the background

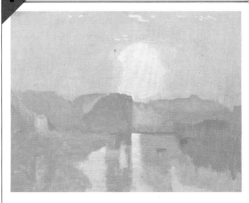

Continue to work on the underpainting by working on the large masses to the left and right of the picture. Make a green darker than the original ground from burnt sienna, Prussian blue and white. Use equal amounts of the sienna and blue with a touch of white. Use a No 8 flat bristle brush to lay down the green paint. Then remove any brushstrokes to give a soft effect by reworking the paint with a badger hair fan brush.

5 Building up the underpainting

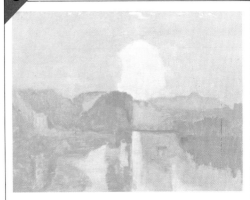

Strengthen the initial underpainting still further with a misty blue. Use Prussian blue as the basis for the color, but add some alizarin crimson and chrome yellow to the paint to give a brownish effect to the background on the left and right. Thin the paint with turpentine and use the paint quite fluidly. Turner tended to put down a strong underpainting made up of several layers which were then continually reworked before the final desired effect was achieved. Paint with a No 5 hog's hair brush, and do not worry if any brushstrokes show as these can be painted over at a later stage. Fill in the white shape of the building just discernible on the left of the composition with flake white.

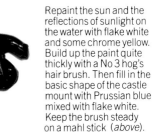

Repaint the sun and the reflections of sunlight on the water with flake white and some chrome yellow. Build up the paint quite thickly with a No 3 hog's hair brush. Then fill in the basic shape of the castle mount with Prussian blue mixed with flake white. Keep the brush steady on a mahl stick (*above*).

6 Painting the castle

Carry on painting the castle mount with Prussian blue and flake white. When the top half of the original underpainting on the mount has been covered, put in the windows on the castle. Use the wrong end of a thin brush, such as a No 1 sable, to scrape back the paint. The result will be that the pale blue underpainting will show through giving an impression of light. Scrape away the paint using short, hatched strokes overlapping each other so they form a solid block.

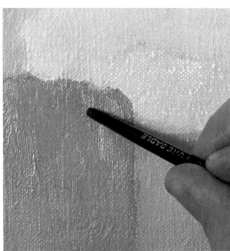

Once the windows have been scratched away, develop the other blue parts of the painting. Blend the fresh paint on the castle into the pale background. Then use the same mixture of Prussian blue and flake white as before to paint in the reflection of the castle on the water. Build up the layers of paint with a No 1 sable brush. At the bottom of the castle where the color is browner, use a little raw umber and lamp black with the blue and white. Extend the paint along the far bank of the river with a No 5 hog's hair.

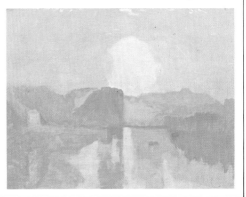

7 Developing the lights

Return to the sun and the pale reflections next. Use undiluted paint without any medium so that it lies thickly on the canvas. Work with a thin No 1 flat hog's hair brush and flake white mixed with a little chrome yellow. Do not keep within the first outline of the sun, but take the paint into the blue of the sky to create a hazy, luminous effect. Use short strokes for the reflections.

8 Adding more color

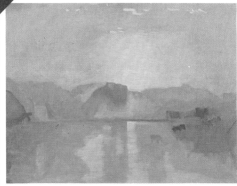

Strengthen the color of the sun and reflection of light in the water with chrome yellow and white. Paint with a No 4 hog's hair flat. Then redefine the details, working with varying mixtures of Prussian blue, burnt sienna and flake white diluted with linseed oil and turpentine. Build up the land on the left and right with a No 5 hog's hair flat. Paint in the hazy pink color in the distance with the same paint with a little alizarin red added to it. Use a No 7 hog's hair flat. Paint the cows with a No 4 sable and burnt sienna and white.

9 Defining the cow

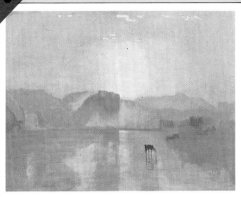

Soften any brushmarks on the surface by dragging a badger hair fan brush across them. Blend the paint so that the land seems to merge with the river. To add more definition to the cow in the water, use a No 1 sable brush. Load the tip with a little burnt sienna mixed with a small amount of white. Paint in the cow's body first. Then draw in the legs by dragging the paint on the body down in thin lines (below). Add the cow's reflection with slightly thinner paint.

10 Working on the river

Mix together chrome yellow, Prussian blue, alizarin crimson and white. Dilute the paint with turpentine and apply it to the river with a No 7 hog's hair filbert (above). Dab off any excess paint with a paper towel (left).

11 Adding highlights

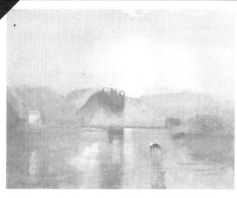

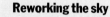

Paint the parts of the sky which are tinged pink by the sunrise with alizarin crimson and flake white. Use a badger hair fan brush to soften the tones in the background. Put additional highlights on the water with chrome yellow and on the cow and castle windows with white. Apply the paint thickly with a palette knife. Create the ripples on the water's surface with the wrong end of a brush.

12 Improving the background

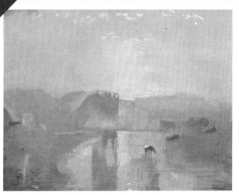

Rework the painting as a whole to enhance the atmospheric effects. Add some more Prussian blue to the sky in the top left corner. Then use a mixture containing more cobalt blue for the misty area in the background (above). Scrape back the river with the wrong end of a brush to create more ripples (left).

13 Reworking the sky

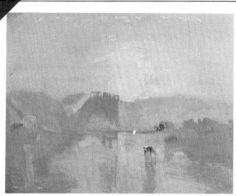

Use a No 4 flat hog's hair brush to improve the blending of the sun and the sky. Pick up the paint on the sun with the tip of the brush and draw it outwards so that the sky becomes quite yellow (right). Work with a glaze medium for these final stages. This should give a softened effect to the whole painting (above).

14 Putting in the final touches

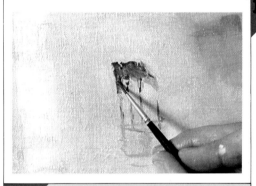

Add the finishing touches to the mist on the hills in the background with a brush wetted with a thin glaze (above).

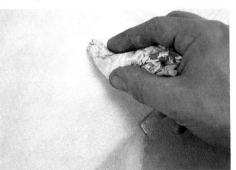

Finally, soften any harsh lines with a paper towel or a rag. Pick up any surplus paint by wiping a rag over the surface. This will make the transition of the tones more subtle. When the paint is completely dry, varnish the painting.

The final version

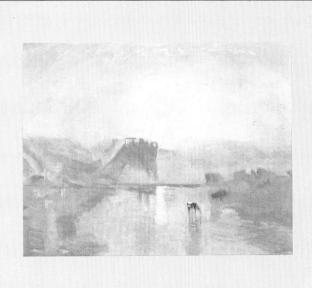

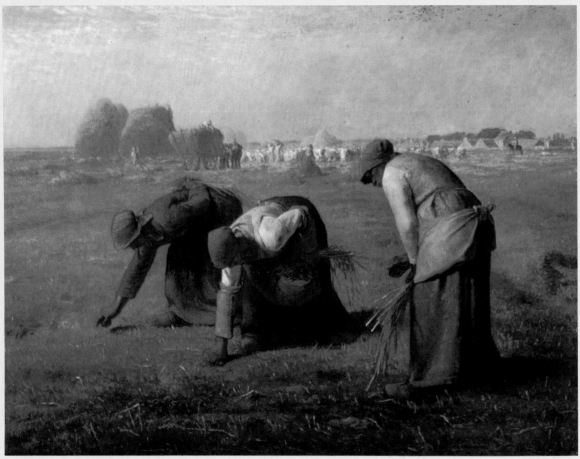

The Louvre, Paris

Millet

The Gleaners, oil on canvas, 33⅛ × 43¾in (84 × 111cm)
Many of Millet's paintings are on this theme of rural life, emphasizing the
labor involved in working the land. He made studies from life and
developed the full compositions later in his studio. Millet invests the
paintings with his sympathy for the subject and he never shows the
festivity or lighter side of country life. In *The Gleaners*, his attention has
clearly been caught by the coloring of the scene and the opportunity to
work out the theme in a carefully structured composition.

The Artist

**French painter
born 1814, died 1875
Influential painter of rural and
agricultural scenes**

Millet's reputation is associated with the lives of peasants who feature in many of his paintings. He himself was the son of a peasant farmer from the rocky peninsula of Cherbourg in Normandy. The dramatic landscape, bordered on three sides by the sea, attracted him throughout his life. In 1837, after studying for three years with a local portrait painter, Millet won a scholarship to Paris. There, he continued to paint portraits and began to make studies of nudes. In 1841, on a visit to Normandy, he married, and his wife returned with him to Paris but died in 1844. At this time, Millet's paintings were rural scenes with figures, which were important because of the practice he gained in drawing the human form and in the use of the pastel chalks technique which he later perfected. After 1845 these romantic pastoral scenes were superseded by single figures naturally observed in rural settings. Millet moved to Barbizon in the countryside near Paris in 1849. The next year he painted *The Sower*. This picture established his reputation for fine drawing, but it was also interpreted as an indictment of society, painted by a man with radical sympathies. There is no evidence that Millet himself took part in politics, although a number of his friends were politically active. *The Sower, The Gleaners* (1857) and *The Angelus* (1859) were all exhibited at the Paris Salon during the 1850s. Millet's vigorous handling and simplified statuesque forms give a timeless grandeur to the harsh reality depicted. The stiff paint consistency retains each mark of the brush, which Millet exploited to convey the rough texture of the peasants' clothing and the coarseness of their skin. Later, at Barbizon, he turned increasingly to landscapes, and made numerous drawings in black and white and in pastel, before the outbreak of the Franco-Prussian War caused him to leave for Cherbourg in 1870. The drawings influenced his painting and also reflected the trend to work more closely from nature in the late nineteenth century. He imitated natural effects by exploiting the contrasting transparency and opacity achieved by using different amounts of medium in oil paint. When painting water, for example, he used thick, broken strokes for the sunlit areas and thin films for the shadows.

Materials

Color

The warm brown tones which predominate in this painting are based on yellow ochre *(2)*, raw umber *(4)* and burnt sienna *(6)*. Areas of local color are added, for example the clothing of the figures, with cobalt blue *(5)* and cadmium red *(3)*. Flake white *(1)* creates light tones in the sky and foreground and highlights on the main figures and across the horizon line. Payne's gray is also needed to give depth to shadows and dark tones. The painting is quite complex and the final effect depends upon thin glazes and washes which warm the tones and develop modeling of the forms. This is best imitated with oil paint, the original medium.

Support

Stretch a canvas using medium weight cotton duck and a wooden stretcher of a suitable size or, for convenience, buy a ready-made canvas. The dimensions here are 17 × 23in (43 × 58cm).

Mediums

Use pure turpentine to thin the paint for washes and glazes. White spirit is needed for cleaning brushes and palette but is not a suitable medium.

Priming

Prime the cotton duck with two coats of liquid gesso primer. Brush it on liberally but do not leave excess moisture on the surface of the canvas. Allow the first coat to dry and sand it lightly before applying the second coat.

Other equipment

Use a soft 2B pencil to draw up the design. Rags or paper towels are always useful for oil painting.

Brushes

Use a decorator's brush to cover the canvas with the initial tint. A flat, medium sized hog's hair brush is then useful for blocking in basic forms. The best type of brush for laying glazes is a round sable, for example a No 8, and a smaller size, No 6, can be used for details. These can be drawn to a point for linear work. However, some artists prefer to use flat sable brushes, finding the brushstroke more precise.

1 Squaring up and drawing the figures

Draw a simple grid of small squares in pencil on the reproduction used as the basis for your copy. Divide the canvas with a proportional grid, drawn lightly with a soft 2B pencil. Draw in the main lines of the composition, checking the position of each figure on the grid. To create areas of tone, shade lightly on the canvas with the pencil point and rub the graphite into the surface with your fingertips.

2 Completing the drawing

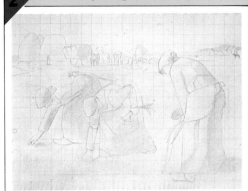

Plan the whole composition in this way, outlining the forms precisely and adding tone to give the basic three-dimensional effect. The difference in scale between the figures in foreground and background is crucial in establishing the deep recession of the horizontal plane towards the hills on the skyline.

3 Laying a tinted wash

Mix a thin wash of burnt sienna, heavily diluted with turpentine. Make a good quantity as it should cover the whole canvas in a thin layer, and can then be used to accentuate the darker tones. Use a stiff 1in (2.5cm) decorator's brush as this disperses the paint evenly in the spirit and covers the canvas quickly. Lay the wash of color over the drawing, but do not press down on the surface. Keep the brush well loaded with paint and work with broad, fluid gestures to cover the surface with a warm tint.

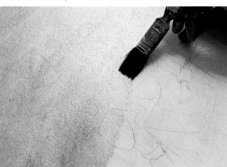

4 Completing the tinted ground

Let the wash dry into a light film of color over the whole surface of the canvas. This establishes a middle tone against which the shadows and highlights can be assessed. A broad expanse of white can give a false impression of the relationships of tones and colors in a painting. Until the time of the Impressionists in the last quarter of the nineteenth century, it was traditional technique to work on a ground tinted with light brown or gray.

5 Underpainting in tone

Start to model the forms with washes of burnt sienna and raw umber, applied with a round No 8 sable brush. Follow the guidelines of your original drawing but aim for a general impression of weight and volume, rather than accuracy.

6 Developing form in the underpainting

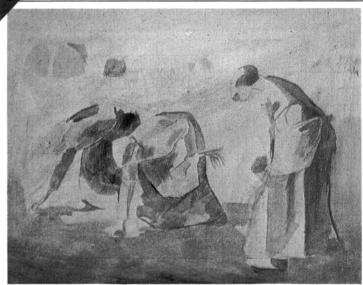

Paint the heaviest shadows with Payne's gray, well diluted with turpentine. Study the way Millet has shown the fall of light on the bending figures and imitate the shadows in the dresses of the women. Put in dark areas on the heads, arms and hands where the forms curve away from the light. Work over the gray with raw umber and use burnt sienna for the mid tones.

7 Modeling with color

Use ultramarine, black, white and raw umber to model the figures at right and left. Mix cadmium red with blue-gray to make the deep pink tone for the clothes of the central figure. Brush in white to create highlights and yellow ochre for neutral tones (above).

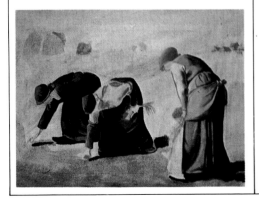

8 Applying color washes and glazes

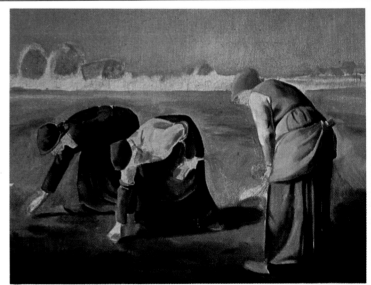

Mix white with cobalt blue and a touch of burnt sienna, dilute the color with turpentine and paint the sky. Brush on the color with a No 8 sable brush, working around the shapes on the horizon line. Apply the paint thinly at every stage to allow modifications of tone as the dark underpainting shows through the layers of color. Put in the changing tones of the ground around the figures with yellow ochre, raw umber and burnt sienna (above left). Rework the dark tones by drawing over the color with thin glazes of Payne's gray and raw umber mixed in gum turpentine. It is vital to retain the transparency of color in a glaze. Apply it with a large, round sable brush and avoid lifting the color beneath which will muddy the glaze.

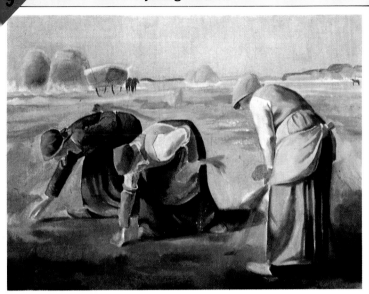

Blend the tones gently with a large sable brush and emphasize highlights in background and figures with white. Draw into the faces, and details such as the bunch of corn, with raw umber *(right)*. Make any vital alterations in tone and color and as a final step lay a thin glaze of yellow ochre over the whole work to unify the forms and give an impression of warm, glowing light.

Complete the blocking in of color across the whole canvas, lightening the tone of the field with a thin layer of yellow ochre mixed with white *(left)*. Put in flesh tones on the figure with washes of burnt sienna and cadmium red and gradually enrich the colors with glazes, heightening tonal contrasts. Add yellow ochre to cobalt blue and brush in the horizon.

The final version

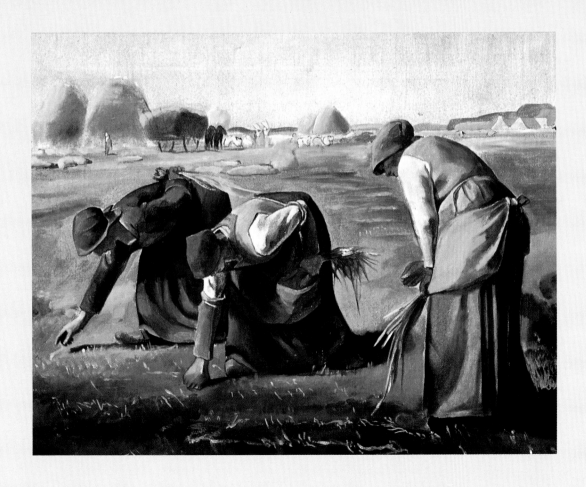

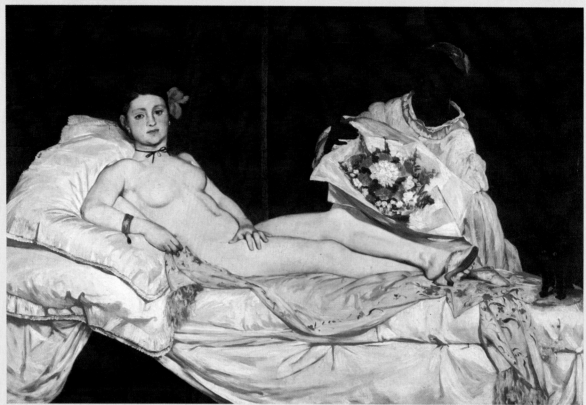

The Louvre, Paris (photo — Bridgeman Art Library)

Manet

Olympia, oil on canvas, 51×74¾in (130×190cm)
When *Olympia* was first exhibited in 1865, the public reception was
hostile, giving no sign that his audience had understood Manet's connection
with the tradition of the Old Masters. Yet Manet was a devoted admirer of
earlier Venetian and Spanish painting and the construction of this picture
owes much to his studies. Many drawings and sketches were made, but the
final version was painted directly from the model, the form of the figure
being mainly achieved through outline and silhouette.

The Artist

**French artist
born 1832, died 1883
Important and innovative artist, a
major forerunner of Impressionism**

Manet was the son of a Paris magistrate who was at first reluctant to allow him to study art. Nevertheless, Manet abandoned the study of law and, in 1850, after a voyage to South America, he joined the studio of Thomas Couture (1815-1879) who had a good reputation as a conventional historical and portrait painter. Manet worked for six years with Couture, evolving his own, more modern technique based on lively brushwork and sharp contrasts of light and shade. His first major work was the *Absinthe Drinker* which showed a squalid scene, and was rejected by the Paris Salon in 1859. However, he exhibited two paintings there before his brief visit to Spain in 1863. This visit confirmed his admiration of Velazquez (1599-1660) and Goya (1746-1828), and encouraged him to bring together old and new styles. The influence of Spanish painting appears particularly in his use of black, which was considered unorthodox since he used it to define shape without half-tones. He began to choose strong, full-faced light sources to eliminate these half-tones and create flattened planes. He exploited the pale areas of light gray or creamy off-white for their luminosity and flatness. The emphasis within a painting and the textures of the subjects were more important to him than a traditional perspective. An example of this is *The Picnic*, with the larger-than-life nude central to the painting, which was exhibited in 1863. In 1865 he exhibited *Olympia*, a picture of a reclining nude in which he restated a classical theme. Manet was criticized for the modern, spontaneous-looking appearance of his works. In fact, both these paintings created scandals, the latter even being caricatured in the press. However, his technique, which combined traditional and innovative elements, drew him closer to his admirers among the Impressionist group. He only refrained from contributing to Impressionist exhibitions because he felt that recognition from official circles, which the younger painters scorned, was still important. After 1870, he adopted elements of Impressionism, such as free handling of paint and intense color and observation of outdoor light, encouraged him to add white to his palette. Manet died, aged 51, but he had by then received the official recognition he coveted.

Materials

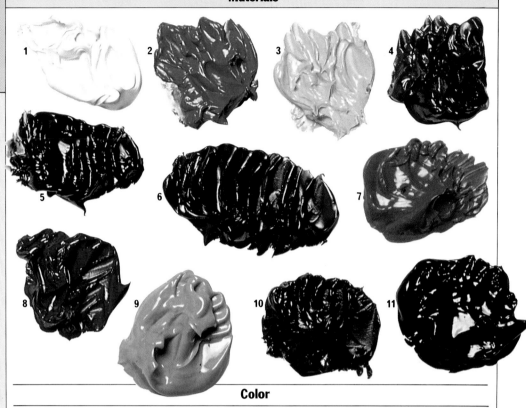

Color

There is a stark contrast in this image between the light tones of the figure and the dark background. Make the copy in oil paint. Ivory black (11) is used as the basis for the darkest tones, with mixtures of burnt sienna (4), and viridian (6). Flesh tones and shadows in the drapery are mixed from titanium white (1), chrome yellow (3), cadmium red (7) and yellow ochre (9) with raw umber (10) and cobalt blue (8) to vary the shades. Cerulean blue (2) and sap green (5) are needed for local color in details such as the flowers and the model's shoes.

Mediums

Turpentine and white spirit both dilute and dissolve oil paint but it is inadvisable to use them interchangeably. Pure turpentine should be mixed with the paint to give it fluidity as it has a rich consistency which enhances the color. White spirit may be used liberally for cleaning brushes, but if used to dilute the paint it reduces transparency of the medium and the colors tend to dry out with a dull surface.

Support

The canvas used is smaller than the original but in the same proportions, 30×45in (76×115cm). When you are making a copy of a painting which is quite large, bear in mind that reproductions distort the color, so it may be impossible to achieve a satisfactory result. You can buy canvases already prepared but they come in standard sizes and may not be suitable. Alternatively get a stretcher and stretch cotton duck over it. This will need priming before you begin to paint.

Priming

A white primer can be made by mixing an acrylic emulsion glaze with an equal quantity of ordinary emulsion paint. Apply one coat and when it is dry hold the canvas up to the light. You will then be able to see any thin patches in the priming. Apply a second coat of primer.

Equipment

The full range of brushes and other equipment which you will need for this painting is *(from top to bottom)* flat hog's hair bristle brushes Nos 4 and 2, a round No 4 synthetic brush, a soft black B pencil, a putty rubber and a ruler. The pencil, rubber and ruler are used to square up the composition when it is initially transferred to the canvas. Although the paint will cover the pencil lines, it is as well to erase the grid when the outlines have been drawn, especially in areas of light tone. The size of brushes used is partly a matter of personal preference. Those listed will be adequate, but you may prefer a larger size, for example a No 8 flat, for filling broad areas.

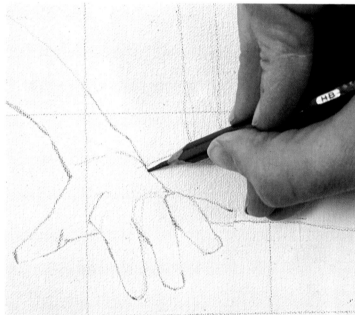

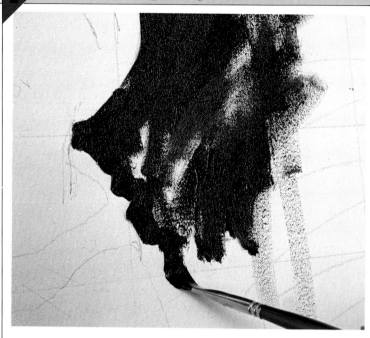

With a flat No 4 bristle brush, mix viridian and black and block in the darkest areas of the background. Work into the outlines carefully *(above)*, but keep the brushwork vigorous so the broad expanse of color is not deadened. Indicate dark shadows in the drapery at the left of the canvas with the same dark green *(below)* using the tip of the brush.

Square up the canvas and draw in the outlines of the composition in pencil, faithfully following the lines of the original *(top)*. It is important to do this accurately, especially when dealing with awkward shapes like the foreshortened hand *(above)*, to establish a correct basis for the painting. Erase lines which cut across areas of light color *(below)*.

Use mixtures of white, ivory black, yellow ochre and raw umber to model the folds in sheets and pillowcases. The earth colors provide a warm tone in the shades of gray. Study the original to observe the directions of the brushstrokes. Lay in basic shapes, but do not attempt to obtain a correct finish, as the forms can be reworked and adjusted later.

4 Working around the figures

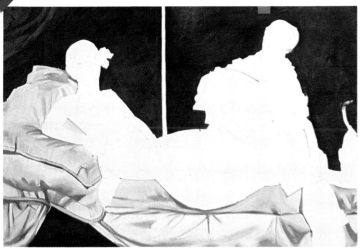

Mix a warm brown tone with cadmium red, yellow ochre, burnt sienna and black. Using a flat No 4 bristle brush block in the

remainder of the background, leaving the figures in silhouette. It will be easier to judge tones and colors in the figures

if the background area is laid in, as there is high contrast between light and dark areas in this painting.

5 Blocking in the figure

Use raw umber and black to paint in the hair and outline the facial features. Highlight the hair with burnt sienna.

With a flat No 2 bristle brush put in dark lines and shadow areas on the figure. Mix a light flesh tone from titanium white,

chrome yellow, yellow ochre and raw umber and work over the whole shape, blending the light and dark tones together.

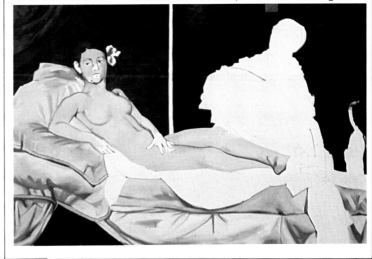

6 Developing the figures

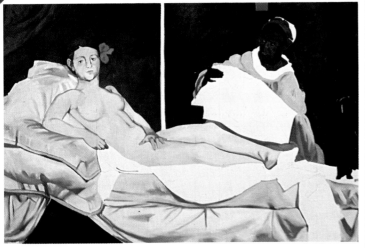

Continue to develop the figure using the same colors. With black and burnt sienna, start to work on the head and

hand of the second figure. Add a little white to make light tones, but do not allow the colors to appear chalky. Use dark

tones to lay in loosely the shape of the cat. With black, white and raw umber, model the folds of the servant's dress.

7 Laying in shadow areas

Mix a beige tone from raw umber, yellow ochre and titanium white. With a flat No 2 bristle brush, define shadow areas on the

bedcover. Draw the shapes carefully with the brush and block in each area of tone, always referring to the original as

a guide to the form and direction of each fold in the drapery. Note shadows around the flowers at the same time.

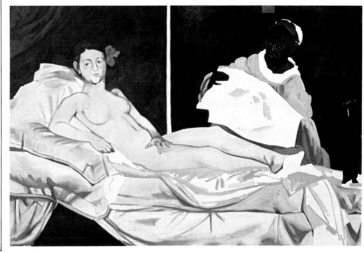

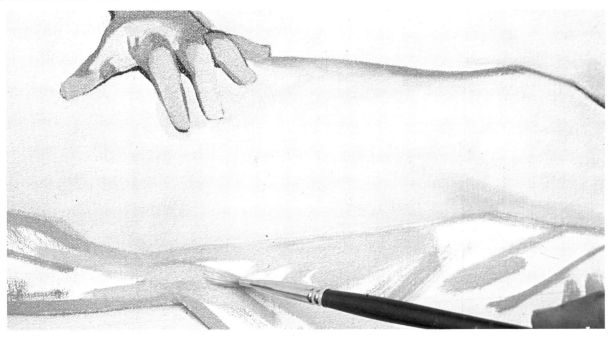

Accurate observation is the key to a successful copy, but the work will become boring if this is seen as an inhibiting factor. This detail of brushwork describing folds in the drapery (left) shows energy in the marks and a well judged use of tonal variations which enliven the image. Use the flat, tip and narrow edge of the brush bristles to 'draw' the folds.

8 Describing local color

Add white and a touch of yellow to lay in light areas on the bedcover and blend the tones lightly with the tip of the brush. Mix chrome yellow and yellow ochre to add color to the tassels and the shoes. Put in shadows on the flower wrappings with grays mixed from black, white and cobalt blue, and use sap green and black for the foliage.

9 Adjusting background tones

Having established the figures work over the background area again, to adjust the forms and colors. Vary the tones to show texture, using black and viridian for the hangings and burnt sienna and black in the central panel. With a No 2 bristle brush draw in linear detail on the couch below the figure, brushing in lighter tone with burnt sienna.

10 Adding detail in the figures

Where necessary make adjustments to facial features in both figures, using a round No 4 synthetic brush for delicate details. Mix black and titanium white and work in details of the servant's dress. Block in the flowers roughly, using a flat brush, with cadmium red, sap green, white and black. Adjust tonal balances where this is required.

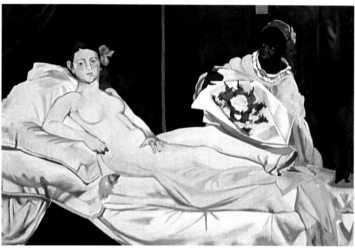

11 Brushing in pattern and color

Work with a round No 4 brush putting in small details such as the cat's eyes and patterning on the wall. A color suggesting gold can be mixed from chrome yellow, cadmium red, burnt sienna and white. Redefine the flower shapes with touches of pure red and sap green, white, black and mix these colors to form warm grays for shading.

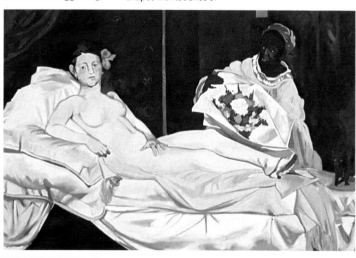

12 Drawing with the brush

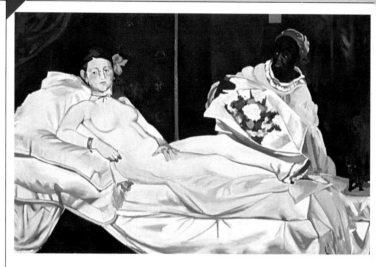

Linear details such as a fine ribbon choker (left) need a steady hand, and it may be advisable to support the brush hand with the other arm, or balance it on a mahl stick. This has a padded end and can be rested lightly on the edge of the canvas. A fine, round brush in synthetic fiber is suitable for this, as it is less harsh than bristle but will not spread out of shape as may happen with a soft sable. The choker is carefully drawn in with rich, ivory black and the small pendant in white, black and a little yellow ochre. The model's gold bracelet is finely painted in the same colors (above), with a larger content of yellow ochre and a broad highlight to suggest the shiny metal.

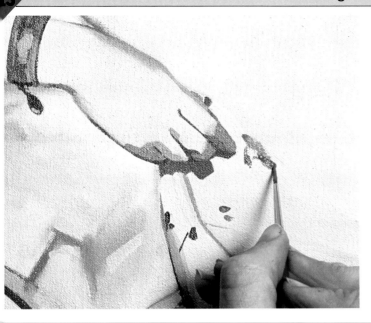

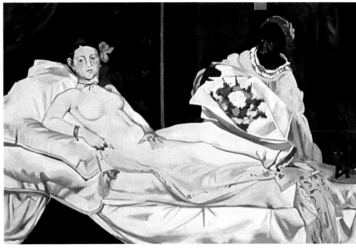

Use the No 4 synthetic brush to make fine marks in bright colors depicting the flower pattern on the bedcover. Work with cadmium red, sap green and white to echo the colors in the bunch of flowers. The impact of the painting comes from high tonal contrasts within a fairly limited range of color so check the tones and emphasize them where necessary.

The final version

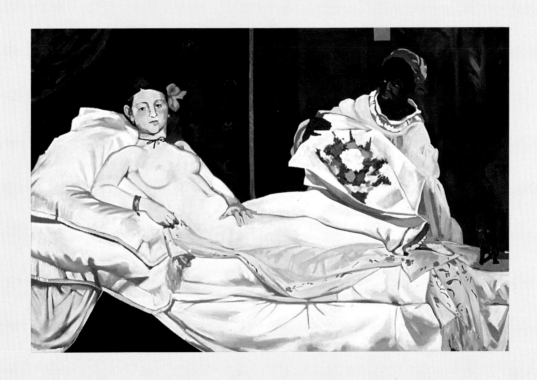

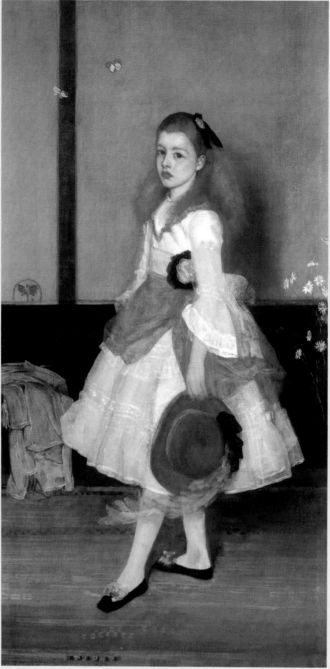

The Tate Gallery, London

Whistler

Harmony in Gray and Green, oil on canvas, 74¾ × 38½in (164 × 98cm)
Among several portraits of members of the Alexander family painted by
Whistler this was the only one to be finished. Perhaps the 70 sittings
required was too daunting for the models. Whistler's method had been
influenced by Impressionist techniques. He made repeated changes and
corrections. This portrait shows varying degrees of opacity in the paint, by
which means Whistler described changes of tone. These contribute to the
subtle color harmonies he valued so highly.

The Artist

**American artist
born 1834, died 1903
Painter and etcher who worked
mainly in Europe**

James Abbott McNeill Whistler was one of the main American artists of the nineteenth century. However, he spent most of his life living in both Paris and London. Born in Massachusetts, his career began inauspiciously when he was expelled from West Point military academy. He then learned etching as a cartographer with the American navy, also a short-lived enterprise. In 1855 he went to Paris where his artistic training included copying works by Old Masters. He became acquainted with the works of Velazquez (1599-1660) which he admired greatly. Other influences on his development included the work of the French Realist artist Gustave Courbet (1819-1877) and Japanese prints, popular in mid century. Whistler also met many Impressionists. In 1859 he moved to London where he eagerly promoted the new French painting which he had been so enthusiastic about in Paris. Whistler soon became established as an artist and engraver. Whistler's mature technique appears relatively spontaneous, but, in fact, he took great trouble over it. He planned both the color scheme and the design in advance. Rather than simply portraying the subject, Whistler aimed to compose harmonies of tone and color. He emphasized this by his habit of giving his paintings titles such as 'Symphony', 'Nocturne' and 'Caprice'. In the 1860s too he adopted the butterfly signature which was to become one of his hallmarks. Whistler had a reputation as a wit and dandy as well as an artist. Much of his work attracted controversy. The most famous encounter was in 1877 when the British writer and critic John Ruskin (1819-1900) publicly denounced Whistler's picture *Nocturne in Black and Gold: The Falling Rocket*, saying that the artist was an impudent coxcomb who had flung a 'pot of paint in the public's face'. Whistler won his rancorous legal tussle with Ruskin, but he was awarded only token damages, and the cost of the action left him bankrupt. Despite this, however, by 1884 Whistler's work had gained even wider recognition, and he painted many splendid portraits of well known society people. Whistler wrote critical essays and took part in public debates on art. One of Whistler's important achievements was to promote exhibitions of new work.

Materials

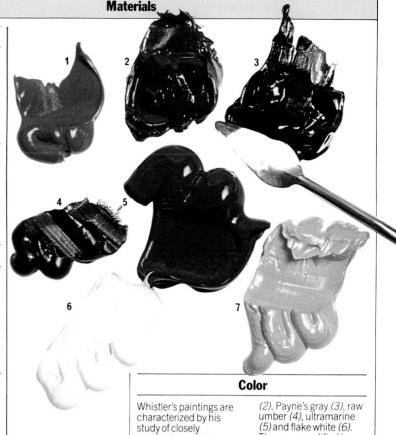

Support

Work to the proportions of your reproduction. In this case the painting is executed on artist's linen, stretched on a wooden frame measuring 36 × 20in (91 × 51cm).

Priming

Acrylic gesso primer covers the canvas quickly and efficiently. Apply two coats, allowing time to dry in between.

Mediums

Pure gum turpentine is used after the initial stages to give the paint fluidity. The tinted ground and underpainting can be done using white spirit to dilute the paint, but the quality is poor for glazing and suface detail.

Other equipment

Keep rags or tough paper towels to hand for wiping brushes and palette, or to lift excess paint.

Brushes

To lay in the tinted ground quickly use a 1in (2.5cm) decorator's brush. For further blocking in use a flat No 8 hog's hair and bring out details with a range of sable brushes, Nos 8, 6, 2, 0 and 00.

Color

Whistler's paintings are characterized by his study of closely harmonious colors. These may vary between light and dark, warm and cool tones. In this painting the cool blue and yellow grays are contrasted with warm browns. Basic oil colors needed are burnt sienna (2), Payne's gray (3), raw umber (4), ultramarine (5) and flake white (6). These are modified by the addition of cadmium red (1) and cadmium yellow (7). The variations of tone in the background are quite pronounced but the figure is subtly modeled and given touches of color.

1 Squaring up and drawing the outlines

Square up the reproduction and the canvas and draw the figure in outline. Use a 2B pencil, sharpened with a knife to a long point. Press lightly on the canvas and fill in areas of dark tone with pencil shading, rubbed into the surface with the fingertips. Note that in the original the forms such as the hand, are sometimes indistinct, while others are sharply defined.

2 Tinting the canvas

Mix Payne's gray, burnt sienna and a touch of raw umber with a large amount of white spirit. With a 1in (2.5cm) decorator's brush, paint a thin layer of color over the surface of the canvas. At first it may seem to obscure the drawing, but the tone will lighten considerably as the wash dries and is absorbed into the ground. Cover the canvas with loose, energetic strokes of the brush. It is not vital to obtain an even tone in the initial tinting and you can work quite freely.

4 Underpainting the colors

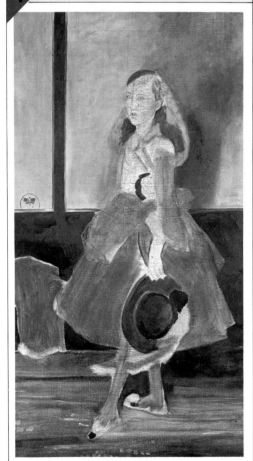

Put in light and dark tones to suggest the colors in the original. Make a light blue from white and ultramarine to cover the walls behind the figure, contrasted with a heavy dark color mixed from raw umber and ultramarine. Keep all the paint thin. Use raw umber and Payne's gray to block in shadow areas behind the figure and in the hair. Underpaint the dress with a thin wash of ultramarine and Payne's gray. Use the same mixture to build up the dark tone of the hat.

3 Putting in dark tones

Strengthen the drawing with washes of raw umber, applied with a No 8 sable brush. Put in broad areas indicating dark tones behind the figure and on the floor. Work on the hair with fluid brushstrokes, developing texture in the paint. The brushwork in Whistler's paintings is an important characteristic of his style and it is helpful to be aware of the direction of each mark from an early stage (above), even in the underpainting.

5 Painting the head

Model the face over the underpainting with white. Draw in the features with a No 6 sable brush in raw umber and red (left).

Work on the hair with a flat bristle brush, using raw umber for dark tones and burnt sienna and white for highlights (right).

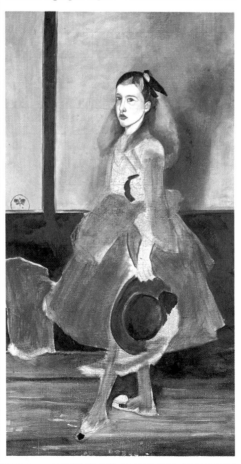

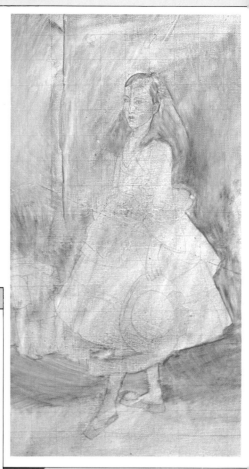

6 Working on the dress

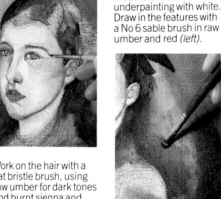

Block in light tones on the dress with white. Use a flat bristle brush and scrub the paint loosely across the surface, working up to the lightest tones gradually by thickening the paint (below). Allow the gray and umber underpainting to modify the white, so a broad range of middle tones can be established. Try to identify the weight and direction of brushstrokes in the original and imitate the texture of the paint.

Paint in detail of the lacy pattern on the dress with small dashes and dots of white, applied with a suitable size of sable brush *(below)*. Keep the paint thick and clean, mixing it with turpentine, so the marks stand out against the gray tones in the form of the dress. Block in the shape of the white stockings, again starting with a thin layer of paint and gradually building up to the areas of pure white. Handle the brush carefully to obtain the modeling of form.

Work on details, mixing dark tones from ultramarine and Payne's gray. Make a light yellow for the sash and feather with cadmium yellow and white and use burnt sienna for color detail.

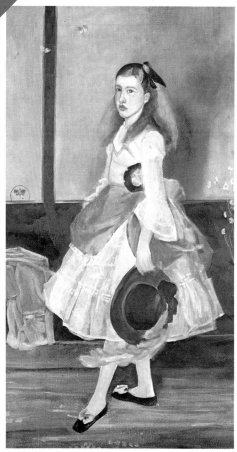

Develop shapes in the drapery to the left of the figure. Adjust the tonal balance where necessary, for example lightening the feather *(below)* with white and cadmium yellow.

Use the smallest sable brushes to draw in the flower pattern on the right, in white, cadmium yellow and raw umber *(below)*. Finally, lay a thin glaze of ultramarine and gray on the dark areas.

The final version

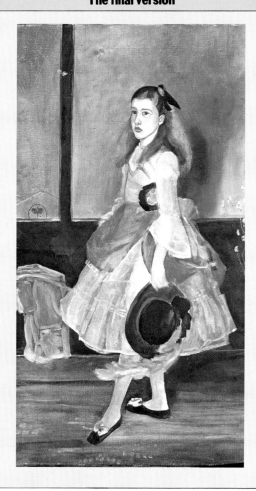

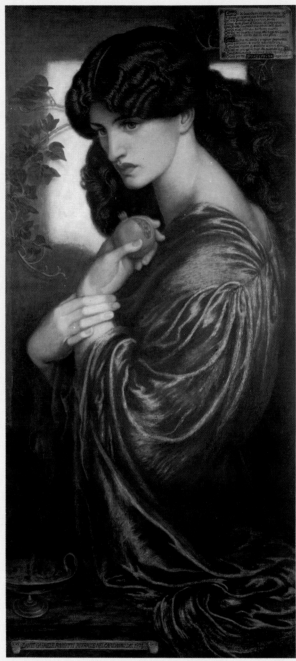

The Tate Gallery, London

Rossetti

Proserpine, oil on canvas, 49¼×24in (125×61cm)
The name chosen by the Pre-Raphaelite school of artists indicates their
desire to recapture the spirit and style of early Italian painting. Rossetti
pursued this aim less fanatically than some others and this portrait of Jane
Morris as Proserpine shows his use of harmonious color and subdued light
to create a mood. The legend of Proserpine's symbolic confinement in the
Underworld appealed to his poetic imagination.

The Artist

**British artist and poet
born 1828, died 1882
Pre-Raphaelite who painted many
portraits in classical settings**

In France one reaction to painting conventions led to Impressionism, while in Britain the work of the Pre-Raphaelite painters showed another type of reaction to very similar traditions. Like the Impressionists, the Pre-Raphaelites wanted to show 'truth to nature' in their works. This manifested itself in an attachment to history paintings which showed scenes from the Bible, legend and history, and in bright and even violent color schemes. The nucleus of the Pre-Raphaelite movement were the painters Dante Gabriel Rossetti, William Holman Hunt (1827-1910) and John Everett Millais (1829-1896). Hunt and Millais were British, while Rossetti's parents had emigrated to Britain from Italy. Rossetti received a conventional training in art at the Royal Academy Schools. He then began working with two painters whom he admired, William Holman Hunt and Ford Madox Brown (1821-1893). In 1848, the Pre-Raphaelite Brotherhood was formed. The name derived from the artists' desire to return to the style of painting which predominated before the Italian artist Raphael (1483-1520). In 1849, at the age of 21, Rossetti painted *The Girlhood of Mary Virgin* which he signed with the initials PRB, which stood for the brotherhood. This picture shows the bright colors and detailed observation which Hunt advised Rossetti would express truth to nature. Although Rossetti experienced many difficulties with techniques, the Pre-Raphaelites were in general conscientious and painstaking craftsmen. In 1851 Rossetti began a useful collaboration with the artist and craftsman William Morris (1834-1896) whose company created tapestries and stained glass from Rossetti's designs. Rossetti is particularly well known for his portraits of women which combine realistic and imaginary themes and show his fascination with fantasy and romance. His main model was Elizabeth Siddal whom he was to marry. After her death in 1862, Jane Morris, the wife of William Morris, modeled for many works. Rossetti's portrayal of *Proserpine* is a sensitive updating of the classic figure and typical of the subjects preferred by the Pre-Raphaelites in its ornate treatment, rich evocation of colors and concentration on conveying luxuriant textures.

Materials

Color

Rossetti worked with a fairly extensive palette of oil paints. Sap green *(2)*, ivory black *(1)*, raw umber *(7)*, cobalt blue *(6)* and titanium white *(9)* are all needed to make up the basic color of the background. Experiment with color combinations before beginning to paint. The background should eventually be blocked in with a mixture of cobalt blue, white and cerulean blue *(3)*. The most important color in the hair is burnt sienna *(8)*. Cadmium red *(5)* should be used for painting in the mouth and creating the flesh color. This should be mixed mainly from titanium white with a little chrome yellow *(4)* and yellow ochre *(10)*. Occasionally a touch of cobalt blue should be mixed with the flesh color to cool down the tones. To keep all the colors as bright as possible and to prevent them from muddying, always ensure that your brushes are clean when you begin to paint with a new color.

Brushes

Whatever brushes you choose to work with is always a matter of preference. Illustrated here are *(from left to right)* a No 4 hog's hair flat and Nos 4, 2 and 1 sable round brushes. Other brushes that you will find useful at various stages of the painting include Nos 4 and 2 synthetic flats which have slightly more flexible bristles than hog's hair brushes. A No 1 synthetic round is necessary for painting in around the ivy leaves. Use a No 2 flat hog's hair brush to fill in the color on the golden bowl.

Support

Proserpine was painted on linen but hardboard is a cheap alternative. If the reproduction is large, use a board the same size and transfer the image with carbon paper. If the picture is small, use a larger board and square up the image.

Other equipment

Sheets of tracing paper, carbon paper and pencils are needed for the method used in transferring the image to the support. Keep a pencil sharpener or scalpel handy while you are tracing the image so that your pencils are always sharp. It is best to use a soft pencil to draw the initial outlines on the tracing paper. However, a hard pencil is more useful when it comes to tracing off the image onto the support. You will also need rags on which to wipe your brushes.

Priming

Hardboard should always be primed when it is used as a support. If this is not done the oil paint will soak through and all the color will be lost. Sandpaper the board before priming it. Then brush away any loose dust. Prime the board with diluted acrylic emulsion glaze using a large decorator's brush to cover the surface quickly. Allow the first coat to dry and then apply a second. This should be all that is required. Although the glaze will look white while it is wet, it dries to give a transparent finish. This means that none of the colors you paint will be distorted when you put them on the support. If you decide to use a linen support like Rossetti the surface will still need to be primed.

Using carbon paper and a tracing is an easy way of transferring the picture from the reproduction to the support. It is very useful if the picture is detailed or if your reproduction is large enough. Place a sheet of tracing paper over the reproduction and trace off as much detail as possible with a B pencil. Attach the tracing to the support *(left)*. Place a sheet of carbon paper between the two, and trace off the picture with an H pencil *(above)*. Continue until the outline is complete *(top)*.

Mix together ivory black, sap green, cobalt blue, raw umber and titanium white to create a fairly dark, greenish-blue color. Block in the dark part of the background using a No 1 synthetic round brush. Paint around the outlines carefully. Pay particular attention to the trailing ivy. The outlines should be fairly sharply defined, to make filling in later on simpler. Keep the outline of the body as neat as possible. Paint with decisive, sweeping brushstrokes to achieve an even line around the shape of the body. Work with short brushstrokes, and overlap them so that the paint builds up quite thickly.

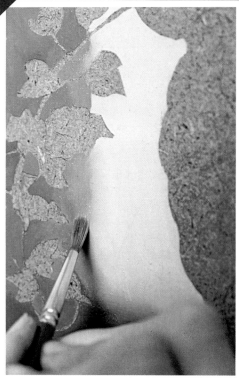

Fill in the light blue part of the background with a combination of white, cobalt blue and cerulean blue. Block in the whole area. Then work with a dry synthetic brush to blend the new paint in with the darker color *(above)*. Draw the lighter paint into the dark. Continue until a soft effect is achieved *(below)*.

4	**Painting the hair**	**5**	**Defining the features**

Defining the features

Once the hair has been put in, the next stage is to paint the face and the neck. Create a flesh color from titanium white, chrome yellow, yellow ochre, cobalt blue and cadmium red. Only a touch of the blue and red are needed, but they provide valuable tonal variation. Use quite a large brush, such as a No 4 flat hog's hair. Block in the whole of the flesh area first. More than one coat is needed to build up the form. Work with small brushstrokes, making sure that none are visible and that an even color is laid down. The paint should be darker on the forehead where the hair casts a shadow.

6 **Filling in the hands**

To paint in the hands, mix up the flesh color using titanium white, chrome yellow, yellow ochre and a hint of cadmium red. Block in the whole area to be painted with the one color. Then define the fingers with a very delicate line of raw umber. Shade in the fleshy part at the base of the thumb with a little cobalt blue. Add the highlights to the fingers on the left hand using white. Try to keep the outline between the hands, the background and the pomegranate as neat as possible.

7 **Initial blocking in on the dress**

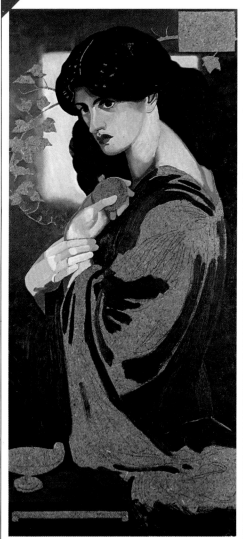

Block in the hair with raw umber, burnt sienna and ivory black. Experiment with different amounts of burnt sienna and raw umber on your palette before beginning to paint. It is essential that the color should be matched as closely as possible before any blocking in is undertaken. First, paint in the darkest areas with a No 4 flat hog's hair brush. Lay fairly broad strokes next to each other to build up the modeling. Use a fine brush to blend the hair on the right into the background. To keep the brush as fine as possible, use a rag to wipe off any surplus paint as it collects. Add the initial highlights to the hair with yellow ochre with a No 1 synthetic round. Use short, quick brushstrokes and blend them into the darker paint. Put in a very thin line where the hair parts.

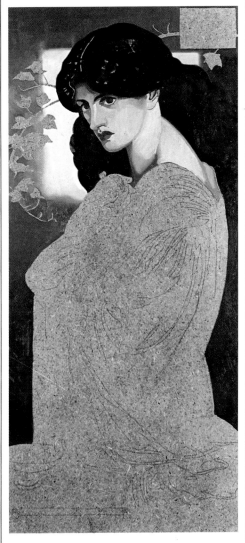

Initial highlights on the hair
Hair merging with the background
Colors blended to give a soft effect
Background blocked in evenly to give an area of flat color
Good pencil outlines visible on the support

Paint in the eyebrows and the eyes with cobalt blue and black. Put a tiny dab of cadmium red in the corner of the right eye. Draw in the lower lid with titanium white and block in the whites of the eyes. Use pure cadmium red for the lips, with a little black added for the line in the middle of the mouth. Finally, bring out the highlights on the face with white and a small amount of chrome yellow *(above)*.

Roughly block in the major forms of the dress. Use cobalt blue, black, and a little bit of chrome yellow and white. Follow the lines of the folds and fill in the left sleeve completely. Work with broad sweeps of the brush. A No 4 flat hog's hair is most suitable. Take great care when painting in the area next to the hand to make sure that the line is even and not smudged. Next, extend the background on the left down behind the gold dish and the scroll. Work with the same color mixture as before.

8 Modeling the face and dress

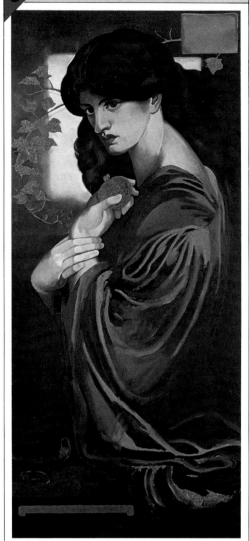

Rework the ivory color of the flesh with white, chrome yellow and a little cobalt blue. Pick up the paint with a dry brush, wipe off any surplus with a rag and then apply it to the flesh areas. Use the paint sparingly, so that it blends in well with the color already blocked in. Also fill in the remaining unpainted areas of the dress. Work with cobalt blue, black and some titanium white. Paint quite liberally with a flowing movement. A large brush is needed so work up the modeling with a No 4 synthetic brush. Any brushstrokes that show can be blended in at a later stage. Change to a No 2 flat hog's hair brush to block in the first layer of paint on the golden bowl. Use raw umber and yellow ochre for the basic color. Then fill in the background color of the paper in the top right corner and the scroll in the bottom left. Look at the original to see what colors are required. Mix together titanium white, ivory black, raw umber, cobalt blue and chrome yellow. The paper should have a fairly blue tone while the scroll should be more yellow. Use a No 2 synthetic flat brush.

9 Painting the ivy

Work with a No 2 brush with synthetic bristles to fill in the ivy on the left of the painting. Create a mixture similar to the color used for the background, but make it slightly darker. Use sap green, ivory black, cobalt blue, raw umber and a few dabs of titanium white. Block in the leaves quite thickly, taking care not to overlap the paint onto the background.

When the leaves are finished, suggest the shadows they throw behind them with a paler version of the same color. Complete the ivy by drawing in the stalks. Use yellow ochre and sap green.

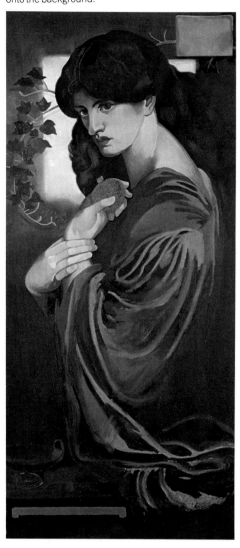

10 Finishing the hair

Add further definition to the highlights on the hair. Use a palette of burnt sienna, raw umber, yellow ochre and titanium white. Apply the paint with a No 4 hog's hair brush. Splay the bristles between your thumb and forefinger. This makes the bristles separate and gives a feathery effect rather than a solid block of color. Use brisk, short strokes for the highlights on top of the head. Paint longer brushstrokes on the hair flowing down the figure's back. Add a few highlights to the hair to the left of the face as well.

11 Painting the pomegranate

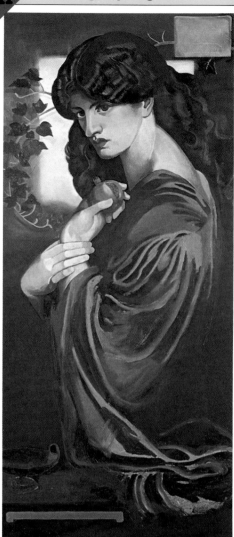

To paint in the main color of the pomegranate, mix a flesh tint from cadmium red, chrome yellow, raw umber and cobalt blue. Block in the color with a No 2 synthetic flat brush. Paint in the fleshy part of the fruit with a mixture of pure cadmium red and chrome yellow. Add the pips with tiny dots of a more orange combination of the two colors. Do this by putting chrome yellow down on top of the reddish area. To give the fruit more shape, add some highlights. Paint a thin line of chrome yellow and white around the edge of the fleshy part (above). Use the same color to build up the pale area to the left of the red part. Lay one brushstroke on top of another to build up the form.

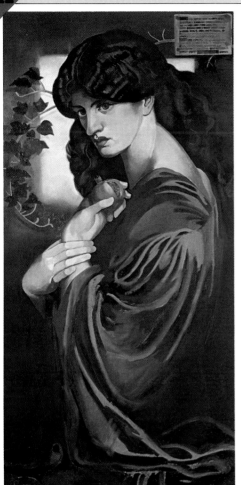

Use a No 2 synthetic brush to paint in the lettering on the paper and the signature on the scroll. Work with fairly liquid paint consisting of ivory black and titanium white. As there are only a few words on the scroll, these can be painted in fairly quickly. However, there is so much writing on the paper in the top right-hand corner that it is better to suggest the writing rather than copy it word for word. Use a thin line for each letter in the signature but vary the thicknesses for the lines on the paper. Paint a combination of light and darker tones on this as well.

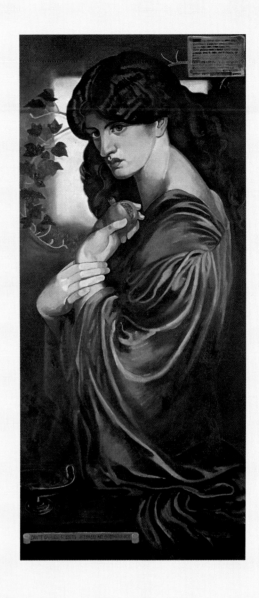

To complete the painting, first rework the shadows on the dress with ivory black and cobalt blue to make them darker. Then use a No 4 synthetic flat brush to add highlights to the folds on the dress *(above right)*. Work with a pale mixture of cobalt blue and titanium white. Paint on the highlights quite thickly and try to eliminate any marks left by the brush. An efficient way of blending the paint to achieve a soft, blurred effect is to smudge it with one or two fingers. Finally, add the golden highlights to the bowl. Use a very thin brush, such as a No 1 synthetic round. Paint a narrow line to outline the inside of the handle, extending it onto the front lip. Then paint in the stem and the highlights on the tiered base. Suggest a thin trail of smoke rising from the bowl. Use the same No 1 round and a gray made from cobalt blue, ivory black and white.

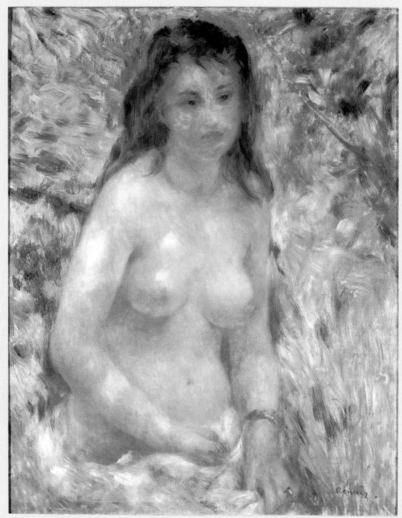

The Louvre, Paris © S.P.A.D.E.M.

Renoir

Woman's Torso in Sunlight, oil on canvas, 32 × 25½in (81 × 65cm)
Renoir's early training in painting on china led him to appreciate the value
of a rational technique. Although he adopted the light Impressionist
palette, he remained interested in modeling volume. The dappled sunlight
falling on the half-shaded figure is described in delicate contrasts of warm
and cool colors, lightly overpainted to produce pearly tones. This
traditional system was subtly adapted by Renoir to include the colorful
shadows favored by the Impressionists.

The Artist

French artist
born 1841, died 1919
Leading Impressionist, painter of
portraits and social scenes

Renoir was born in Limoges, but his family moved to Paris shortly after his birth. His father was a tailor. At the age of 13 Renoir entered a china workshop where he was employed in painting designs on porcelain. Since his family needed his wages, he hesitated for some years before committing himself to the full-time study of painting. He was 21 when he joined the studio of Marc Gleyre (1806-1874), where a group of students including Monet (1840-1926), Sisley (1839-1899) and Cézanne (1839-1906) were working. They were all pioneers of modern painting. Renoir and Monet, aiming at complete fidelity to the natural effects of light in painting, founded the Impressionist movement. In order to achieve their aim, the Impressionists painted in the open air. This was a reversal of the traditional procedure whereby artists could sketch in the open air, but paintings had to be done in the studio. Renoir had some early success with portraits and exhibited at the Paris Salon; but for the most part he lived hand-to-mouth, like his companions. In the 1860s, resistance to new ideas in painting was strong. While working with Monet, often in the open air, he began a series of paintings in which touches of unmixed color rendered the momentary impression of light reflected from surfaces. However, these paintings evoked hostile reactions when they were exhibited. Renoir continued to use the palette which had become associated with the Impressionists. It was restricted to pure tones at maximum intensity and eliminated black. But Renoir went on to paint pictures more carefully composed than the earlier informal studies from nature. His work after 1906, when he settled in the south of France, was principally of nudes, in which he combined Impressionist theory with a more classical treatment of figures. *Woman's Torso in Sunlight* (1875), for example, is a classical nude composition with an unusually luminous and brilliant use of color, which he achieved using translucent paint brushed thinly over a pale ground. The broken brushstrokes of the contrasting background give the bright impression of sunlight. This is typical of the style the artist developed later in life. Renoir was a skilled craftsman and one of the most important Impressionists.

Materials

Brushes

The brushes you paint with will depend largely on what you prefer to use. Recommended brushes include a No 14 hog's hair flat for laying in the initial wash; Nos 8 and 5 flat bristle brushes; a badger hair fan brush for blending tones and a No 1 sable brush for painting in the details. Clean your brushes with white spirit after use.

Support

Stretch a piece of fine artist's linen canvas over a frame. Make the support the same size as the original painting.

Color

The original was painted in oils so work in the same medium. As Renoir was going through a phase of not using black in his palette when he worked on *Woman's Torso in Sunlight*, create all the darks with other colors. The most prominent colors in the picture are varying shades of green, yellow and blue in the background. These are mixed from emerald green *(1)*, Naples yellow *(2)*, cobalt blue *(4)*, viridian *(5)*, chrome yellow *(7)*, flake white *(8)* and ultramarine *(9)*. Cadmium red *(3)* and alizarin crimson *(6)* provide the warm tones in the flesh color. Light red will also be useful.

Priming

Prime the support with four coats of acrylic gesso. Allow each coat to dry before applying the next. Work with a large brush and put on the primer evenly.

Mediums

For the initial stages use pure turpentine for the medium. Then use equal parts of turpentine and linseed oil.

1 Tinting the ground and drawing the outline

Mix a thin wash of pink using flake white and light red well diluted with turpentine. Brush it over the whole surface with a No 14 hog's hair flat. Draw a grid on the reproduction with a pencil and scale it up in proportion on the canvas with a fine sable brush and light red paint *(above)*. Copy the outline of the figure and indicate the shape of patches of light tone on the skin. Draw the shapes in the background roughly to establish the basic lines of the composition.

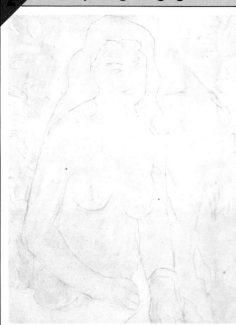

Study the original carefully to identify the lightest tones in both background and figure. There are obvious highlights on the flesh where the dappled light falls on the figure. Block in the drapery with a solid area of flake white and put in smaller patches of white where appropriate *(above)*. This constitutes a basic underpainting of light tones over which the colors are modeled to show the form.

Put in a rough imitation of the background colors. Use mixtures of viridian, chrome yellow, flake white and ultramarine to create a range of greens, varying from those with a heavy blue cast to lighter yellow-greens. Work loosely, keeping the paint wet by thinning it well with turpentine *(above)*. The colors should be transparent to allow the ground to show through. Use the No 5 bristle brush to cover the area quickly.

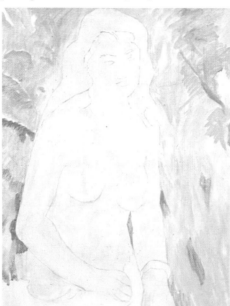

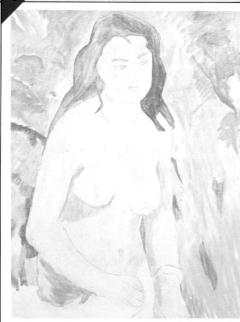

Block in underpainting on the body to show the dark tones. For the flesh, use Naples yellow mixed with a little alizarin crimson and white, brushed in with a No 5 flat bristle brush. Use a flat No 8 hog's hair bristle brush to put in the hair *(below)*. Mix a little viridian with the crimson and yellow to create a brown tone. Thin the paint and lay in a light wash down the left-hand side, a darker tone on the right.

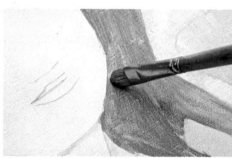

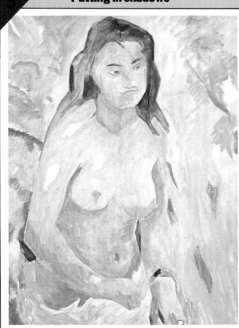

Develop the flesh tones using two basic colors. Mix a cool tone from cadmium red, Naples yellow, white and cobalt blue. Make a darker tone with the same colors and cover the whole area of the figure. Show the shadows on face and neck with the dark tone, blending the paint well.

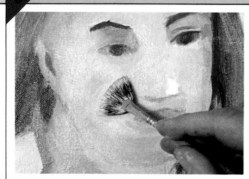

Put in more detail on the face and hair. Use the same colors as in the previous step to create the flesh tones but add some variety to the light, dark and middle shades, modeling the shape of the face and roughly describing the features. Blend the tones together with a badger hair fan brush *(above)*. To make the dark color for the hair, mix cobalt blue, alizarin crimson and viridian. Highlight with midtoned and lighter orange and brown, mixed from chrome yellow, cadmium red and flake white. Use bristle brushes to lay in basic colors and a No 1 sable for details.

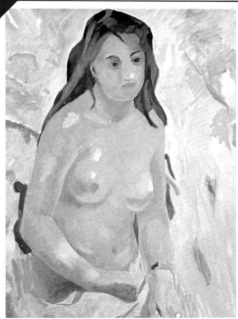

Start to build up the impression of solidity in the figure, blocking in light and dark tones. Add turpentine and linseed oil to the paint to give it a thicker texture and cover the surface more generously. Preserve and emphasize the highlights, noting the contrast of flesh tones.

8 Heightening tonal contrast

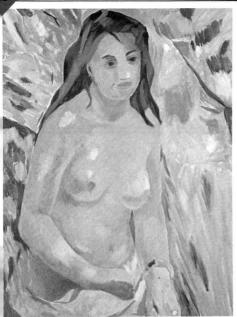

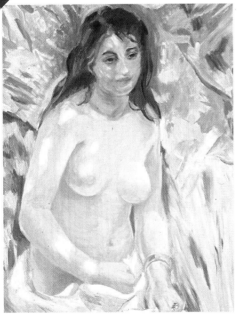

Rework the colors in figure and background, building up light tones and more definite shapes. Put in a light pink glaze on the figure, mixing cadmium red and white with linseed oil and turpentine. Work quickly and vigorously on the background, breaking down the areas of color with heavy brushmarks. Add emerald green to the underpainting colors.

9 Applying glazes

Heighten the colors with thin glazes, mixing plenty of oil with the paint to give transparency. To make the tones more vivid, glaze with a mixture of Naples yellow and crimson in the face and body. Add cobalt blue to darken the shadows. Develop the structure of the face with heavy white highlights on the nose, forehead and chin. Vary the brush size used.

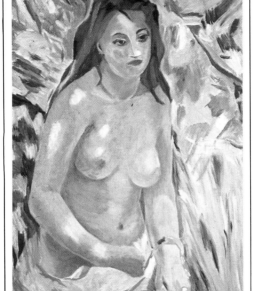

10 Painting the details

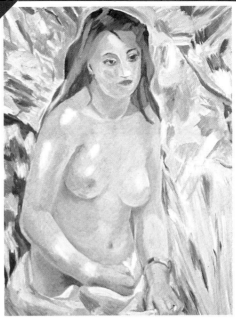

Work on details of the bracelet, drapery and ring. Use Naples yellow, chrome yellow, cadmium red and white to imitate the gold bracelet (right). Apply the paint with small sable brushes. Put in shadows on the drapery with a dark tone made from viridian and alizarin crimson, with a touch of white added. Show the curving folds with heavy strokes of pure white.

11 Reworking the colors

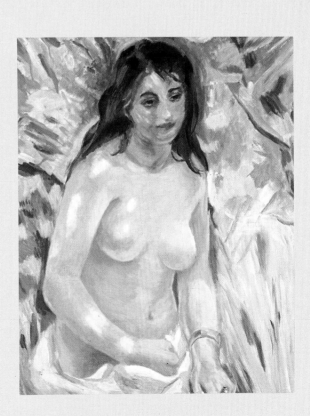

Lighten the tones in the whole image and rework the background to emphasize the green of the foliage. Use a No 5 bristle brush to glaze over the area on the right-hand side of the painting with light and mid toned greens. Thicken the paint and add texture to the brushwork. The main task at this stage is to capture the luminosity seen in the original, so light tones and yellow tints can be exaggerated slightly to show the effect of light. Adjust the shapes in face and hair, using small sable brushes to draw in detail with dark tones. Lay in highlights with a bristle brush and blend the colors. Put a thin layer of light pink over the flesh tones, except where there is heavy shadow.

The final version

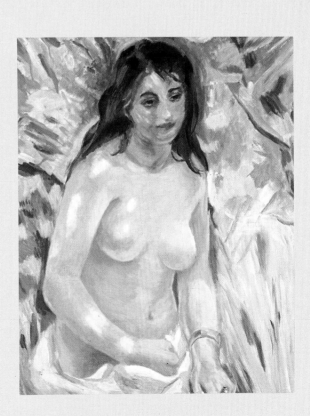

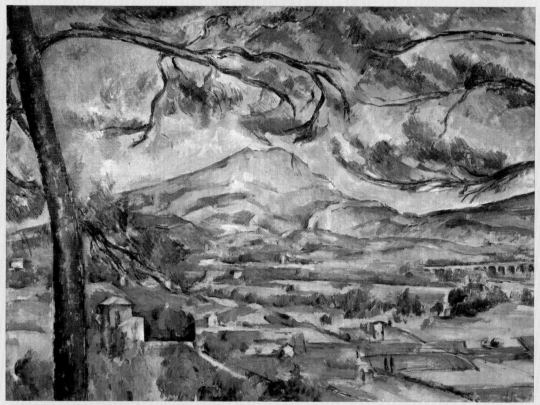

Cézanne

Mont Sainte-Victoire, oil on canvas, 26 × 35⅜in (66 × 91cm)
In all the many studies Cézanne made of the Mont Ste-Victoire, the form of
the mountain dominates, uniting the expanses of land and sky. While
Cézanne adopted the principles of Impressionism, he also wished to retain
the classical design of the Old Masters. He converted the fleeting effects of
light and distance into orderly compositions, almost architectural in
structure. Cézanne's technique was regulated by his insistence on visual
truth and the validity of his means of representing nature.

The Artist

**French artist
born 1839, died 1906
Important Impressionist painter of
landscapes and still lifes**

Cézanne was among the most important French painters of the late nineteenth century. There are few artists whose work has been so influential. As a result of his analysis of color and form, he brought about a revolution in painting. Cézanne was born at Aix-en-Provence in southern France. At his father's wish he began to study law, but soon abandoned this in favor of painting. In the early 1860s he went to Paris where he lived until 1870. He met other young painters, including Camille Pissarro (1830-1903), who introduced him to open air painting. Cézanne took part in the first Impressionist exhibition in 1874. The group, whose aim was to show the true 'impression' as seen by the eye, was ridiculed by critics and public. Cézanne, however, was interested in more than the immediate impression of nature. He had studied the Old Masters and wished to unite what he had learned from Impressionism with earlier traditions. In order to do this, he developed an unusual method entailing prolonged study of his subject. This was chiefly possible in the case of landscape and still life painting where objects did not move. Cézanne's many landscape paintings of his native Provençal scenery show his love of the country, and, unlike those painters who used a single color to describe an area of sky or foliage, Cézanne varied the color and tone everywhere. For example, in his watercolors, the white paper was often left uncovered between strokes of color, heightening the effect of contrasting hues. Similarly, in his oil paintings, Cézanne tended to use pale grounds which acted as the lights. This practice meant the artist did not have to overload the surface with paint. Cézanne worked in a slow, methodical way, and would often spend years on one work, leaving it and returning later to make adjustments. The way in which he worked tended to isolate him from human society, and Cézanne mainly lived a solitary life in Provence. He devoted himself to work, and only late in life did he begin to achieve recognition. Cézanne distrusted theory and wrote little on art, always urging that artists should learn by observing nature. A retrospective exhibition in 1907, a year after his death, finally established his artistic reputation.

Materials

Color

The perspective is created with bright oil paints in the foreground and using more muted tones in the background. The initial outlines are painted in with cadmium red (11) and Prussian blue (5). The pale sky coloring is made from ultramarine (10), cobalt blue (2), flake white (12) and some Naples yellow (7) and crimson (6). Yellow ochre (3) and raw umber (9) are needed for the foreground. The green tones are built up with emerald green (4) and viridian (8). Cadmium yellow (1), burnt sienna and light red should also be on your palette.

Priming

Prime the canvas with two thin coats of acrylic gesso unless you have bought one of the ready-primed canvases that are available. Cézanne used to paint directly on the canvas or else used a white, untinted ground.

Mediums

Linseed oil and turpentine should be used as the medium for this oil painting. Work with a combination of the two, using much more turpentine than oil. This makes it possible to paint in thin, transparent, glazes.

Support

Choose fine cotton duck as the support and stretch it. You can use any size but keep the image in proportion. The version here measures 18 × 23¾in (46 × 60.5cm) which is smaller than the original.

Brushes

Cézanne seems only to have painted with small size sable brushes, so do the same to capture the essence of the original. Suitable round sable brushes are (from top to bottom) Nos 3, 2, 1 and 0. You will need a large flat synthetic or hog's hair brush to apply the primer. Wash the brushes with white spirit.

Squaring up and drawing the outlines

Transfer the main lines of the composition to the canvas by squaring up the reproduction in pencil and copying the grid in proportion onto the support with charcoal. Use broad rectangles to divide the picture plane and put in the diagonals. Sketch out the shape of the tree and mountain in charcoal, drawing lightly so the lines will not be difficult to cover when you start painting. Note the balance of vertical and horizontal emphasis in the composition. Mix mauve from cadmium red and Prussian blue, well diluted with turpentine, and reinforce the outlines loosely, working with a No 2 sable brush.

2 Putting in foreground

Start by putting in touches of the most vivid colors in the painting. As the tone of a color becomes less distinct with distance, the brighter hues are those which would be nearest to the artist's eye in reality.

Continue to use the No 2 sable brush. The color is built up gradually with small brushmarks. Use emerald green for tree foliage and grass in the foreground, and burnt sienna in the wood of the tree.

3 Laying in light tones

By contrast, establish a light tone in the sky and across the horizon line. Mix a light gray, tinged with blue and pink, from ultramarine, cobalt blue, flake white and a small amount of crimson and Naples yellow. Look closely at the original to identify areas of this color and brush them in vigorously with a No 3 sable. Apply the paint sparingly and as accurately as possible, as the tones will later be lost if the paint is too thick.

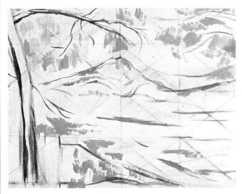

4 Developing the foreground

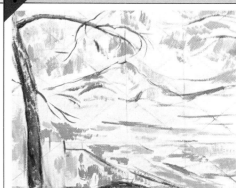

Work into the foreground of the painting with Naples yellow, flake white, yellow ochre and raw umber. Put in the light yellow tones of the landscape, adding a little red to the color in the middle ground. Brush in dark areas on the tree trunk and branches with raw umber and describe the patch of earth at the bottom edge of the canvas with the same color. Use burnt sienna and white to pick out the lighter tones.

5 Adding tonal depth

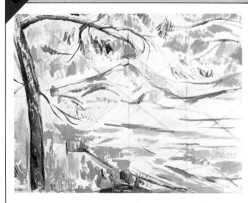

Create a light and dark tone of green by mixing emerald green first with white and yellow ochre, then with a little raw umber and ultramarine. Develop the foreground area with short, vertical strokes of the No 3 sable brush. With the same colors put in light marks indicating foliage on the tree branch across the top of the canvas. Use plenty of turpentine at every stage, so the paint is fairly thin and fluid, and easy to apply.

6 Establishing form and distance

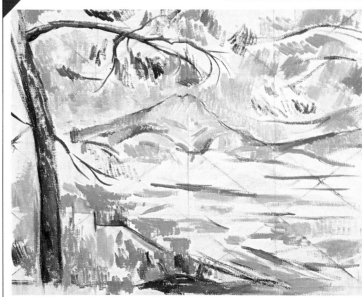

Mixing light mauve and pink tones from the same colors used earlier for the sky, model the shape of the mountain and fill a broader area of sky. Work loosely over the previous marks, building up the form with a series of brushstrokes following the main direction of the planes and angles in the original. Contrast the heavy purple and pink shadows with lighter tones tending to yellow on the crest of the mountain and in the sky to the right.

7 Reworking the colors

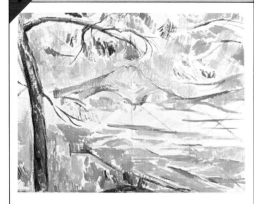

Modify tones in the middle distance and foreground, working with a No 2 sable brush. Mix mid toned greens from viridian, emerald green, cobalt blue, white and ultramarine and brush them in. Then rework the light yellow areas, with white, Naples yellow, light red and yellow ochre.

8 Covering the middle ground

Continue to cover the remaining areas of bare canvas, imitating the tones and colors of the original. Gradually emphasize the form of the mountain and brush in light green-grays where the horizontal plane receding from the foreground meets the foot of the mountain. Draw further detail of the tree branch, in dark green mixed from raw umber, emerald green and Prussian blue. Drag the No 2 sable brush lightly over the surface to copy the feathery texture of the foliage. Having now established a basic range of tones over the whole canvas, rework in each area where necessary.

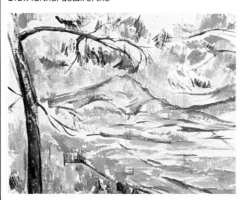

9 Modifying the tones

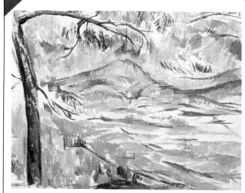

Work broadly across the top of the canvas, putting in the tree foliage more heavily with dark and mid tone greens, adding a little yellow ochre in places to link the color with the foreground tones. Modify colors in the distance, laying a light mauve and raw umber mixed with white over the mountain.

110

10 Blending the colors	**11** Making corrections	**12** Reworking the tree

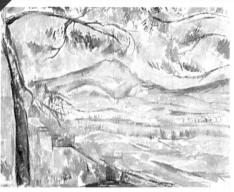

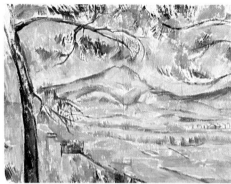

Stand back from the work and check it against the original. Make sure that you have correctly achieved the layout of the composition as a whole

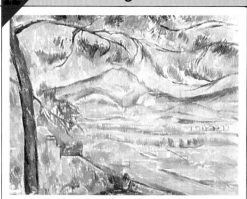

Soften the colors in the whole painting. Mix the paint with turpentine and linseed oil and blend the tones together, blurring hard lines between the various patches of color. Mix raw umber, ultramarine and a little white, and brush in the line of trees in the middle distance.

and that the impression of distance emerges from the color relationships. Make minor alterations with a No 2 brush, using the appropriate colors.

Develop the form of the tree, so that it provides a strong vertical focal point in the foreground. Use raw umber, burnt sienna and white to round out the shape of the trunk and put in the foliage more heavily with green, emphasizing dark areas with Prussian blue and lights with Naples yellow.

Thicken the paint with linseed oil and put in details, such as the small, isolated buildings. Note the thicker paint is given transparency by the oil.

Define the structure of the bridge more clearly putting in shadows with a mixture of raw umber and

Prussian blue, solid light tone with yellow ochre and white. Imitate the loose brushwork.

Heighten color contrasts in the foliage, applying the paint in heavy strokes to show the texture of the brushmark. Tiny bare patches of canvas should still break through.

The final version

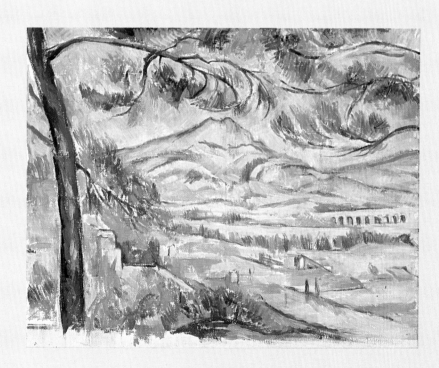

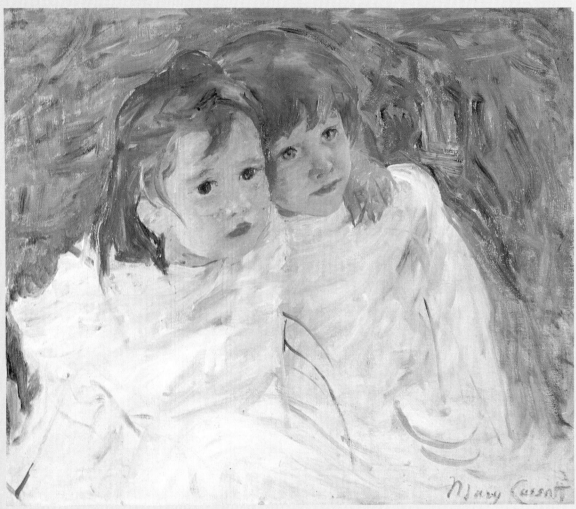

Glasgow City Art Gallery © A.D.A.G.P. (photo — Bridgeman Art Library)

Cassatt

The Sisters, oil on canvas, 18¾ × 21¾in (46.3 × 55.5cm)
This painting is unfinished, though signed by Cassatt, and it shows her free
style of painting, based on Impressionist principles. The local color is built
up in broad strokes of thinned paint, sometimes with colors mixed in
advance on the palette but also with hues blended together when in place
on the canvas. Through her close friendship with Degas and study of the
Old Masters, she developed a preference for structured compositions. This
unfinished work retains the freshness and charm of the subject.

The Artist

American artist
born 1844, died 1926
Major American Impressionist,
leading female artist

Mary Cassatt is widely regarded as the best American Impressionist artist. However, even today her work is less familiar than that of many of her colleagues. She was born in Pennsylvania into a well-to-do family. Her parents, particularly her mother, were well read and fond of travel. The family lived in France for several years from 1851. At an early age, she decided to follow a career in art, but she encountered opposition from her family, especially her father. This was because, at that time, it was not considered suitable for women of her social class to have careers. She studied at the Pennsylvania Academy of Fine Arts in Philadelphia for four years, and then moved to Europe where she found it easier to be accepted as a serious artist. She lived mainly in France, but also traveled widely particularly in Italy and Spain. She studied and copied works by Old Masters. Cassatt settled in Paris in 1873. From 1872, she entered work for the Salon and her works soon attracted the attention of Edgar Degas (1834-1917). Cassatt probably had more in common with Degas than most of the other Impressionists because she, like him, studied and admired the works of the Old Masters, placing great emphasis on disciplined work using models and on a deliberate and calculated approach to design, line and color. Degas invited her to take part in the Impressionist exhibition of 1879. Her paintings, besides the popular Impressionist themes of the theater and social life, increasingly featured mothers, children and domestic scenes. This choice of subject matter was at least partly determined by social convention which dictated that women were not even allowed to be in a room alone with a man unless he was a relative. So, whereas most of her fellow Impressionists could work with models, both clothed and nude, Mary Cassatt had to turn to female models and domestic scenes. She often used relatives and their children. Cassatt achieved a unique position in France, both as an American and as a woman. She did much to promote awareness of Impressionist works in America and their sale to many museums and patrons. She actively supported the struggle for women's suffrage in the United States.

Materials

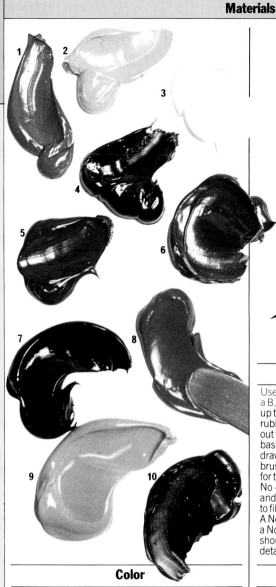

Equipment

Use a soft pencil, such as a B, and a ruler to square up the painting. A putty rubber is needed to rub out the grid lines once the basic outlines have been drawn in. Not many brushes are necessary for this picture. Use a No 4 flat hog's hair bristle and a No 4 synthetic flat to fill in the large forms. A No 2 flat hog's hair and a No 6 sable round should be used for details.

Color

A good selection of oil paints is needed for this composition. To block in the first stages of the background use yellow ochre (9), cerulean blue (1), titanium white (3) and ivory black (7). The main hair coloring is supplied by a mixture of burnt sienna (6) and yellow ochre. Thin glazes of gray made from black and cobalt blue (5) are required for the clothing. The flesh tones should be mixed from cadmium red (8), burnt sienna, yellow ochre, white and raw umber (10). The final background should be given more depth with sap green (4), chrome yellow (2) and white.

Priming

Tack a sheet of cotton duck canvas measuring 16 × 20in (40.5 × 51) over a wooden frame to stretch it. Prime the surface with two coats of a mixture of white emulsion glaze and emulsion paint. Let the first coat dry before applying the second.

Squaring up the image and drawing the outline

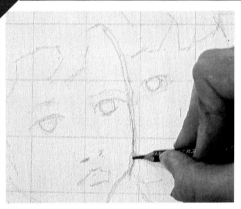

Draw a light pencil grid on the original picture, making small squares in relation to the size, so you can be accurate in drawing. Transfer the grid, in proportion, to the canvas and draw in the basic outlines of the figures with a B pencil. Do not press too firmly or you will mark the surface of the canvas irrevocably. Gently erase the grid lines with a putty rubber.

2 Putting in the background

Block in background color using yellow ochre, cerulean blue, white and black. Apply the paint with a flat No 4 hog's hair brush in short, heavy strokes. Aim to build up a range of greens, varying between blue and yellow hues and light and dark tones, but do not mix the paint too much on the palette. Allow the marks on the canvas to melt and smudge together but take care to leave slashes of bare canvas showing.

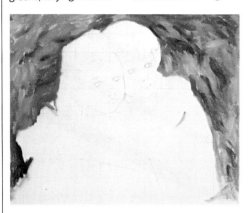

3 Brushing in the dark tones

With burnt sienna and yellow ochre, using the same No 4 brush, put in the dark tones in the hair of both children. Work with bold, fluid strokes and brush the colors together to obtain the correct tone.

It was a principle of Impressionism to build up form by identifying all the colors discernible in a surface or texture and applying them straight to the canvas, with the minimum of mixing on the palette.

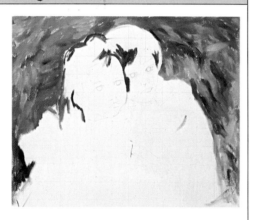

4 Developing the flesh tones and facial features

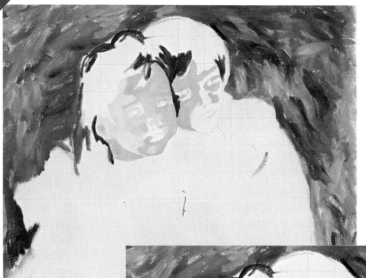

Put in a basic skin tone on the faces, adding small amounts of cadmium red, burnt sienna and yellow ochre to white. Dilute the paint slightly with turpentine and brush it on freely. Then roughly define shadow areas on each face with a thin layer of raw umber. With a flat No 2 hog's hair brush, loosely draw in the eyes and nostrils in burnt umber. Blend the colors together where appropriate, but do not smooth out the paint surface. The forms should be modeled with lively brushstrokes.

5 Adding color to the hair

Work on the hair with yellow ochre, burnt sienna and white. Again, take up the colors separately on the flat No 4 bristle brush and allow them to mix on the canvas. Study the original to see how each individual brushmark contributes to the form, showing the direction of each strand of hair and the overall effect of the broad mass of color. Build up the contrast between rich, warm tones brushed in with burnt sienna and the highlights, created by blending white into the yellow tones. Part of the charm of this painting lies in the free handling of color and texture in the paint. Try to retain the effect of spontaneity.

6 Establishing the lightest tones

Make a mid gray from black and cobalt blue thinned with turpentine. With a round No 4 synthetic bristle brush draw in the fold lines on the clothing. Where there is a mass of shadow, scrub the paint into the canvas to form a patch of gray tone. Clean the brush thoroughly and work loosely over the area with pure titanium white. Brush in a little raw umber to give a warm tone to shading below the faces. With the flat brush, return to the modeling of the faces and adjust the tones where necessary. Note here the artist has applied blue-gray shadow to the nose and eye of the little boy and laid in a lighter tone down the side of the girl's face.

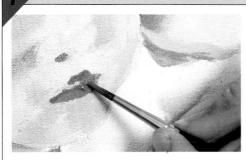

Rework the background area around the two heads with sap green, chrome yellow and white, giving the colors a lighter and more acid tone. Bring out the pink cast of young skin by retouching the flesh colors with mixtures of cadmium red, burnt sienna, white and chrome yellow. Draw into the features, emphasizing the shape of the eyes with burnt sienna and the blue-gray previously mixed for shading the clothes. With a round No 6 sable brush define the shape of the lips in cadmium red and model the shape more precisely by adding touches of chrome yellow and burnt sienna. Build up texture in the hair, enhancing the highlights .

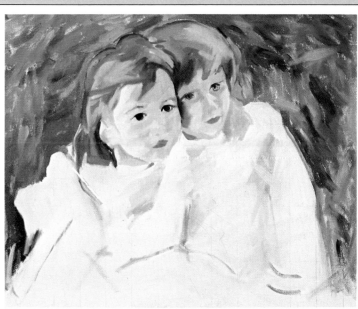

The final version

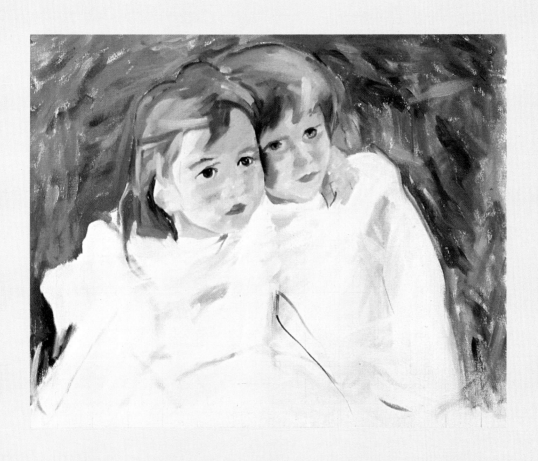

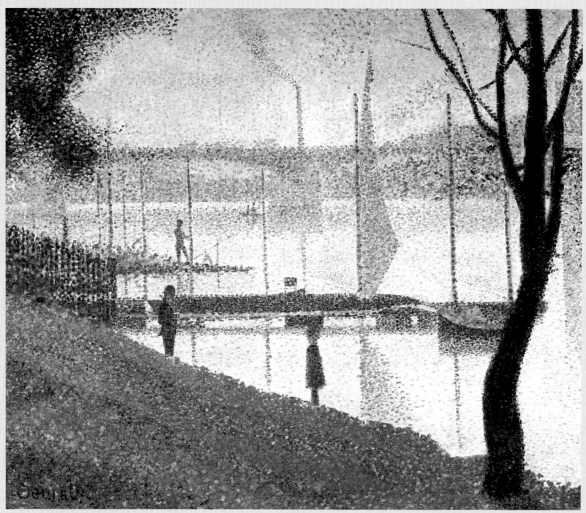

Seurat

Bridge at Courbevoie, oil on canvas, 18 × 21½in (45.5 × 54.5cm)
Seurat developed the technique of Pointillism. This exploited contrasts of
warm and cool color, light and dark tone, and the optical reactions from
complementary colors (yellow/violet, red/green). For example, the green
of a tree evokes a contrasting pink tone in the surrounding sky. The
painting method involves placing tiny dots of color side by side according
to a predetermined scheme. Here Seurat has created the effects both of
solid form and shimmering, hazy light.

The Artist

**French artist
born 1859, died 1891
Leading Post-Impressionist who
developed Pointillism**

Georges Seurat developed the painting technique known as Pointillism in which tiny dots of color are juxtaposed to create the impression of areas of solid color. Seurat was trained as an artist in the conventional French tradition. He spent a secure if unexciting childhood in a family of which he was the youngest child. Having trained at the Ecole des Beaux-Arts, he spent a year in military service. On his return in 1881, he began to develop the theories of color which made his reputation. His first large work, called *Bathers, Asnières*, in which the paint was applied in minute dots of pure color, was only exhibited in 1886, although he had finished it in 1884. His technique became known as Pointillism and was based on the supposedly scientific analysis of light rays and reflections. Seurat always referred to his way of working as 'my method', and applied it systematically throughout his pictures, even on their frames. Like many of the Impressionists with whom he exhibited, he chose landscapes, urban scenes and entertainers as his subjects. These were not, however, treated in the spontaneous manner of other painters, but were stylized and formal. Seurat did not write extensively about his work, but he gave a brief summary of his ideas in one letter which stated his belief that art is harmony. His means of achieving harmony are contrasts of tone, color and line. Seurat's somewhat slow and deliberate painting method restricted his large work to the studio, but he made frequent visits to the north coast of France where he collected material for landscapes and seascapes. These are extremely evocative of the light and space of the coast. Seurat had several close friends who shared his theories, but his short life was otherwise rather solitary. He continued living in the family home, and it was only after his early death at the age of 32 that it became known that he had had a mistress. Although Seurat regarded his ideas as being scientifically based, juxtaposing dots of contrasting colors often tended to create a gray effect rather than the pure colors he strove to achieve. Even so, the invention of Pointillism was an important step forward in the development of color theory. His work attracted many followers.

Materials

Color

Seurat painted in oils but acrylic paints will give the same results and have the advantage of drying much more quickly. Alizarin crimson (3), monastral blue (2) and yellow ochre (10) make up the initial basis of the background. Add burnt umber (9) to crimson and blue to paint the tree. Raw umber (8) makes up the darkest tone of the riverbank. The lightest tones in the painting are mixed from cadmium red (6), cadmium yellow (1), white (7), monastral blue and yellow ochre. The foliage on the tree is pure viridian (5). Only use black (4) if you cannot create it by combining other colors.

Brushes

Relatively few brushes are required for this painting as the brushstrokes are of uniform size. The pointillist effect can be created using just two sizes of round sable brushes. For this version Nos 3 and 4 were used. Other items that are needed include plenty of old rags or paper towels to wipe your brushes on.

Color plays such an important role in this painting that the brushes should be cleaned especially carefully before each new color is applied. Wash the brushes frequently.

Mediums

Acrylic paints can be diluted with a wide variety of mediums. The cheapest and most easily available is water. However, this tends to give the paint a transparent effect similar to watercolor which is not particularly suitable if you are trying to achieve a pointillist effect. Instead, use one of the many mediums prepared for use with acrylics. There are two main types in liquid or gel form. The latter provides the paint with a thicker consistency than plain water or a liquid acrylic medium. The medium can also be used as a varnish.

Support

As the original painting is not very large, it is best to work with a support the same size. Select a sheet of good quality cotton duck or the more expensive linen canvas if possible. Stretch the canvas over a firm wooden frame, tacking or stapling the edges down firmly. If the canvas is not ready-primed, cover it with two or three coats of white emulsion. Use a large decorator's brush to apply the coats evenly and quickly.

Pointillism

Seurat developed the technique of Pointillism. This involves placing dots or small brushstrokes of pure color next to one another *(top)*. When viewed from a distance, these dots fuse in the eye of the spectator, creating the impression of an area of solid color. Seurat developed his ideas from scientific theories of color. His approach was extremely innovative because previously artists had either mixed their pigments on the palette or canvas. Many other artists followed Seurat's example. Today, a similar theory lies behind the use of dots of a small number of colors to create the whole color spectrum in commercial printing. The colored inks used are cyan (blue), magenta, yellow and black. The different colors are created by overprinting the colors *(bottom)*. However, in his painting, Seurat did not overlap his colors but placed them side by side.

1 Establishing the composition

Mix a warm blue-gray from white, monastral blue, alizarin crimson and yellow ochre. Apply it to the whole surface with a 1in (2.5cm) decorator's brush. Make a dark tone from blue, crimson and burnt umber and put in the shape of the tree. Work with little dots of paint, using a No 4 sable brush, but also allow the paint to drag slightly to make areas of unbroken color. Dab in the diagonal with alizarin and yellow ochre.

2 Developing the foreground

Add raw umber and crimson to yellow ochre to create a warm brown. Dot in the lines of the river bank, working loosely to lay in a basic dark tone. Overlay this with dots of yellow ochre to brighten the color of the bands. Make a dense area of tone, but do not fill the space too heavily or allow the colors to mix together. The effect depends upon the combination of marks.

3 Adding contrast

Work into the areas between the yellow bands on the bank. Two colors are used here. The first is a heavy, greenish brown, and this is juxtaposed with bright blue, mixed by adding white to monastral blue. Continue working with the No 4 sable brush. In this technique, the dots should be of roughly the same size, though it is not necessary to be too precise. Do not entirely cover the tinted ground in any area at the start.

4 Laying in dark tones

Gradually build up the forms of the figures on the river bank and the jetty cutting across the center of the painting. Put in the darker tones first, making warm purple and brown tones from mixtures of burnt umber, monastral blue and alizarin crimson. You must study the original carefully to identify the precise colors, as each area of the final painting contains several layers of dots and much of the work done in the initial stages will be concealed or altered by subsequent applications of paint.

5 Building up color

Use fine lines of deep purple dots to put in the verticals and shape the figures. Then work over the whole painting to lighten the tones, using pale mixtures of cadmium red, monastral blue, white, yellow ochre and cadmium yellow. The overall tone of the picture tends to blue and mauve, and you must make an accurate assessment of the color combinations. Emphasize details with darker colors where necessary, using the same mixtures but without the added white. The detail (above) shows how complex the work becomes as you develop the color. Note that in the area of the river bank, the light mauve dots are taken up into the yellow areas, but spaced further apart to provide unity.

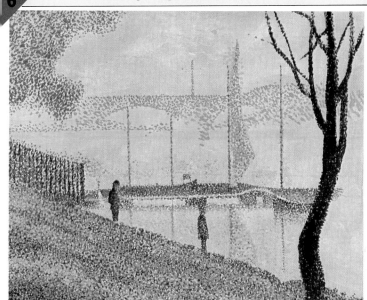

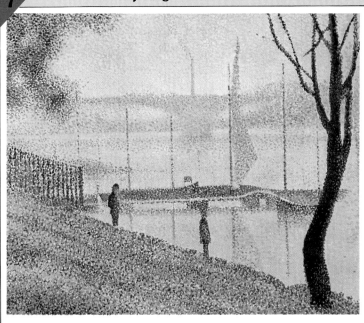

Put in the shape of the tree foliage in the top left-hand corner of the canvas. Use viridian, as the basic color, and space the dots according to the density of tone in the final shape. Mix white and monastral blue to make a single mid tone and establish the hazy shape of the bridge across the background. Note that it is sometimes necessary to exaggerate or overstate the color in the early stages of pointillism. It is then modified by the addition of other hues.

Work across the ground color of the sky with a warm pale tone mixed from ochre and white *(left)*. Puts dots of a mid toned blue into the tree at the left of the image and then lighten the blue with white to alter the tone of the bridge and make the shape less distinct. Use this sparingly to work down the right-hand side of the brown tree. This models the form by suggesting light and shade. Mix pink and light orange tones with cadmium red, white and cadmium yellow. Put dots of these colors in the central area of the canvas, enlivening the overall color of the sail and the central support of the bridge. Strengthen the tones in the whole image, moving quickly from one area to another. Link the colors so the forms gradually emerge as solid shapes, but blend into each other subtly. Pay close attention to small details. However, avoid developing one area more than another. Work on all aspects of the composition at once.

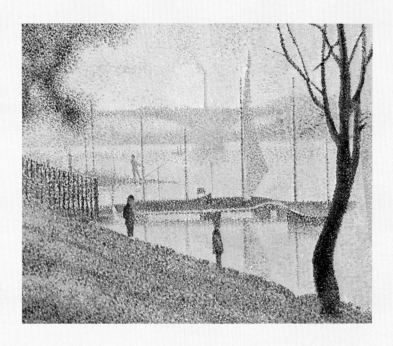

Develop the form of the tree, putting in dots of brown and gray. Overlay colors and light tones, echoing the pinks and warm colors which appear in foreground and middle ground. These colors add vitality to the painting and you should experiment. As the final image is quite subtle you may be tempted to work cautiously, but, as can be seen in this detail, the work contains some extremely vivid hues. This is equally true of such broad areas as the sky and water. The general impression of a calm, light blue is gained through juxtaposing light yellow, pink, pale mauve and blue. The tree here is the only shape which is sharply defined, so the colors are distinct, whereas in the tree foliage on the left dark tones are mingled with the pale sky colors.

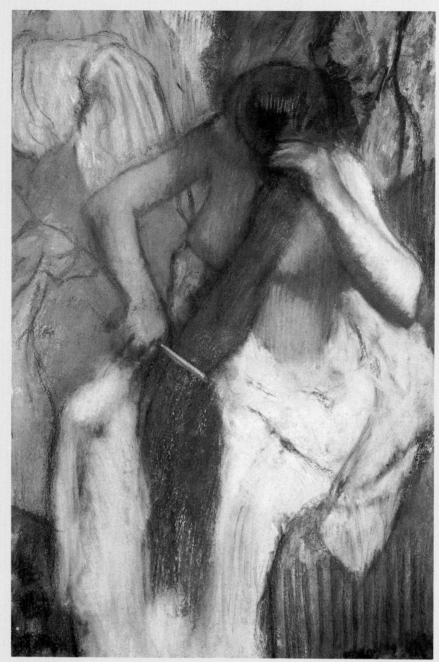

The Louvre, Paris (photo — Bridgeman Art Library)

$\mathcal{D}egas$

Woman Combing her Hair, pastel on paper, 32¼ × 22½in (82 × 57cm)
This is one of the extensive series of nudes, bathers and dancers in which
Degas found the full expression of his acute observation and technical
brilliance. Degas had a natural preference for drawing, and he freed pastel
from its traditional use in imitation of easel painting to develop vibrant,
complex masses of color and texture. Degas made his own pastels from
pigment and gum rolled into sticks. He experimented to achieve a rich
combination of textures.

The Artist

**French artist
born 1834, died 1917
Major Impressionist artist famous
for works in pastel**

Edgar Degas is probably best known for his paintings and pastel drawings of dancers and of horse-racing scenes. He came from a banking family which had connections in Italy. He studied in Paris, making copies from Old Master paintings and drawings. He attended the Ecole des Beaux-Arts where he was taught by a former pupil of the early nineteenth century French artist Ingres (1780-1867), whom Degas greatly admired. Degas also visited Italy, staying with relatives and continuing to study in the museums. In Rome he produced his first important paintings. *The Bellelli Family* (1860), painted on his return to Paris, demonstrates one type of solution to the problem of grouping figures in a realistic setting. He had now established himself as a serious artist and turned to new subjects involving movement. These were works depicting horses and riders and, later, the dancers for which he is famous. Together with his friend Edouard Manet (1832-1883) he helped to organize the first exhibition of the group which was to become known as the Impressionists. They attracted hostile criticism but Degas, although troubled by the financial crisis of his family's business, again supported a second exhibition in 1876. Degas was not an Impressionist in the narrow sense of the term, because he aimed not merely to record the immediate impression of light, but to show forms moving in space. Degas experimented with many techniques in his works in both oil and pastel. In his oil paintings he tried out a variety of grounds and even used raw canvas. When working with pastels he built up a web of color from strokes of pastel going in different directions. Degas also experimented with fixatives to make his pastels more durable. The ballet dancers and singers whom he painted were shown in poses which suggested movement by a careful selection of line and arrangement within the picture frame. He even had models of dancers made in order to understand their movements thoroughly. Some of these were cast into bronze after his death. Later in life he suffered from failing eyesight and, when he could no longer paint, he turned to making sculptures. His last works were brilliantly colored pastels in which broad strokes describe the dancers' actions.

Materials

Color

Raw umber (1) is used frequently in this drawing, to outline the composition initially and for dark tones and shadows on the hair and body of the figure. Pastel colors may vary slightly from one manufacturer to another. They can be bought separately or in boxed sets (below).

The blue, for example, may be most closely represented by cerulean blue or phthalo blue (2). Remember also that the colors visible in the reproduction are the basis for your work, rather than the actual tone used by the artist. The warm, vibrant tone in the hair and foreground

of the drawing are created with a deep red (3) and burnt sienna (4). White (5) is vital for the light tone of the drapery and to modify the colors in the flesh. The background is filled around the figure with pale cadmium yellow (6) and light rose. The shadow on the flesh tone

is given a cool, dark cast using olive green (7) and heavy dark areas are emphasized with burnt umber. The key to pastel drawing is a gradual mixing of tones and colors, built up by overlaying strokes of different hues. Degas worked vigorously with the medium.

Support

Heavy white cartridge paper was used here, tinted with a wash of burnt sienna. Pin or tape the paper firmly to a board and mark out the drawing area – 20½ × 14½in (52 × 37cm). Use a large, soft brush, such as a No 8 sable, to cover the whole of the paper with a light tint of watercolor, and make sure the paper dries flat. If you prefer, it may be stretched before the wash is applied. As an alternative, you could work on one of the many tinted papers available, choosing a suitable tone which is warm but not too dark. The paper should have a tooth to hold the pastel but not a pronounced grain.

Equipment

A pencil should be used to square up the initial grid and charcoal is needed for linear detail in the drawing. Fixative is essential in pastel drawing. This is obtainable in aerosol cans or can be sprayed from a bottle using a metal mouth spray. The spray is right-angled so you can dip one end in the fixative and blow through the mouthpiece. The fixative is drawn up through the vertical tube and blown onto the drawing by the force of the air through the horizontal tube. Pastels are very powdery and the colors quickly mix and become devalued if the drawing is not fixed frequently.

1 Squaring up the composition

When copying a pastel drawing, find a good quality reproduction which enables you to identify the marks made by the artist. Draw a grid on the picture and make a proportionate grid on the tinted paper. For this use a large ruler and make the lines very lightly with thin charcoal, a pale neutral colored pastel or a soft pencil. In this example the pencil used to draw the grid was too hard and the lines remain visible as the pastel has not adhered to the texture of the pencil mark. Copy the main outlines using a raw umber pastel stick.

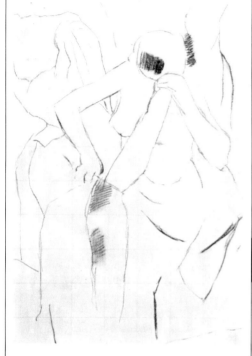

2 Blocking in the basic colors

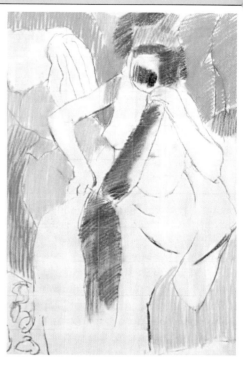

Block in broad areas of color in the figure and background. The colors used are light rose, pale cadmium yellow, cerulean (or light) blue and burnt sienna. Fill each shape with heavily laid strokes of color, the marks following the same direction to create an even tone. In the same way, block in the hair with burnt sienna, adding touches of raw umber for the dark tones. Rub the surface of the drawing gently with your fingertips.

3 Shading the figure

Strengthen the shadows on the body, putting in vertical strokes of raw umber. Note that in the original the direction of the pastel marks is calculated to define or emphasize the changing planes and angles in the form. The vertical lines show the weight of the upright torso against movement in the arms. Be cautious when laying the pastel in the early stages. If the first layer is too heavy, additional colors will not lie cleanly on top and the colors will mix and become dull.

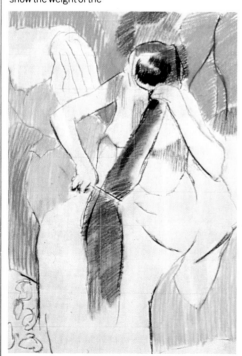

4 Strengthening color contrasts

Gradually build up the tonal contrasts in the figure. Strengthen shadow areas on the body, using olive green (above) to tint the heavy tones on face and shoulder. Add strokes of raw umber and burnt sienna, working across the figure to lay in dark tones on the arms and torso. Put in the patches of rich red and brown in the hair with burnt sienna and deep red. Emphasize the dark areas with burnt umber and again blend the color lightly with your fingertips. Pay close attention to the tonal balance in the original.

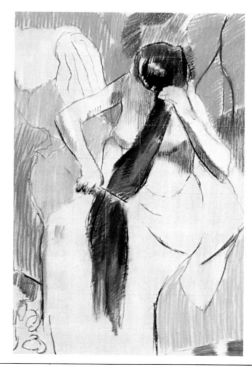

5 Modeling the figure

Extend the green and raw umber on the body, less heavily than in the cast shadows. Put in the light tones of the flesh, hair and drapery with white. Work over dark shadows on the breasts and the model's right arm to create a middle tone.

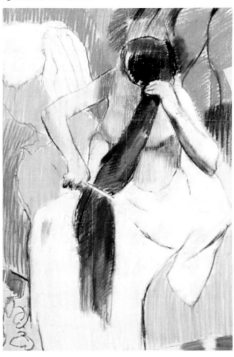

6 Developing the background colors

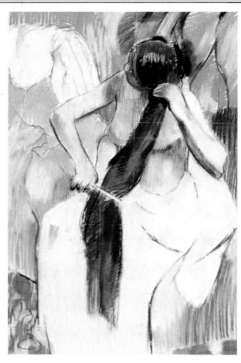

Put in the highlights in the background with white and combine areas of color as you assess them from the original.

Smudge the tones together to soften and mix the colors and integrate the separate shapes.

The final version

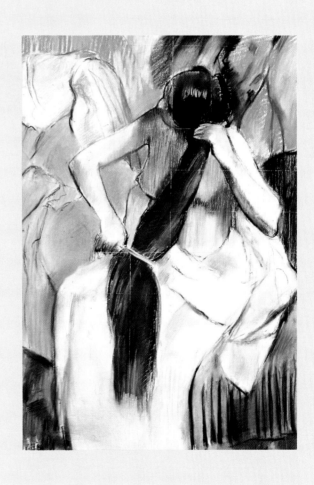

7 Redefining the image

Darken the background tones where appropriate with touches of raw umber, blended into the colors. Put in the folds of the drapery with light strokes of cerulean blue. Add detail to the pattern in the foreground on the left-hand side of the image with raw umber (right). Work on the linear design in the composition with a thin stick of charcoal.

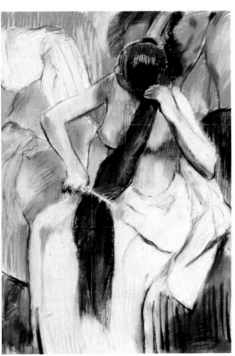

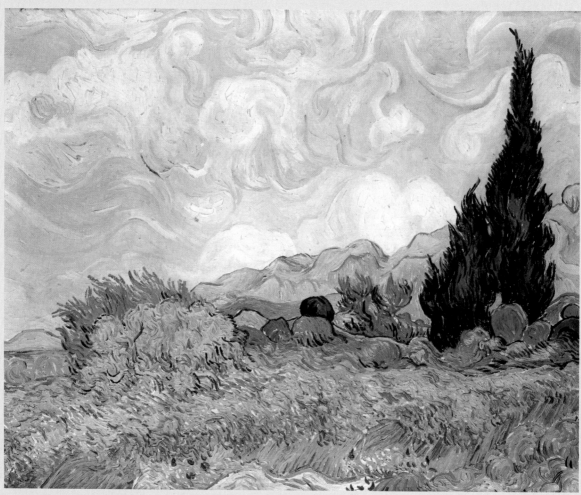

van Gogh

Cornfield and Cypress Trees, oil on canvas, 28⅜ × 35¾in (72 × 91cm)
Van Gogh's urgent preoccupation with painting continued even while he
was recuperating from a mental illness in an asylum near Arles. This
landscape is drawn from the surrounding countryside of cypress trees,
cornfields and hills. Van Gogh has stressed linear and tonal qualities over
color. He always handled color in a rational and craftsmanlike manner,
but the vigorous style of his brushwork reflects his restless nature and the
energy he channeled into his painting.

The Artist

**Dutch artist
born 1853, died 1890
Popular individualistic painter of
portraits and landscapes**

Vincent van Gogh's career as an artist was short, lasting only 10 years, but his output was prolific. When he died he left 800 oil paintings and about the same number of drawings. The son of a Protestant pastor, van Gogh attempted various occupations before studying theology and then becoming a missionary. He went to work in a mining area of Belgium and when, in 1880, he finally turned to painting, he continued to live there. For the next six years he taught himself to draw and paint. Van Gogh chose the people living around him occupied in their daily tasks for his subjects, and he employed dark colors and heavy forms in his early work. Many of these paintings, such as *The Potato Eaters* (1885) show the influence of the French artist Jean Francois Millet (1814-1875) who also painted scenes of peasants. Van Gogh had a few lessons in Antwerp, Brussels and The Hague and in 1886 he moved to Paris to live with his brother Theo (1857-1891). There he absorbed many of the current ideas including Impressionism which had the effect of lightening his color schemes. His subjects also now changed, and he began to paint brilliantly colored portraits and self-portraits as well as scenes of Paris. Van Gogh was keen to learn a variety of styles and techniques and he particularly copied the Old Masters and Japanese prints. During his stay in Paris, he met Toulouse-Lautrec, Degas, Seurat and Gauguin, and in 1888 he went to live in Arles in the south of France. Van Gogh's response to the brilliant light of the Mediterranean was exuberant and he discovered new possibilities in the use of color, applying it in broad masses and using vigorous brushstrokes. At the end of 1888, van Gogh had a nervous breakdown. He suffered from frequent attacks of mental illness until his death. In 1889 he went to live in an asylum in St Rémy-de-Provence at his own request, but he still continued to paint. For example, in the last 70 days of life he managed to complete a painting every day. Even though he had recurrent attacks, he carried on painting landscapes and portraits almost compulsively. He painted to communicate the intensity of his feelings and this naturally led him to use stark contrasts of color. In the last year of his life he moved to Auvers, near Paris. He died in 1890.

Materials

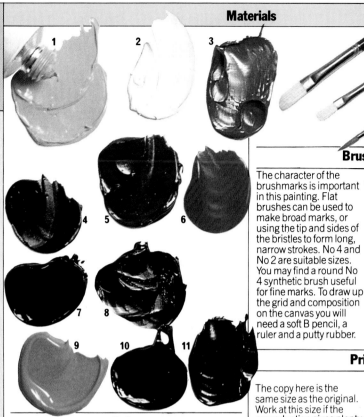

Brushes

The character of the brushmarks is important in this painting. Flat brushes can be used to make broad marks, or using the tip and sides of the bristles to form long, narrow strokes. No 4 and No 2 are suitable sizes. You may find a round No 4 synthetic brush useful for fine marks. To draw up the grid and composition on the canvas you will need a soft B pencil, a ruler and a putty rubber.

Priming

The copy here is the same size as the original. Work at this size if the reproduction gives plenty of detail, as this will allow you to imitate the expressive brushwork which was typical of van Gogh's later style. Buy a wooden stretcher of the right size and a suitable amount of medium weight cotton duck. Stretch the duck firmly, securing it with staples or tacks. The canvas must be well primed so the oil paint cannot soak into the fabric. Use two or three thin, even coats of primer rather than a thick coat which may crack. Mix emulsion glaze with white emulsion paint.

Color

This painting is composed of many separate marks forming heavy masses of color. The palette of oils consists of chrome yellow *(1)*, titanium white *(2)*, cerulean blue *(3)*, raw umber *(4)*, burnt sienna *(5)*, cadmium red *(6)*, ivory black *(7)*, viridian *(8)*, yellow ochre *(9)*, sap green *(10)* and cobalt blue *(11)*.

Squaring up

Divide the reproduction into squares and transfer these to the canvas using a soft pencil; a B grade is best. Because the painting is so complex, make the size of your squares fairly small. Do not press too hard with the pencil, so that the lines do not show through. Sketch in the main areas of the picture, following the grid on the reproduction.

Initial painting of the sky

Define the general areas of the clouds. Use a No 4 flat hog's hair brush and a mixture of cerulean blue, chrome yellow and white. Start to establish the outlines of the clouds with a smaller brush, a No 2 flat hog's hair is ideal. Apply a blue-gray mixture made by mixing cobalt blue, ivory black and white.

3 Heightening tones

Continue to block in the clouds with a No 4 flat hog's hair brush. Use a mixture of cobalt blue, yellow ochre, ivory black and titanium white, but vary the strengths depending on the exact area being worked on. When trying to recreate the bold and sweeping flourishes of van Gogh's brushwork, follow the reproduction very closely. The only way to gain a similar effect to the original is to attempt to imitate each individual brushstroke. The rich paint texture and strong brushwork are characteristics of van Gogh's style, which it is important to retain in any recreation.

5 Developing tone and texture

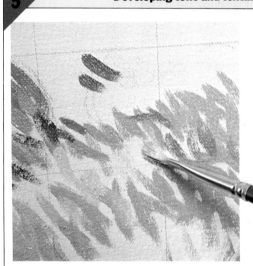

Next begin to work on the cornfield with short, chopped strokes. Use a mixture of titanium white, yellow ochre and chrome yellow. Consult your reproduction and vary the strength of the mixture accordingly. Build up the different tones of the corn gradually. More detail should be added to the cornfield as the picture progresses. Block in the corn in the distance.

4 Painting the horizon

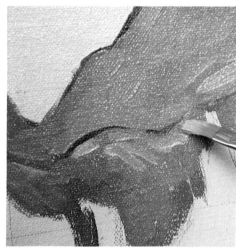

Having established the cloud areas, begin to outline the mountains which run across the painting. Use a No 2 flat hog's hair brush and a mixture of cobalt blue, titanium white and ivory black. Fill in the mountains with a slightly lighter mixture following van Gogh's bold brushstrokes (left).

6 Building up contrasts

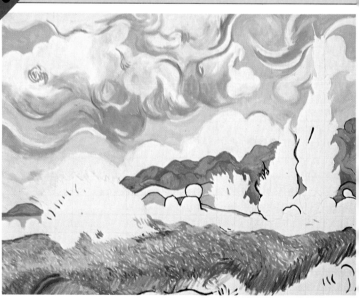

Continue to build up the cornfield. Work in layers and use the short brushstrokes to imitate the rippling effect gained in the original. Next begin to outline the trees and bushes in the middle distance with a dark green made by mixing sap green, cobalt blue and raw umber. A fine brush is best for this. Remember to check the exact color and position of the brushstrokes carefully.

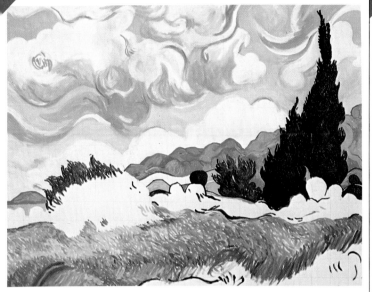

Build up the foreground gradually, working wet into wet to create the smeared effect of the original. Match the exact tone of the brushstrokes with the reproduction. Add yellow and green highlights to the bushes, and brush in the red flowers at the base of the cornfield. Compare finally with the reproduction, and adjust the tonal balance and brushstroke detail.

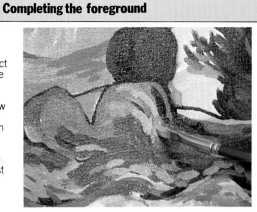

Block in the cypress trees with the dark green mixture using a No 2 flat hog's hair brush. Vary the strength of the green slightly, according to the original. Try to follow the positive brushstrokes of the original, but make sure that you keep to the correct outlines. For the foliage on the left of the picture, apply the green mixture in the same way as the brushstrokes for the corn *(left)*.

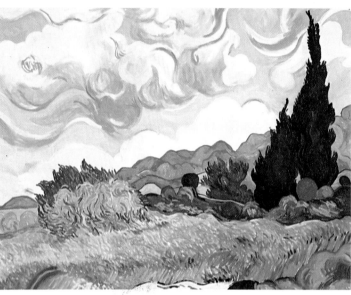

Continue to block in the bushes in the middle distance. Use the No 2 flat on its side.

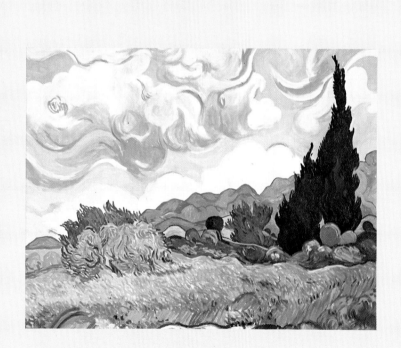

Add further detail to the corn and foliage imitating the shades of the original.

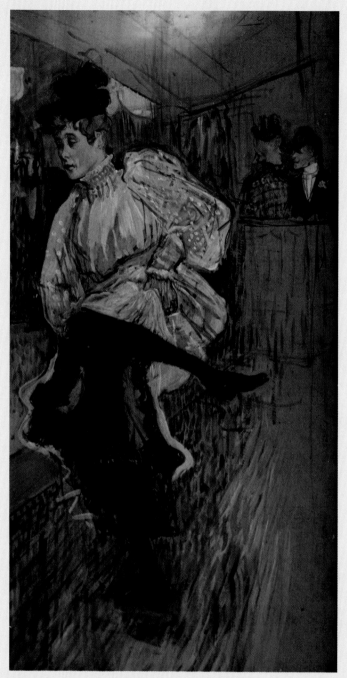

The Louvre, Paris (photo — Bridgeman Art Library)

Toulouse-Lautrec

Jane Avril Dancing, oil on natural linen, 34×18in (86×46cm)
Lautrec often painted Jane Avril, a popular cabaret performer. He enjoyed
her reserved expression and angular movements. The format of the
painting emphasizes the hopping dance step, while stressing the depth of
the room. Lautrec liked the unusual placing of figures, a motif influenced
by Japanese prints. He worked in overlaid, lightly mixed strokes of color
on natural linen which shows through the paint, giving harmony to the
colors and modeling in the half-tones.

The Artist

**French painter and lithographer
born 1864, died 1901
Painter of Parisian life in the late
nineteenth century**

Henri de Toulouse-Lautrec belonged to no particular group or school of painting, but his work reflects the life associated with Bohemian Paris in the 1890s. He developed a talent for drawing at an early age, and then devoted himself to painting when he became permanently crippled at the age of 15, after breaking his legs in two serious falls. From 1882 Lautrec studied painting in Paris. Like many contemporary painters, Lautrec was attracted to the design of Japanese prints whose style of informal composition became a feature of his work. In 1884 he met Edouard Manet (1832-1883) and Edgar Degas (1834-1917) who gave him great encouragement. Like Degas, Lautrec found his subjects in the popular quarters of Paris where the circus, cabaret and café-concert provided him with plentiful material. The colorful and sometimes bizarre world of entertainment was his favorite subject. Lautrec made friends with most of the customers, professional entertainers and artists whose portraits he painted. In addition, he frequented the *maisons closes* where the prostitutes lived. He made a number of drawings and paintings of these girls in which he gives a dispassionate view of women, unaware that they are being observed. Lautrec despised posed models and preferred to capture his subject naturally. Unlike the Impressionists, who were interested in the rendering of light, he was fascinated by movement, and he conveys a feeling of motion in nearly all his paintings. In 1889 Lautrec began to exhibit his work and also design posters for theaters and dance halls, particularly the Moulin Rouge. He became best known for his color prints of artists who performed there, and in 1892 he took part in an exhibition of Montmartre life. In his painting technique, Lautrec used vivid colors which he applied in bold strokes. He mainly worked in thinned oil paint. He often worked with gray unprimed cardboard as his support and left large parts of the surface uncovered in contrast with the areas of color. The natural color of the cardboard formed a major part of the design. By 1898 Lautrec's health had started to deteriorate as a result of his alcoholism and general way of life. He died in 1901, but many of his posters remain very popular.

Materials

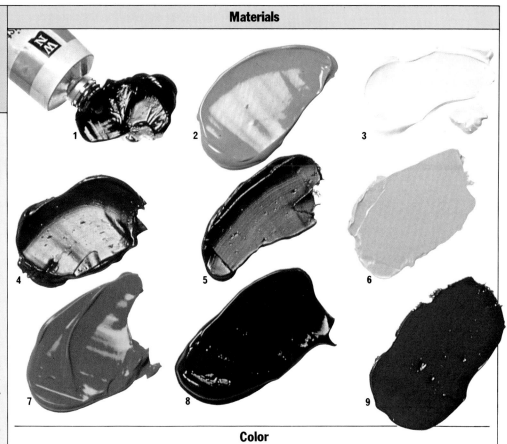

1 2 3

4 5 6

7 8 9

Color

A feature of this painting is the contrast of titanium white (3) and ivory black (8) against the neutral tone of the canvas. The background colors are gray-greens, so add sap green (1), chrome yellow (6) and cobalt blue (9) to the palette. Warmer tones in the figures are mixed from cadmium red (7), burnt sienna (4) and yellow ochre (2) and white. Raw umber (5) enriches the dark tones and shades light colors.

Equipment

The brushwork in this painting is vigorous and spontaneous. In order to capture the spirit of the original it is important to use brushes which you can handle comfortably and with confidence. Only three brushes were used in this example. They are (from top to bottom) flat bristle brushes Nos 4 and 2 and a No 4 round synthetic bristle brush. The No 4 brushes are useful for blocking in color and describing detail. The

No 2 is a fine brush which can be used in drawing details such as the lacy flounces of the petticoat. Alternatively it is possible to complete the image using two or three sizes of round bristle brushes if preferred. Bristle is more suitable than sable which is too soft. To draw up the image you will need a long ruler to measure the grid and charcoal for the linear drawing of the figure. Keep a soft rag or paper towel to hand.

Support

Here the copy was made the same size as the original, 34 × 18in (86 × 46cm). The color of the canvas is important as it plays a vital part in the overall tonal balance. Use artist's linen, which has a natural brown tone, firmly stretched on a wooden stretcher. Bleached linen or a canvas board will not be suitable as it would then be necessary to tint the whole surface evenly. This would not match the tone of the original and would give a false interpretation of the colors.

Priming

Prime the canvas thoroughly with acrylic emulsion glaze diluted with water. This dries to a transparent, colorless finish which does not affect the natural tone. However, it does have the vital properties of a primer in that it seals the surface and prevents absorption of the oil paint.

Mediums

Turpentine and white spirit are used to thin the paint and as solvents for cleaning brushes. White spirit can be used for thin stains of color in the initial stages but as a general rule it is not a good medium for oil paint. It reduces the rich, oily consistency and if used throughout the painting may cause the colors to dull considerably as they dry, and in some cases to crack or powder when dry. Pure turpentine does not have this effect when used moderately and is more reliable, though also more expensive.

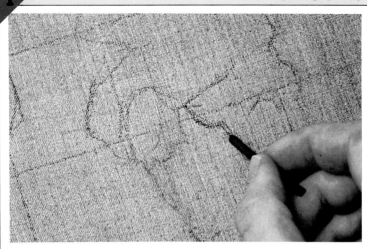

Lay a grid over the print which you are copying and draw a grid in proportion on the canvas with a stick of charcoal. Mark the grid lightly so that unwanted lines can be removed later *(right)*. Draw in the main outlines of the composition *(top left)*, copying the figure carefully and putting in the basic shapes in the background. Once the figure is established rub off the grid lines inside the form with a soft rag *(bottom left)*.

2 Drawing the figure

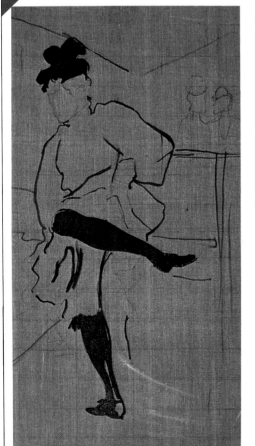

Tint black with raw umber and burnt sienna to make a rich, dark tone. Add a liberal amount of turpentine and mix well so the paint is thin and fluid. Using a flat No 2 synthetic bristle brush draw in the outline of the figure and the main lines in the background. Load the brush with paint and make flowing lines suggesting the fullness of the dress and energy in the limbs. Block in the dark shapes of hat and stockings with solid color.

3 Adding background tone

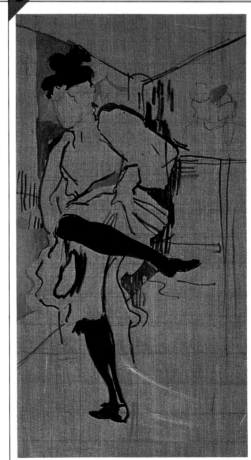

Mix chrome yellow and cobalt blue, and gradually add small amounts of white and black to achieve the tones of green for the background. Use a flat No 4 bristle brush and work in broad, bold strokes, building up solid areas of color. Note that the sash of the dancer's dress echoes the background color, so brush in the appropriate tone. Use a heavy, dark green to the right of the dancer. This throws the figure into relief and indicates the receding space behind her. The natural color of the canvas is a crucial factor in this painting. Judge your brushwork carefully, as corrections should be kept to a minimum or the image will lose its vigorous, sketchy quality.

4 Developing the composition

Studying the original carefully, you will see that the dancer is drawn with a number of energetic lines which contribute to the impression of movement. Using the fluid mixture of black, burnt sienna and raw umber as before, return to the drawing and put in the lines with loose, confident gestures of the brush. Block in the dark jacket and striped pattern of the background figures. At the same time draw in dark lines on the floor which give the perspective of the scene. Keep them quite straight, but do not use a ruler as the style of the picture is lively and informal. Mix cadmium red, cobalt blue and white to create a light mauve, and, with a round No 4 synthetic brush, color areas of the frilled petticoat on either side of the dancer's right leg.

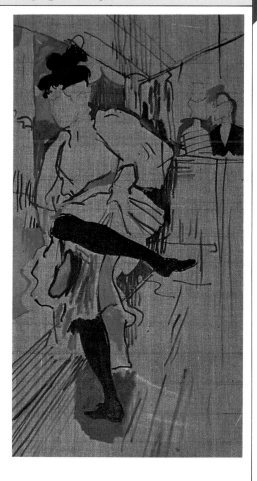

6 Building up texture

With a flat No 4 bristle brush lay in the dark area behind the dancer at the left of the picture. Use black mixed with raw umber and thinned with turpentine to brush in short, vertical strokes. Let the canvas show through between the marks, and build up the textures gradually. Block in the petticoat with thin layers of black, barely staining the canvas, and draw into it with thicker paint and a flat No 2 synthetic bristle brush to show the lines of gathers and flounces. Gradually build up the required density of tone with diluted washes of paint. Note how the marks in the original are angled to show the fall of the fabric and the lace down the right-hand side is described with small twists and flourishes of the brush.

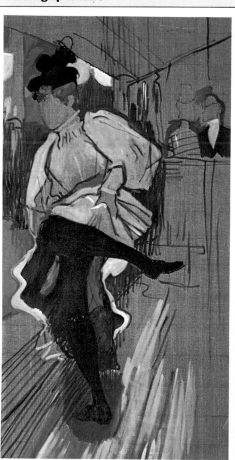

5 Putting in local color

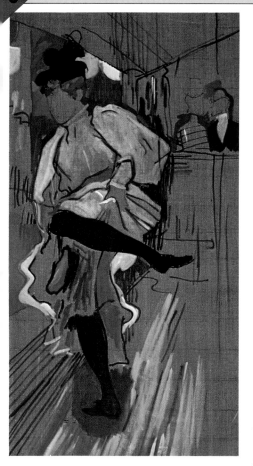

Make a thin mixture of black, white and a little yellow ochre and brush in mid tones on the dress. Using a round No 4 synthetic brush, paint in the hair with yellow ochre and chrome yellow, with admixtures of white and raw umber to create the full range of tones *(above)*. Observe the shapes and changes of color carefully so you can copy them correctly. Put in warm tones in the foreground with a mixture of yellow ochre and raw umber. With a flat No 4 brush lay in white highlights across the whole picture area. Add a little mauve to the white down the left-hand side of the dress. Use white and a bluish-mauve in the wall behind the dancer. The floor to the right of the figure is marked with broad brushstrokes of white mixed with yellow ochre.

The head of the dancer is fully painted and there is no need to rely on the color of the natural canvas, so it is worthwhile spending time on getting the shapes right. For instance, the face can be reworked if it is not successful initially. Analyze the underlying structure, studying the original carefully, and put in the main areas of light and shade *(left)*. Then draw the features and add local color in the lips and eyes *(below)*. When the shading is complete, rework the light tones.

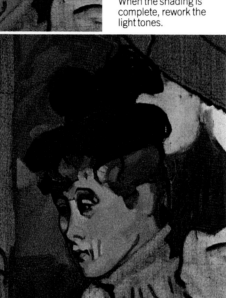

Allow the basic flesh tone to dry out, and then work on the structure of the face in detail. Use the No 2 brush and start by drawing in the basic lines of eyes and nose with burnt umber. The expression of the dancer should be easy to capture if you pay close attention to the particular shape of the features – the arched eyebrows, heavy eyelids, curved nose and small Cupid's bow mouth. Having drawn the main lines, put in heavy shadows in the eye sockets with burnt sienna. Mix in a little raw umber and make short strokes describing details such as the lines beside the mouth, and under the lower lip and nostril. Use cadmium red to paint the shape of the mouth. At the same time, assess the tones of the hair in relation to the light flesh colors, and adjust the balance of tones in the whole head and hat. Dilute a small amount of raw umber and burnt sienna and color the hat of the male figure behind.

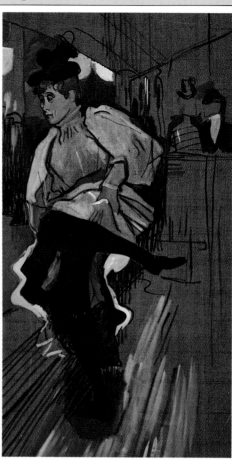

Lay in flesh tones on the dancer's face and hand and the faces of the figures in the background. Mix a basic tone from yellow ochre, chrome yellow, white and a little cadmium red and block in the basic shapes. Add raw umber to the paint to darken the tone and shade the eye sockets and the lower part of the face where there is a shadow cast from the nose. To strengthen the contrast between the dark and light tones, tinge the brown hues with a little cobalt blue to give them a cool cast.

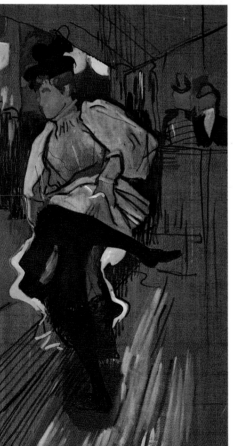

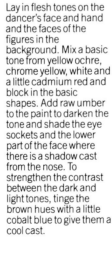

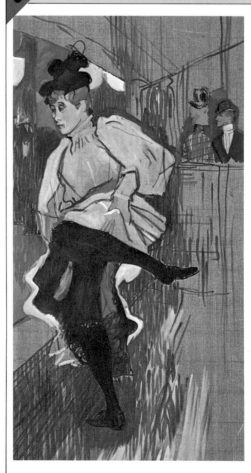

Make a mid toned green with a mixture of chrome yellow and cobalt blue and darken it with black. Thin the paint to a runny consistency with turpentine and with the round No 4 bristle brush, sketch in vertical lines behind the model's right shoulder. With smaller, tapered brushmarks, work over the bare canvas and into the light colored area of floor, out from the lines of the figure. Add sap green to the mixture to make a brighter tone of green and brush in color around the two background figures. With the No 2 brush draw in the features of the background figures. These are only loosely sketched in on the original. Use cadmium red for the woman's lips, burnt sienna for the man's mustache and raw umber for his hair, together with mixtures of cadmium red, chrome yellow and yellow ochre for the hair of the woman. Apply the paint thinly, in small dabs, staining the canvas rather than applying paint to the surface. Add white to the orange tones for small patches of highlight.

Using pure titanium white and a No 4 brush, put in bold marks to make up the texture of the dress. This must be carefully judged, so that the canvas shows through in the appropriate areas, leaving a mid tone to describe folds in the fabric. Build up slashes of intense white *(right)* to show gathering in the fullness of the dress and dab in small dots on the sleeves with separate brushmarks. When the high tones are finished, work into the dark shadows of the petticoat with black mixed with a little raw umber to heighten the tonal contrasts in the figure. Stand back and study the overall effect of the painting, against the original which you have copied. Check tones and the brushwork detail.

The final version

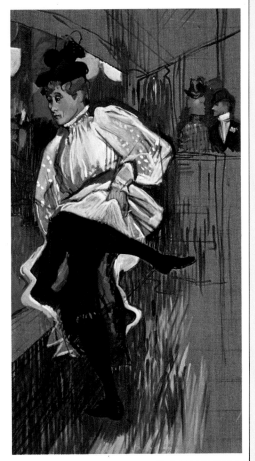

Monet

The Waterlily Pond, oil on canvas, 34¾ × 36¼ (88 × 92cm)
Monet worked hard to create the beautiful garden of his home at Giverny
and spent much of his later life working there, studying the water, foliage
and flowers which surrounded him. The Japanese bridge over a dappled
pond was a favorite subject. Monet responded spontaneously to his
immediate observation of natural effects. His color schemes were not
unplanned, but he worked without preliminary drawings or
underpainting, acquiring detailed knowledge of light and color in nature.

At the start of his artistic career Monet was a caricaturist. He then became a follower of the French painter Eugène Boudin (1824-1898) and Dutchman Johan Barthold Jongkind (1819-1891), two landscape painters who believed in painting straight from nature. Monet was born in Paris but he lived at Le Havre on the Normandy coast where, at the suggestion of Boudin, he worked out of doors. In the early 1860s Monet studied in Paris where he met many painters who were to become his friends and colleagues. In the 1870s while working with Pierre Auguste Renoir (1841-1919) on an island in the Seine, Monet began to use small touches of unmixed color to show how light was reflected from water and leaves. This innovatory idea developed into one of the main tenets of Impressionism – that colors lie in the spectrum of light and are absorbed and reflected by surfaces. The Impressionists believed that by observing how this took place, they could recreate the actual appearance of nature. Capturing light and fleeting impressions was their aim and this they achieved using color in an innovatory way. The Impressionists worked using broken colors, which means painting with colors in a pure state rather than mixing or blending them. Another characteristic of the Impressionists was that they painted shadows using complementary colors. Until the late 1880s, however, Monet preferred to paint in the full midday sun so that he avoided shadows altogether. He constantly pursued his researches into color which resulted in physical hardship for his family since his paintings did not sell. Monet, in fact, rarely finished a painting at one sitting because the light and atmosphere changed in only a short space of time. He usually blocked in a scene by painting it roughly first, and then completed the painting at a later date. Monet stressed the momentary nature of visual impressions by painting several studies of the same view at short intervals showing the different light conditions. These include *Haystacks* (1891) and *Rouen Cathedral* (1892-1894). Another well known series is *Waterlilies* (1916) which he painted at Giverny near Paris. Monet is often considered the most typical nineteenth century French Impressionist painter.

Materials

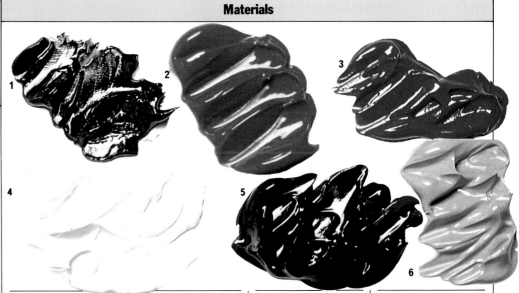

Color

In keeping with the principles of Impressionism Monet used bright, pure colors, mixing them together on the canvas to obtain the effect. The painting here varies from this style somewhat in adding ivory black *(5)* to the palette. This is used to strengthen dark tones. Acrylic colors are brighter and rather less subtle than oil equivalents but in this case the freshness adds to the vibrant tones in light falling on foliage and water. Hooker's green *(1)*, cobalt blue *(3)* and yellow ochre *(6)* are mixed to create the basic colors, modified with white *(4)* and cadmium red *(2)* which is used in the lilies.

Support

Work on a stretched canvas measuring 28 × 30in (71×76cm). Use cotton duck as the fabric.

Priming

It is important to have a clean, white surface. Brush on two coats of acrylic emulsion primer.

Brushes

It is not possible to identify accurately every shape and mark in this painting, so you should build up a mass of brushmarks which correspond to the original texture. A range of flat or filbert bristle brushes from No 1 to No 5 and a sable No 3 will create a variety of strokes and textures.

Squaring up

Many of Monet's paintings of his garden at Giverny near Paris were on a grand scale but he also liked this almost square format in smaller works. In choosing the size of your canvas, allow yourself freedom to paint loosely, but do not scale up the image too dramatically or it will be difficult to control the composition. Draw up a grid of squares on the reproduction and transfer the grid to the canvas in proportion, using a soft pencil. Sketch in the main lines of the composition to establish the structure of the bridge and briefly indicate the area of the lake, waterlilies and background foliage.

2 Putting in the mid toned greens

Mix Hooker's green and emerald green to make a middle tone. Assess the basic divisions in the composition and sketch in areas of color with a filbert No 5 bristle brush. This helps to place the various elements in the image. Color variations can be laid over the green at a later stage. The texture of the original is rich and complex, so it will not be possible to imitate every mark accurately, but keep the brushwork active.

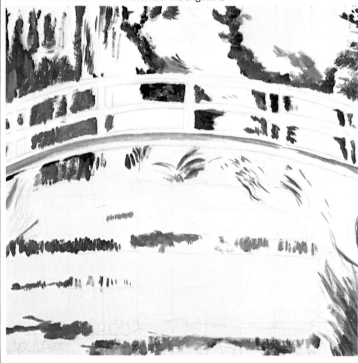

3 Blocking in the light yellow

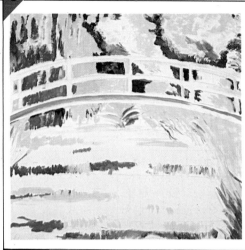

Work across the rest of the canvas with a light yellow, made from yellow ochre and white. Paint quite thickly over the areas where this color predominates. Dab it on to break up the surface where the color is visible showing through overlaid darker tones. Do not attempt to be too precise as this layer will be partially covered and both the basic colors can be reworked when a more complex image has been built up. The combination of tones can then be more fully developed.

5 Building up the background

Develop the tones in the background foliage, adding plenty of gel medium to the paint to keep it thick and wet. Use white, Hooker's green, emerald green, cobalt blue and yellow ochre to mix a variety of hues corresponding to those in the original. Apply the paint in dabs and vertical streaks with a round No 3 sable brush. Build up a semi-abstract arrangement of color, suggesting a tangle of trees and bushes, with splayed clumps of reeds directly below the bridge. Work mid and light tones over the green and yellow.

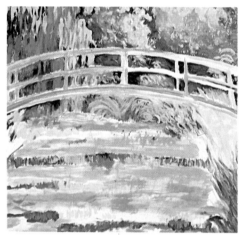

Gradually build up the color, starting with thin, streaky marks and developing the tone and texture. Load the brush with paint and dab it firmly onto the canvas surface, allowing the colors to mix and blend. Note the directions of the different brushstrokes and imitate them as closely as possible. Add touches of bright, pure color with the light tints to break up the areas of tone.

4 Laying in the light blue

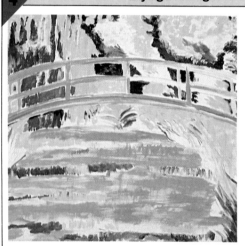

Mix a light toned blue with cobalt blue and white. Thin it slightly with water and block in a basic tone for the water, using broad horizontal strokes and vigorous scribbled marks. Do not allow the color to become flat and solid. The technique of painting with color directly on a white canvas was a basic principle of Impressionism which enlivened the image. Previously, painters had applied a toned base to the canvas. Loosely fill in the shape of the bridge with the same light blue tone.

6 Developing tone and color in the foliage

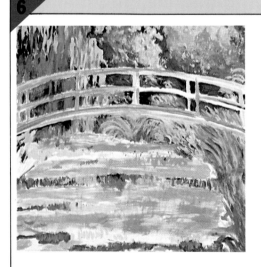

Work towards the foreground, putting in the colors on the foliage to the right of the painting. Use Hooker's green, white and yellow ochre to create the color mixtures. The tone of this area is a more vibrant yellow than in the background so you should add a greater proportion of yellow ochre to the mixtures. Apply the paint with a brush and palette knife, putting on thick marks and scraping back to develop the texture. Acrylic dries quite quickly and cannot be effectively scraped off once drying has started, so keep the paint fresh and thick while working on this section. Lay heavy streaks of the different tones side by side, describing the separate stalks and leaves, then work the colors one over another to achieve small areas of broken color as in the original. Add touches of cadmium red and blend them into the green to make the rich red-brown which is interwoven with the yellow and green tones. The brushmarks have a clear direction but become less distinct as the colors are built up Details of the painting show how the gel medium gives body and translucency to the

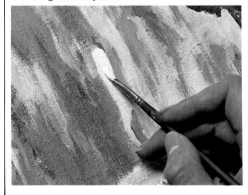

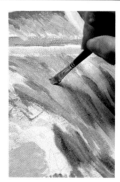

color. It can be laid on in a heavy impasto layer with the palette knife (above left) which can be removed and reworked while the paint is still wet. The bristle brush (above

right) leaves broad streaky marks, which gain tonal variety from the texture made by the brush bristles. Gradually break down the area with small dabs and streaks.

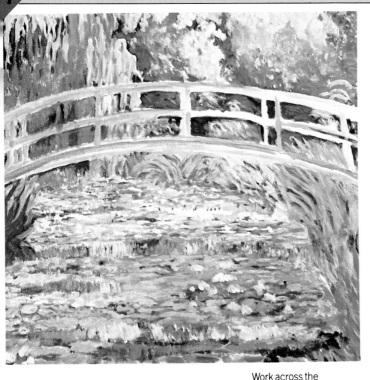

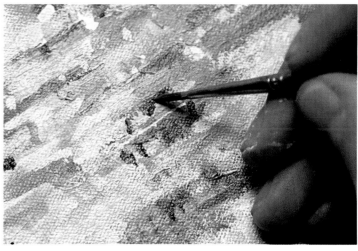

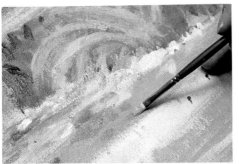

Work across the foreground area, using small and medium bristle brushes, developing detail and texture. Use the same colors as before and mix a variety of different tones and hues to represent the water surface and plants. Build up the paint thickly, working wet on wet and scrubbing in thick paint with a stiff bristle brush.

Define large areas of blue and green first and then identify separate patches of tone to draw out the complexity of the original. Reflections on the lake and the mass of leaves and flowers in the lilies are put in with hundreds of tiny flecks of harmonious and contrasting colors. Use some strong blue and green to emphasize certain forms, for example the reeds below the bridge on the left-hand side of the image. Include color contrasts such as the red-brown flecks in the water *(top right)* and a heavy dark green *(above*

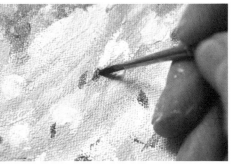

right) mixed with black to increase the density. This will add depth to the image but note that the original has an overall unity derived from linking the tones in foreground and background. Use the

No 3 sable brush to work on details and bristle brushes for the broader areas and elongated strokes. At the same time define the structure of the bridge more clearly.

This detail *(above)* shows a darker tone being applied over the initial area of light blue. A flat No 4 hog's hair brush is

used to dab in the color. The dark blue reeds *(below)* are brushed in with the side of the brush in curving, fluid strokes.

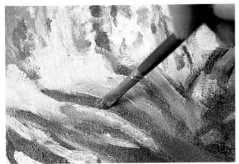

The waterlilies are highlighted with white, over pink and light orange tones which break up the predominance of blue

and green in the foreground. Wait until the underlying colors are dry to put in the white so it remains luminous and unmixed *(below)*.

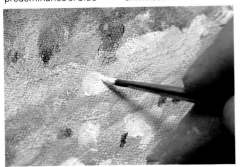

The final version

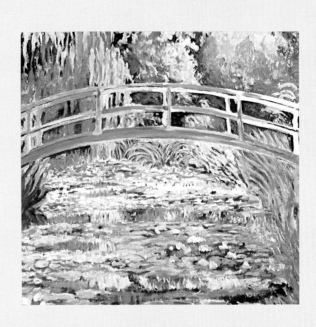

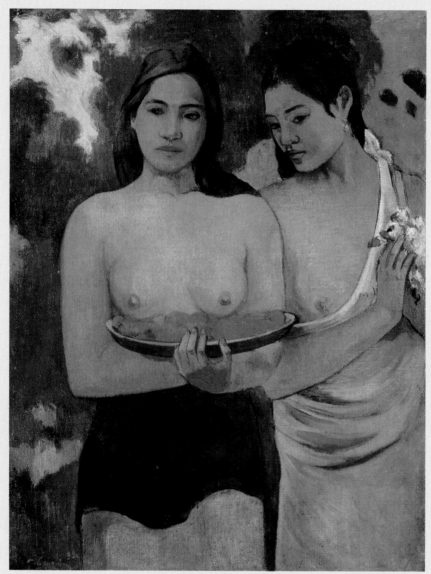

Metropolitan Museum of Art, New York

Gauguin

Tahitian Women, oil on canvas, 37 × 28¾in (94 × 73cm)
Gauguin's interest in sculpture and Tahitian carvings influenced his
approach to form in his later paintings. This work dates from his final visit
to Tahiti, just four years before his death. The figures are stylized and a
charcoal study for the figure on the right exists, suggesting that he did not
work wholly from life in this composition. The characteristic bold, matt
colors were evolved partly in response to the coarse, absorbent canvas
which he used when in Tahiti.

The Artist

**French artist
born 1848, died 1903
Painter, sculptor and printmaker
who worked in France and Tahiti**

Gauguin was an amateur painter and collector who at the age of 35 gave up his business career to become an artist. He was born in Paris, the son of a journalist and a Peruvian Creole mother. He spent part of his childhood in South America and served for six years as a merchant seaman. By 1871 he was in business on the Paris stock exchange. He painted as a hobby and was encouraged by the Impressionist Camille Pissarro (1830-1903) to take part in several exhibitions. Then, in 1883, Gauguin decided to give up business in order to live from his painting. He soon found that this was impossible, and had to resort to casual jobs to support himself and his family. In 1886, however, he left them and moved to Brittany where he met Emile Bernard (1868-1941), an undistinguished painter but an enthusiast for early Christian art. Gauguin began to develop a style which went against the ideas of Impressionism, and featured symbolic and religious images. *Vision After the Sermon* (1888), for example, shows peasant women watching a vision of Jacob wrestling with angels. Gauguin used areas of color enclosed by outlines. This was one of the original tenets of Symbolism which Gauguin saw as a synthesis of color and form, suggesting mental images or ideas, rather than recording direct visual experience. He often used heavy, unprimed, absorbent fabrics, which produced a texture visible beneath a thin, opaque layer of paint, and a matt surface. He sometimes added wax to the paint to make it duller. He usually used thick, opaque paint for both light and shade, emphasizing the simple, stylized figures and two-dimensional effect. In 1887 Gauguin traveled to Martinique. He remained there for several months before returning to France in poor health. The work he brought home impressed van Gogh (1853-1890) who persuaded Gauguin to stay with him in Arles. Gauguin finally emigrated to the South Seas in 1895. He succeeded in finding a new way of life with the islanders, and new subject matter in their myths and life style. In the eight remaining years of his life he painted many masterpieces, and his work has often been claimed to have opened the way for abstract art. His works remain popular today through many color reproductions.

Materials

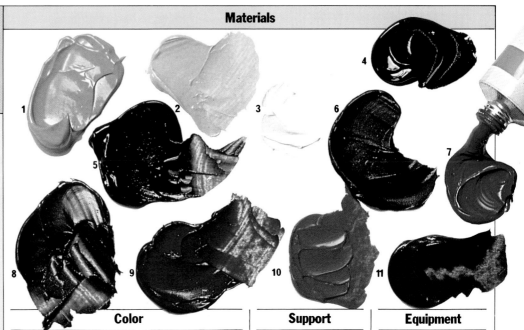

Color

Towards the end of his life, Gauguin painted using broad areas of color in bold oils. It is best to paint in the same medium to achieve a good version of this painting. A combination of raw umber *(6)* and ivory black *(4)*, well diluted in turpentine, are needed to redefine the basic pencil outlines. Burnt sienna *(11)*, titanium white *(3)* and raw umber make up the color of the hair. The green tones in the background are supplied by viridian *(8)*, sap green *(5)* and cerulean blue *(7)*. The main colors for the flesh are chrome yellow *(2)*, cadmium red *(10)* and yellow ochre *(1)*. Cobalt blue *(9)* is needed to paint in the clothing on both figures. Use turpentine rather than linseed oil for the medium.

Support

Use fine grained cotton duck for the support. Here the version was the same size as the original and stretched over a wooden frame. Prime the surface with a mixture of equal amounts of acrylic emulsion glaze and white emulsion paint. Apply two coats with a large decorator's brush. Make sure that the first coat is completely dry before applying the second.

Equipment

You will need a soft pencil and a ruler to square up the picture. Rub out any prominent grid lines with a putty rubber. Use a No 2 hog's hair flat to draw in the outlines. A No 4 hog's hair is needed for the initial blocking in. Fill in the large areas with a No 10 hog's hair flat. A No 4 synthetic round and a No 2 bristle flat will be useful for details.

1 Squaring up

Mark a grid on the print or photograph of the painting and square it up onto the canvas. Draw the outlines of the figures carefully with a soft pencil. Adjust the lines to make the shapes as accurate as possible and put in details of the facial features and hands. Once the drawing is finished rub out the grid lines with a putty rubber.

2 Drawing with the brush

Mix raw umber with black and thin the paint with turpentine. Use a flat No 2 bristle brush to reinforce the outlines of both figures and a No 4 brush to block in dark tones of the hair.

3 Blocking the dark tones

Paint the rest of the hair with raw umber, burnt sienna and white for the highlights. Mix the colors to make the darker tone, and brush in pure burnt sienna and white over the top to describe the warm glints and draped strands of hair. Use burnt sienna and raw umber again, diluted with turpentine and brushed on thinly, to lay in the dark tones behind the figures. The areas of color in this painting are quite well defined, but the tone is never flat and even. Look for the subtle modulations between warm and cool color. Apply raw sienna, modified with white, to the side of the fruit dish. Brush the colors together on the canvas rather than mixing tones on the palette.

4 Working on the background

Block in the background colors across the top and down the left side of the canvas. Keep the paint fairly thick and opaque and brush the tones into one another lightly at the edge of each shape. Use chrome yellow, cadmium red and yellow ochre to mix the orange and yellow hues. The heavy greens can be made from viridian and sap green, with white added at the right of the picture to produce the chalky tone, and cerulean blue to create the sea-green tinge. Cover broad areas with a flat No 10 hog's hair bristle brush and add lighter touches, such as the curve of cadmium red in the top left-hand corner, with a No 4 brush.

5 Painting the skirt

Add a little raw umber to black to enrich the tone and block in the skirt of the left-hand figure. Use a large, flat brush to fill the shape.

8 Modeling the blue dress

Using a flat No 4 brush, mix a cool gray from black, white and cobalt blue. Paint in flowing lines corresponding to the folds on the dress of the right-hand figure. Work over the whole area with cerulean blue, laying in the paint broadly with a No 10 brush. Modify the blue with a light yellow, a mixture of chrome yellow and white, to create the highlights on the folds. Blend the tones together with light strokes of a 2in (5cm) decorator's brush.

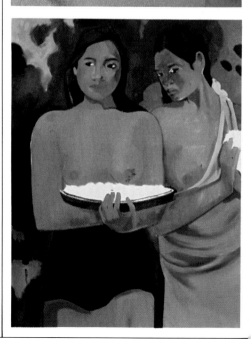

6 Putting in flesh tones

Create several vivid flesh tones with cadmium red, chrome yellow, burnt sienna and yellow ochre, lightened with white. Block in the faces and bodies, imitating the arrangement of orange, pink and brown hues. To emphasize the shadows, brush in thinned black and raw umber, modeling the forms loosely to give the general shapes and colors. Note that the face of the left-hand figure is only partly in shadow, whereas there is a dark, cool tone across the features of the second figure, showing how her head is turned from the light. The tones may be a little exaggerated at this stage and can later be modified.

7 Completing the first figure

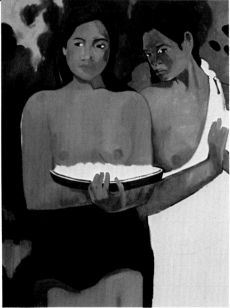

Add cadmium red to white and mix in a little cobalt blue, to make a mid toned pink tending to mauve. With the flat No 4 hog's hair bristle brush, block in the skirt of the left-hand figure, covering the remaining area of bare canvas below the dark tone. Darken the mixture with a little black to put in the heavy shadow over the hip. Brush in a lighter shadow and blend it well into the pure pink to show the curve of the skirt across the figure's legs. As you gradually cover the canvas, check the colors continually against the original to ensure that a correct balance of tone is emerging. The shapes in the composition are relatively simple .

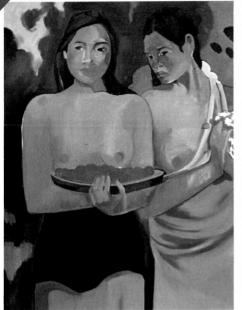

Adjust the tones in the background and loosen up the texture of the paint. Spread color with your fingers to blend the tones together and smudge the hard edges. Mix a dark green from viridian, black and sap green. Rework the shadows around the figures to give more intensity to the tonal contrasts. Emphasize this effect by bringing out shadows and highlights in the clothing of the right-hand figure. Use white with a touch of chrome yellow to describe the folds across her shoulder and breast and strengthen the yellow tone in the skirt. Complete the bunch of flowers in her hand with touches of white and orange-pink applied with a No 4 flat brush.

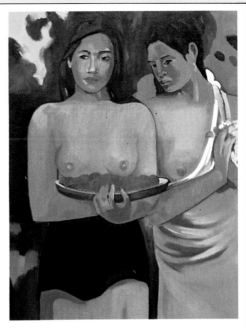

Use pure cadmium red, straight from the tube, to block in the cherries in the bowl. With the round No 4 synthetic brush sketch the circular shapes separately and then lay in solid color so there is some variation of tone suggesting the rounded forms. Suggest small areas of shadow with cobalt blue, thinned with turpentine and brushed lightly into the red. Lay a thin layer of chrome yellow over the tops of the cherries, to model the form against the blue shadows. Put in small patches of red to show the flowers held by the right-hand figure. Draw in the leaves with sap green, outlining the shape with a flat No 2 brush and modeling the curves with white.

The final version

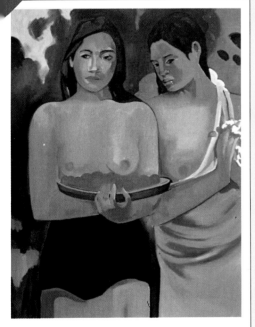

Having reached a stage where the canvas is fully covered, work on color corrections where necessary. The painting is characterized by the use of flat areas of color, lightly blended, to model the forms. Study the figures and rework the flesh tones, putting more depth in the shadows and a thicker layer of color over the bodies. Even the tone of the dark shadows on the face of the right-hand figure, adding cobalt blue to the dark colors to create a cool, vibrant contrast with the pink and orange tones. Heighten the light tones and define the features more clearly, drawing in linear detail with black and raw umber, using a flat No 2 bristle brush.

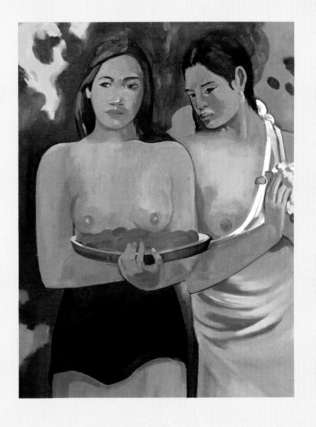

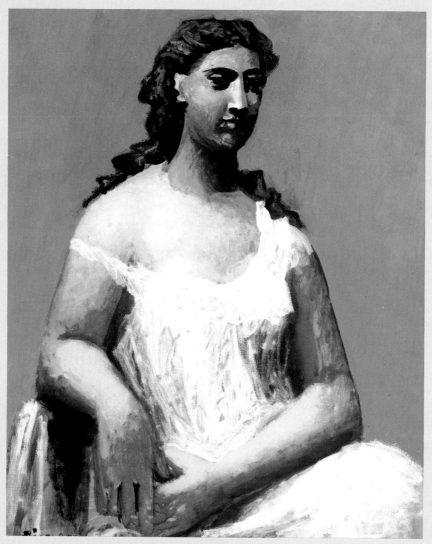

The Tate Gallery, London ©S.P.A.D.E.M.

Picasso

Seated Woman in a Chemise, oil on canvas, 36¼ × 28¾in (92 × 73cm)
Picasso did not reject the discoveries of his Cubist period, but he avoided
becoming trapped by them. He returned for a while to classical ideas in a
series of portraits and nudes. These combined elements of Cubism with
conventional vision, and volumes were emphasized through drawing. In
this brilliant example, the clear color scheme conveys both sunlight and
solid form, almost like a sculpture. The sense of weight and volume is
increased by the relative distortions of size in the hand and head.

The Artist

Spanish painter and sculptor born 1881, died 1973
Prolific and inventive artist, founder of Cubism

Throughout his long life, Picasso was responsible for many of the radical changes which have taken place in twentieth century art. Born in Malaga in southern Spain, he studied at the School of Fine Arts in Barcelona and at the Royal Academy of San Fernando in Madrid. Having been well tutored by his father, a painter, he easily surpassed the standards of the academic examinations. In Barcelona he came under the influence of French painting and he made three visits to Paris where he eventually settled in 1904. On his first visit to Paris he was impressed and influenced by the works of Henri de Toulouse-Lautrec (1864-1901) and Georges Seurat (1859-1891). He experimented with a number of different styles and rapidly mastered several painting techniques. In 1907 Picasso painted *Les Demoiselles d'Avignon* in which the figures appear to have been flattened into planes of color. This was a major break with all conventions of representation and the starting point of abstract art. Picasso was following the lead of Paul Cézanne (1839-1906) in the search for a new way to show solid forms on a two-dimensional surface. Together with Georges Braque (1882-1963) he developed the style known as Cubism from its affinity with geometric shapes. One of the techniques which became an integral part of Cubism was collage. Derived from the French word *coller* meaning 'to glue', collage involves sticking pieces of newspaper, cloth and any suitable objects onto a ground to form an abstract image. The materials used were often chosen for their representational value or else to provide some texture to the work. Picasso also used the principle of collage in his sculptures, making a bull's head, for example, out of parts of a bicycle. In his Cubist phase in the years around 1910, when Picasso painted an object, he depicted it from different angles to give the impression of a three-dimensional object even though it was painted on a two-dimensional surface. By 1918 Picasso started painting in a more naturalistic style, completing a series of female nudes on a monumental scale, though still keeping his Cubist technique and using unrealistic color schemes. As well as being an innovator in modern art, Picasso excelled in many other fields.

Materials

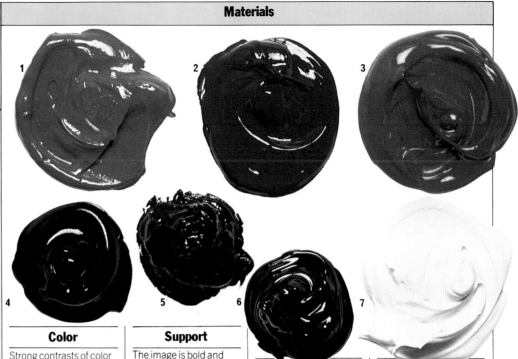

Color

Strong contrasts of color and tone give an effect of bright light. White acrylic (7) is heavily applied to the chemise and is the base for flesh tones, mixed with cadmium red (3), burnt umber (5) and yellow oxide. Cerulean blue (1) is the main background color modified with acra violet (6). Black (4) and French ultramarine (2) are added to the dark shadows.

Support

The image is bold and striking so it is advisable to work at the same size as the original. A smaller scale may prove inhibiting to the vigorous style and expressive brushwork. Work on a tightly stretched canvas, made from cotton duck over a wooden frame, secured with staples or tacks. This must be primed before painting.

Priming

A fairly heavy priming is needed to give a good tooth for the paint. It is not so vital to seal the surface when working with acrylics. Use a mixture of emulsion glaze and white emulsion paint. Apply it in two separate coats, leaving traces of the brushmarks on the surface.

Brushes

Use flat hog's hair bristle brushes, No 5 for blocking in and Nos 2 and 3 for more detailed work.

Mediums

A matt acrylic medium added to the paint gives it more fluidity. This is a liquid medium used in addition to water.

1 Squaring up and drawing the outlines

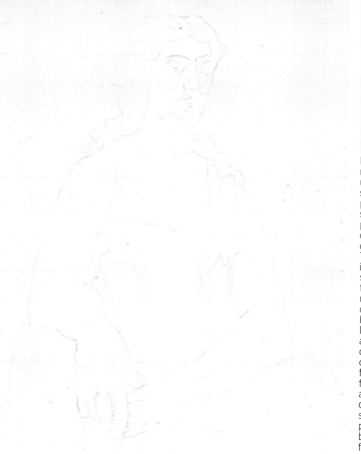

Measure the reproduction and draw up a suitable grid of small squares with a soft pencil. On the canvas, scale up the grid in strict proportion. Copy the outline and main features of the figure in pencil There is some distortion in the figure which gives it sculptural weight and form, so it is important to make a correct analysis of the relative scale of the head, limbs and body. Draw the lines quite accurately in pencil but do not spend too long on details once the basic form is established. The figure should be accurately located in the composition, but you should soon start painting, as the vigorous brushwork is a vital feature of the image.

2 Establishing dark tones

Lay out some burnt umber on the palette and dilute it with plenty of water. With a flat No 5 bristle brush, put in areas of dark tone. Apply the paint thinly at first and build up the heavier shadows gradually in the hairline, face and outlines of the arms. This stage acts as an initial modeling of the form over which a more complex texture is later developed in thick paint. Brush the dark brown washes freely over the surface of the canvas.

3 Laying in a tonal wash over the figure

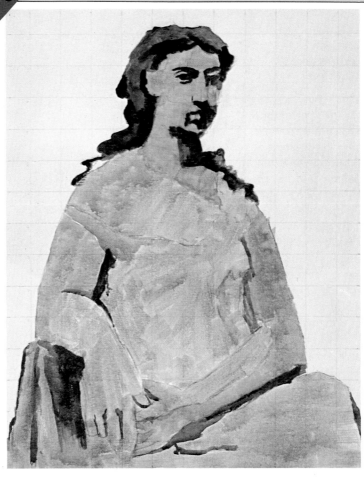

Thin down the wash of paint even further with clean water. Cover the whole figure with a light stain of burnt umber. Spread the wet color loosely with a large bristle brush to create an active texture in the brushmarks. This forms the basis of the tonal structure in the figure, as some of the initial underpainting will remain visible when the lighter colors, in the flesh tones and white of the chemise, are applied. Acrylic paint dries quickly so it is easy to build up color on the surface, over the existing dark tones.

4 Coloring the background

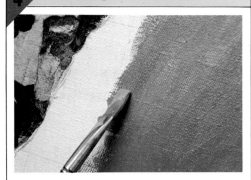

Mix light blue from cerulean blue and white. Do not dilute the paint but apply it to the background area thickly, using a No 5 bristle brush. To achieve the grading of tone towards the top of the canvas brush in more white.

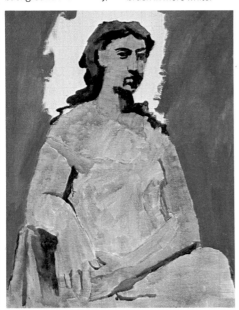

5 Developing tones in the background

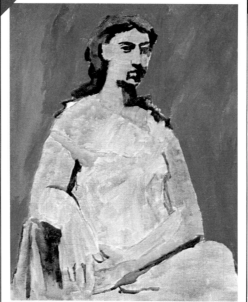

Add a touch of violet and more cerulean blue to the mixture to block in the area around the head. Again brush in small amounts of each color separately while the blue is still wet to imitate the tones in the original. Spread the paint heavily, leaving the marks of the brush showing to provide a rich background texture. Work closely around the outline of the figure.

6 Reinforcing the drawing

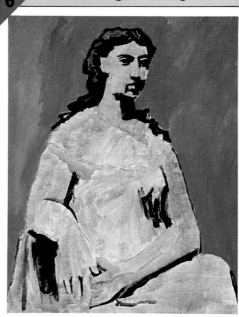

Reinforce the dark tones of the figure with a dark brown mixed from burnt umber, black and French ultramarine. Use paint with a creamy, fluid consistency and follow the shapes and rhythms created by the brushmarks in the original. Work boldly, noting the exaggerated, dark areas of shadow in the face and hair and the heavy mass of the body defined by linear marks.

7 Modeling the figure

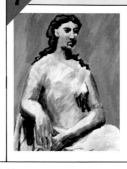

Paint in mid tones on the figure with thin washes of burnt umber. Remember that some of this modeling will remain visible in the final version and so it is vital to work over the whole figure, even where the basic form will be covered by the loose strokes describing the chemise.

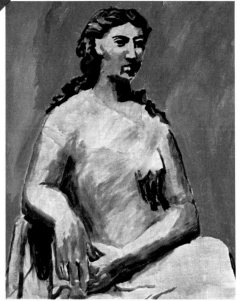

Develop the shape of the head and texture of the hair. Study the way the brushmarks are used to suggest the general fall of hair and separate curls. Work from light to dark, using black, burnt umber and yellow oxide, drawing the forms with a flat No 5 bristle brush and blocking in solid areas of color where appropriate. Then rework the light tones, adding white to a mixture of

yellow oxide and burnt umber to create a light beige for the highlights. Make small flourishes with the brush to imitate the effect of waves on the top of the head and falling around the shoulders. Use the same tone to begin modeling the face. The mood of the image depends upon the overall warm tone, laid in by the underpainting, and the high tonal contrasts.

Put in the middle tones of the flesh colors. Mix cadmium red with burnt umber and white to make a deep, opaque pink. Paint this color into the neck, face and arms, identifying those areas of the figure which are the same basic tone and color. Again, keep the texture rich and loosely brushed. The lower part of the face which is

shadowed has a neutral gray tone. Mix this tone from black, white and yellow oxide, and brush it in under the cheekbones, nose and chin and down the neck, into the heavy dark tone to the right. Do not cover the areas too broadly, as the tonal scale is created partly by contrast between thinly washed color and opaque shadows.

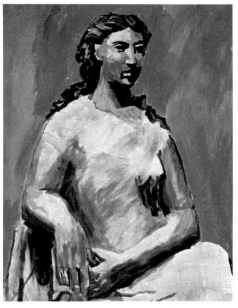

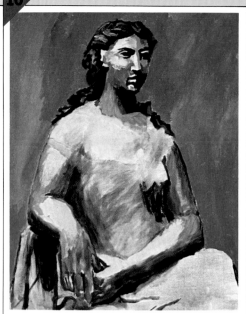

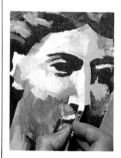

Block in the light skin tones with a pale pink mixed from cadmium red and white. Highlight the curves of the face with a No 3 bristle brush, putting in a thick layer of opaque paint. Draw the brush across the weave of the canvas to create broken color at the edges of the shapes. Cover the chest and arms with the same tone.

The final version

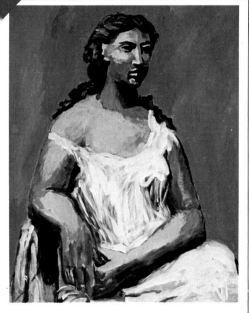

Brush in the chemise with vigorous strokes of a flat No 5 hog's hair bristle brush, working in pure titanium white straight from the tube. Imitate the marks as precisely as possible, but work with unrestrained gestures to build up the high tone. Make sure the modeling underneath is not completely covered. Having established the contrast between the

lightest and darkest tones, adjust the balance of the middle tones, working over the face and hair to develop the form and detail. With the No 2 bristle brush, emphasize the dark shadows and drawing of eyes and nose in a mixture of black and burnt sienna. Put small streaks of white across the light tones in the hair to suggest the highlights.

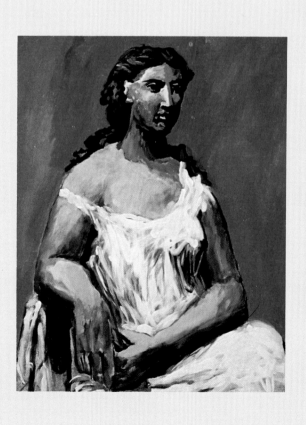

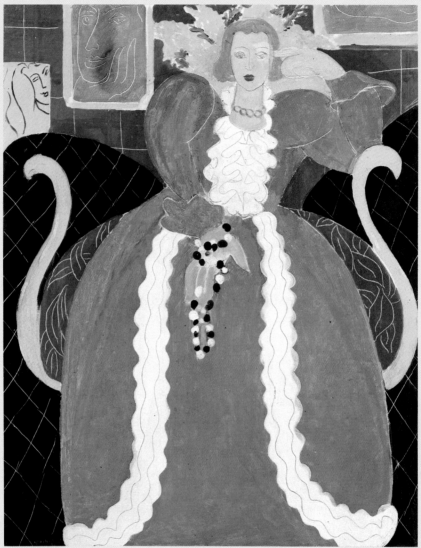

Philadelphia Museum of Art ⓒ S.P.A.D.E.M. (photo — Bridgeman Art Library)

Matisse

Lady in Blue, oil on canvas, 36½ × 29in (92.7 × 73.7cm)
Throughout his career, Matisse explored the expression of form in terms of
pure color. He simplified the shapes excluding tonal changes and cast
shadows, and introduced adjustments of relative scale, as in the
proportions of this figure. The model for the painting was Lydia
Delektorskaya, Matisse's secretary. While definitely a portrait, the
painting is also an abstract design in line and color, in which the figure and
ground share the same pictorial flatness.

The Artist

**French painter and sculptor
born 1869, died 1954
Leading modern artist who
explored color and form**

Matisse was never to become a wholly abstract artist, but he created a style of painting which led to new possibilities of pictorial design. He was born in northern France where his father was in business. The family were modestly prosperous and Matisse followed his father's plan for him to study law. He qualified and took up a professional career. While recovering from an illness Matisse began to paint, and in 1892 he realized that this was his vocation. He moved to Paris and enrolled in the class of the artist Gustave Moreau (1826-1898) at the Ecole des Beaux-Arts. Conscious of this late start, he spent five years as an exceptionally hard-working student, following the school curriculum and copying Old Masters. He experimented both with Pointillism and with the linear manner of Art Nouveau, but Matisse was struggling to create his own style, extending his means of expression in color. In 1905 he exhibited works with artists he had met at Moreau's studio. The show was not well received and the outraged critical reaction to the 'distorted' colors and shapes gave rise to the term 'Fauve', meaning 'wild beast'. The Fauve technique combined the expressive brushstrokes of van Gogh (1853-1890) with flat plains of saturated color associated with Gauguin (1848-1903). It marked a reaction to the polished finish of much nineteenth century French painting and to the realistic results of photographs. Matisse visited North Africa and studied Near Eastern art as he explored the use of pure color in expressive design. After 1917 Matisse lived for part of each year in the south of France. The subjects of his paintings were interiors, still lifes, reclining figures and nudes, and were usually highly decorative and colorful. In 1929 he summarized the ideas which had occupied him in the Fauve years by saying he had been searching for intense color with the aim of expressing light, because he believed light to be expressed by a harmony of intensely colored surfaces. From 1932 Matisse produced large-scale murals, in which color and shapes were further simplified. In 1943 he painted decorations for the Chapel of the Rosary at Venice. His aim, later in life, was to achieve harmony of color and shape, without losing the quality of either in the combination.

Materials

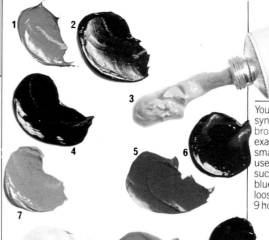

Brushes

You will need a large flat synthetic bristle brush for broad areas of color, for example a No 10. A smaller size, No 8, is used for small shapes such as the beads. The blue of the dress is loosely brushed and a No 9 hog's hair bristle brush is more suitable than a synthetic, being more resilient and of a stiffer texture. The brushwork is an important factor in the image. To put in linear detail which defines the forms use a round No 2 sable brush.

Color

Although the effect in this painting is of simple, vivid color, this is dependent upon mixing paints to obtain a precise hue. Acrylic colors are bright and easy to apply. The only colors applied straight from the tube are emerald green (1) and the cobalt blue (6) of the dress. The yellow is mixed from lemon yellow (3) and cadmium yellow (7). The predominant red is cadmium red (5) mixed with a little yellow. Red and yellow ochre (9) are used for the hair. The dark tone is a mixture of black (4) with burnt umber (2) and French ultramarine (10). Titanium white (8) is used quite liberally in the trimming of the dress.

Other equipment

The patterns in the background of the painting are made by scoring through the wet paint, rather than adding lines of white. For this you will need a palette knife with a short, pointed blade which is rigid and easy to control.

Mediums

Acrylic paint is water soluble but a range of mediums is available which alter the quality of the paint. Adding a liquid, matt medium gives the paint a more fluid consistency. To thicken it, giving a heavy texture to the brushmarks, you can add gel medium, a white paste which does not affect the color of the paint when dry.

Support

Buy a wooden stretcher of a suitable size and proportions. The copy shown here is on a canvas 30×24in (76×60cm). Tack heavy cotton duck over the stretcher, securing the edges on the back with staples or round-headed tacks. A canvas board could equally well be used and acrylics can also be applied to paper without priming.

Priming

Acrylics, unlike oil paints, do not attack the fibers of canvas as they dry to a tough, plastic skin. However, priming is necessary to produce an even, sealed surface, otherwise much of the initial paint application is dulled as the color seeps into the fabric. A mixture of ordinary white emulsion and a polymer medium fills and seals the absorbent canvas.

Apply three coats altogether and allow each one to dry out thoroughly before the next is brushed on. When the third coat is completely dry, rub the whole surface lightly with sandpaper. This smooths it and allows the paint to flow more easily, producing the flat areas of color which cover the background and area around the figure. If canvas board is used a similar priming process is advisable, as these boards are quite heavily textured and have a slight sheen which is sometimes resistant to the acrylic paint. The priming will ensure that the color goes on evenly and the brushwork can be controlled to obtain the desired effect.

1 Drawing up the composition

Square up the image by laying a pencil grid over the reproduction and draw a proportional grid on the surface of the canvas. Work lightly with the pencil to avoid making indentations in the stretched fabric. Using the grid as your guide, draw the outline of each shape. In this case, it is easy to assess the shapes distinctly as each area of color is bold and separate. Put in as much detail as you feel will be necessary to provide a sound basis for the painting but concentrate on describing shapes accurately. Pattern details such as the checks in the background can be tackled later.

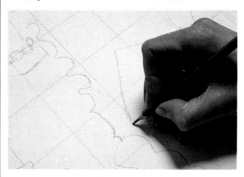

Make a vibrant yellow by mixing cadmium yellow and lemon yellow. Dilute the paint with water so it flows freely but does not run. Paint in the yellow shapes with a flat No 10 synthetic bristle brush, carefully following the pencil outlines. The original painting by Matisse was in oil, but the more recently developed acrylic paint is specially formulated to provide a flat surface and clear color. Pat in small dabs of white while the yellow is still wet.

Acrylic paint dries quickly and it is possible to keep colors quite separate even working continuously. Fill in the red areas next, using cadmium red with a touch of cadmium yellow added. The fine, white linear pattern is scored into the color, so work on a small area and score into it while the paint is still wet, then paint in another patch and score again. Use the point of a

trowel-shaped palette knife and judge the marks accurately in relation to the whole shape.

Next work on the black shapes and mix burnt umber and ultramarine with black to enrich the color. As for the red areas, cover a section and score in the diamond pattern while wet, then repeat the process until the black area is complete. Acrylic paint becomes rubbery as it dries, and scoring into paint which is too dry will make a ragged, clumsy line. If the color is wet the knife can be pulled lightly through the paint layer, baring the primed support to give a clean line. Although the surface is quite tough and resistant, it is only fabric, so be careful not to press too hard with the knife or the stretched surface may be dented and begin to sag. This technique is not difficult but it does require an accurate eye.

The broad areas of blue in the dress and behind the figure must be painted more expressively to follow the appearance of the original. Use a flat No 9 hog's hair bristle brush and apply cobalt blue paint mixed with a gel medium. The gel gives extra body to the paint so the broad brushstrokes are accentuated. This provides the necessary texture, for example in the sleeve and skirt on the left of the figure. A bold painting with vivid color such as this looks deceptively simple. Study the reaction of colors together carefully, both in the original and in your own painting, to be sure of achieving the correct effect. Use the scoring technique again to draw in the background face and lines of the sleeves.

The remaining white border down the front of the dress is given its texture in two layers of paint. First fill it in with a flat layer of blue, the same as the body of the dress. Work carefully into the shape leaving a fine white line at each edge to define the precise shape. Use a flat No 10 synthetic bristle brush to spread color accurately into the broad curves.

Allow the blue to dry completely before working on the next stage. Then paint over the shapes with titanium white. The paint is quite opaque so the blue can be covered quite easily, but since it is an intense color, traces may be seen through the white layer. The linear design is again scratched in with the pointed palette knife and this time appears in blue. Score into wet paint but try to keep the lines even and flowing although it may be necessary to divide the shapes into smaller sections. This technique effectively reproduces the style of the original painting but is not the actual method used. It may give a more delicate result than brushing the marks directly onto the surface.

Use emerald green with gel medium added to brush in the shapes of foliage behind the figure *(below)*. Study the shapes and draw them vigorously with the No 10 synthetic bristle brush. The gel retains the mark of the brush. Mix titanium white with cadmium red to make a vivid light pink. Paint in the face and hands and brush in touches of red while the paint is still wet to copy the brushwork and modeling of form in the original *(right)*. At this stage do not be concerned with details of the features, but aim for a basic rendering of shapes and tones. Then move on to painting the beads. The shapes of the initial drawing should still be quite clear. Work in black and white and use the No 8 synthetic brush to put in each small patch of paint *(far right)*.

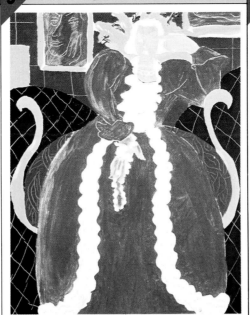

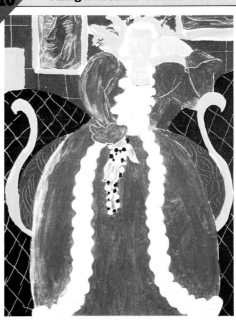

The final version

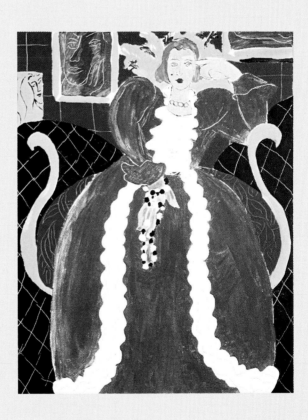

11 Completing the figure

Mix yellow ochre with a little cadmium red and paint the hair, allowing the brushmarks to suggest texture. Vary the thickness of the paint as you apply it, to make a contrast of light and medium tones. With yellow ochre and a No 10 synthetic bristle brush, outline the links of the necklace, mixing in red to darken the tone and suggest shadow in the curving shapes. With the smaller synthetic brush draw in the broad line of the lips, using cadmium red. The final stage is to draw in the dark lines defining the head and features. Mix black with a little green and dilute the mixture to make it fluid but still controllable. With a No 2 sable brush outline the eyes, nose, face and hands and the head in the yellow picture.

Mondrian

Composition with Red, Yellow and Blue, oil on canvas, 27 × 28in (69 × 72cm)
This picture is one of a series of wholly abstract paintings using limited
color by Mondrian. The design relates strongly to forms derived from
natural objects which he studied in preliminary drawings. Mondrian's
sense of design became gradually more abstract, resulting in these highly
disciplined works using primary colors, black and white on a grid
structure.

The Artist

**Dutch artist
born 1872, died 1944
Pioneer of geometric abstraction in
Europe and the United States**

The Dutch artist Piet Mondrian was one of the best known and most single-minded exponents of abstract art. He was born in Amersfoort in central Holland and lived there until 1905 working as a landscape painter, following in the footsteps of his uncle Frits Mondrian, a respected artist. These early works used a muted palette in which grays and dark greens were the dominant colors. He was also a very good draftsman. Mondrian's paintings of around 1905 included bright colors and showed the influence of van Gogh (1853-1890), Georges Seurat (1859-1891) and the Norwegian painter Edvard Munch (1863-1944). However, after 1911 when Mondrian moved to Paris and came into contact with members of the Cubist movement, his work gradually changed. Mondrian had begun to equate naturalistic representation with subjectivity, and he wanted to achieve a less personal and more objective artistic style. To do this, he gradually reduced the elements in his paintings until only the fundamental units of the painting remained. Soon Mondrian's works were based solely on a grid and consisted purely of horizontal and vertical lines criss-crossing at right-angles. His paints became flat planes of the primary colors red, blue and yellow, together with the non-colors black, white and gray. Mondrian wrote extensively about his theories of art, developing his ideas particularly with his fellow Dutchman Theo van Doesburg (1883-1931). The main vehicle for Mondrian's ideas was the magazine *De Stijl* which he founded with van Doesburg in 1917. Mondrian called his theories and style of abstract painting Neoplasticism. Mondrian always took his ideas about art and form extremely seriously and, indeed, parted company with van Doesburg in 1925 because van Doesburg had introduced diagonal lines into a painting, and Mondrian found this practice unacceptable. The strict grid paintings were not popular with the public, and Mondrian often had to earn his living by selling paintings of flowers which he did in watercolor. In 1939 Mondrian moved to London and the following year to New York. His style is easily recognized because of its apparent simplicity, and he adhered to his ideas of artistic objectivity throughout his career.

Materials

Priming

Use heavy, fine grained cotton duck as the support. For the best effect, make your version the same size as the original. Working in exact proportions also eliminates any complications that might occur when transferring the lines onto the support from the reproduction.

Mediums

Use a matt acrylic medium rather than gloss. The latter tends to form a skin which will tear when the tape is lifted.

Support

Once the support has been stretched on a wooden frame it should be primed. Cover the surface with three coats of an acrylic emulsion. When the final coat is dry, paint over the primer with white acrylic. This provides a good base on which to paint and also reduces any chance of the fresh paint bleeding under the masking tape. It also helps prevent brushstrokes from showing.

Other equipment

Apart from the support, paints and brushes, the most essential material needed for this painting is a roll of wide masking tape. This ensures that the lines in the composition can be kept as straight and well defined as possible.

Brushes

Only a few brushes are required. Although it might seem more sensible to fill in the large areas of color with a fairly big brush, it is best to work with small ones as great care must be taken when painting next to the masking tape. A 1in (2.5cm) and ½in (12mm) synthetic brush are the main brushes needed. A No 5 flat hog's hair is also useful.

Color

Pure, unmixed colors are used in this painting but you still need a palette as the paint must be quite fluid when it is applied to the painting. Work in acrylic, which is the same paint as the original, and dilute the paint with an acrylic medium. The colors required are black (1), cobalt blue (2), cadmium red (3), white (4) and cadmium yellow (5).

1 Drawing the grid and masking horizontals

Measure the composition carefully to establish the precise spacing of the horizontal and vertical lines, allowing for the thickness of the lines themselves. Scale up the measurements on to the canvas, marking them out along each edge. Draw in all the lines with a sharp, hard pencil, using a ruler long enough to reach right across the canvas (*right*). Lay strips of masking tape along the pencil lines to isolate the black horizontals (*below*). Keep it straight and precise and rub down the edges firmly with your fingertips.

When the masking tape is firmly rubbed down, paint over the edges with clear matt medium to seal them and prevent color bleeding under the tape when you paint in the black lines.

2 Painting the horizontals

Tape each side of the horizontal lines in the same way (*above*). If the canvas is not quite the same proportion as the original, tape the edges to give a white border around the actual design. Seal the tape with matt medium, let it dry and then paint in the lines with pure black, using broad strokes of a flat 1 in (2.5cm) brush (*below*).

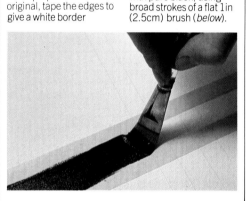

3 Peeling off the tape

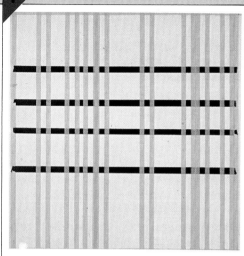

Paint all four of the black horizontals which cut right across the canvas (*below*). Let the paint dry to a matt finish and then peel back each piece of tape separately (*above*).

Lift one end and pull the tape up from the canvas, back along the straight line as it was originally laid. Work quickly but carefully and check that the paint is not smudged.

4 Masking the verticals

Apply masking tape to each side of the verticals (*above*). Make sure you follow the ruled lines exactly as masking tape tends to curve as it is laid and this may not be visible until it is too late. Rub down the tape firmly and paint over it with matt medium to seal the edges. If necessary mark the lines to be painted lightly with pencil, as the design can become confusing when taped.

5 Painting the verticals

Paint the verticals with an even layer of black, using the same wide flat brush as before. As you work check that the masking tape is firmly adhered to the canvas. It will not stick properly if the paint underneath is not fully dry. If the tape is well sealed with medium, you can work quite freely over the edges and the outlines will remain clean. Let the paint dry thoroughly and then peel off the tape. Take up each piece separately from one end and pull it away down the length of the canvas.

6 Putting in the short horizontals

Check the measurements of the grid and draw in the two short horizontals in the lower right-hand section of the painting. Make sure the paint is quite dry on the verticals and then tape up and seal the short lines. Let the medium dry and brush in the black. Again wait until the paint has dried fully before taking off the tapes. This step establishes the shape of the red section and the colors can now be applied.

Masking the rectangles and painting in the yellow

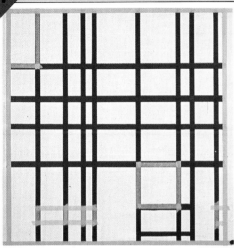

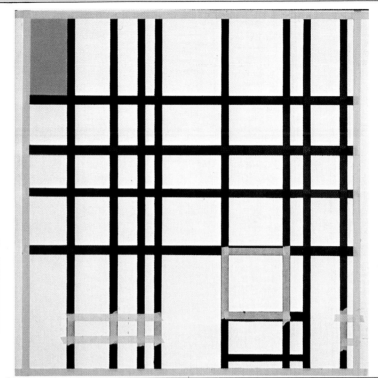

Paint over the edges of the tape with medium, using a ½in (12mm) brush, and leave it to dry. Fill in the yellow shape smoothly, applying color straight from the jar. Some acrylics are made to a free-flow formula and it is easy to achieve a flat, even surface, working with a No 5 hog's hair bristle brush. If you are using tube paint, brush in all directions to smooth out the paint layer, putting the color on quite thickly. Make sure the brush is perfectly clean to start with or the impact of the pure color against the black and white grid will be spoilt. Let the color dry thoroughly before peeling off the masking tape.

Apply masking tape around each shape which is to be filled in with color. Starting in the top left-hand corner, carefully mask off the yellow rectangle, rubbing down the tape over the black .

Repeat the process to mask the red rectangle. Draw the blue bar and small red shape in the lower part of the grid and apply tape along the pencil lines and over the black paint.

The final version

Completing the colors

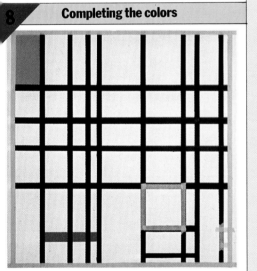

Paint in the blue bar in the lower right-hand side of the picture. Make sure the black lines crossing the shape are precisely

masked and sealed. Again keep the color clean and flat. Finally paint the red shapes and remove the tapes.

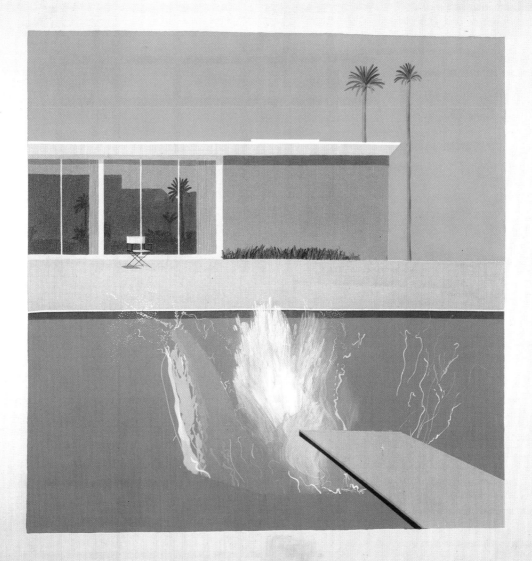

The Tate Gallery, London © David Hockney 1967 Courtesy Petersburg Press

Hockney

A Bigger Splash, acrylic on canvas, 95½ × 96in (242 × 243cm)
Hockney's paintings graphically capture the character of a place or person
and the prevailing mood of a scene. His sharp, witty observation of his
surroundings is matched by the masterly and versatile handling of his
media. Here he uses bright color and emphatic shadows to describe the
heat, flat light and stillness of a Californian summer, broken by the sudden
eruption of the splash, the only indication of human activity. Fast drying
acrylic paint provides the precision and clarity crucial to the image.

The Artist

British painter
born 1937
Leading modern artist skilled in
many media and techniques

David Hockney is one of the world's leading contemporary artists. He has exercised his wide ranging talents in several media and areas of art including book illustration, etchings and theatrical set designs. He was born in Bradford, Yorkshire in 1937. He attended Bradford College of Art before moving to London to study at the Royal College of Art. Hockney's precocious and controversial talents quickly attracted attention and, in 1961, he was one of the artists featured in an influential and important exhibition entitled 'Young Contemporaries'. Hockney's early work shows the influence of contemporary American art and Pop Art both of which were important at the time. His early drawings were done in an apparently rough, almost scribbled style and often showed the influence of graphic design and images. Hockney has made frequent visits to the United States since the early 1960s, and these have supplied the themes and settings for many of his subsequent works. Hockney has painted many portraits of friends which reveal his versatility with the medium of acrylics. The advent of acrylics and their increasing popularity from the 1950s has been one of the most important technical innovations in painting since the development of oil as a painting medium. Acrylic is water soluble, dries quickly and can be used to create a wide variety of effects. Hockney has particularly exploited the broad, flat effects which can be achieved with acrylic. For example he has painted scenes of California, some even from photographs, which try to convey the strong, bright light by using acrylic applied with small rollers to give an even effect. The Californian series of paintings of swimming pools and studies of water exemplify Hockney's more mature approach in which he tries to combine naive and sophisticated painting techniques. Hockney has said that he likes to experiment in order to find new possibilities in painting. Hockney has traveled widely and is a keen observer of landscape. He has also done many drawings of male nudes which have reintroduced a theme which was popular in Renaissance times, but has since fallen into neglect. Hockney's work in other areas as well as painting has made his work known to a wide public.

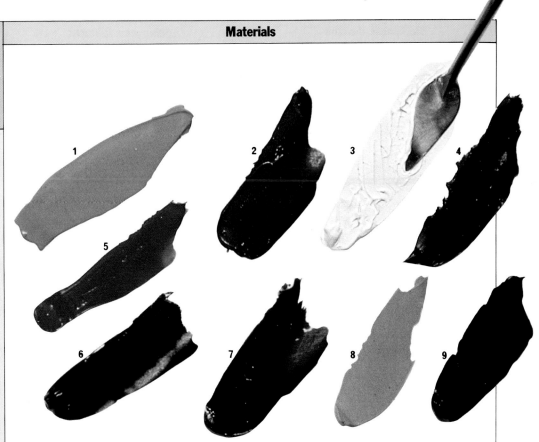

Color

Acrylic paint is used here as in the original painting. It has more suitable properties than oil for work involving masked areas and broad expanses of flat color. The basic color of the sky and pool is monastral blue *(2)*. The warm tones are mixtures from yellow ochre *(1)*, raw umber *(4)*, burnt sienna *(5)* and a touch of alizarin crimson *(7)*. The window

reflection, grass and palm trees are given a green cast with viridian *(6)* and cadmium yellow *(8)*. Black *(9)* is added to create the dark tones and white *(3)* is heavily used for highlights, details of the splash itself and to lighten the color mixtures. A correct imitation of the tonal qualities of the image is important.

Mediums

It is necessary to obtain a fluid consistency in the paint so flat areas of color can be covered evenly. This can be achieved by mixing the paint with a gloss medium. Liquid acrylic mediums are quite thin so make sure the color is well dispersed before you start to paint. Add water as well and do not allow the surface to become too glossy.

Support

Use linen as the support, stretched and primed with white emulsion primer. The original painting is quite large and if you wish to scale it down, keep to a size which will be suitable for painting mainly with brushes. Here the size used is 29 × 29in (73 × 73cm).

Equipment

The basic divisions of color in the composition are created by masking areas with adhesive tape and painting in flat color using a sponge roller. The masking tape is applied accurately around the outline and rubbed down firmly to the canvas with the fingertips. Follow the lines of the drawing carefully and do not try to lay a straight line of tape without a guide as the tape bends almost imperceptibly and this can cause considerable distortion in the image. Always let a freshly painted area dry completely before applying more tape. Peel off the tape when the new color is dry. You will need two small sponge rollers, a roll of masking tape, a No 6 bristle flat and a No 4 sable brush for details, and a pencil and ruler for squaring up.

1 Blocking in the blue

Square up the image and stick masking tape around the edge of the sky and pool. Then paint in the pool with monastral blue diluted with water. Use a roller to cover the surface quickly and evenly. Block in the sky with a paler color made from white and monastral blue. Leave the tape in place (*top*) until the paint is dry to touch. Then peel it away (*middle*) to reveal the straight edges (*above*). Tape around the diving board next. On the left-hand edge overlap the tape so that a white margin will remain. Paint the board with a mixture of yellow ochre, black and white (*below*).

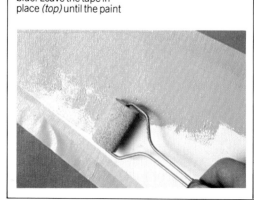

2 Adding main features

Mask off the patio with tape to leave a white border with the pool. Block in a pale color of white, burnt sienna and a little alizarin. When this is dry, mask off the wall and paint with yellow ochre, white and burnt sienna.

3 Putting in dark tones

Mask off each area before painting it. Put in the black on the edge of the board and pool. Leave the white line along the patio. Paint the roof with yellow ochre and white and the shadow it casts with burnt sienna and yellow ochre.

4 Painting the window

Paint the curtains black with a No 6 bristle flat. Over this put stripes of yellow ochre, raw umber and white. Leave the window frames bare. Paint the reflection with raw umber, monastral blue, black and white. Use a No 4 for the palm.

5 Applying details

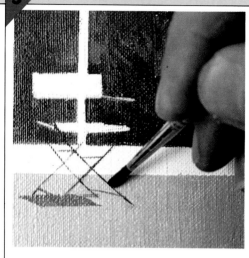

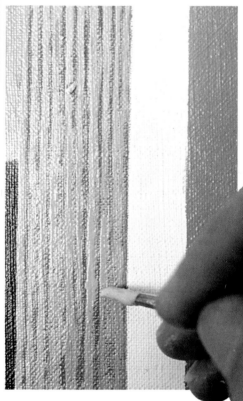

Draw in the legs of the chair on the patio with a No 4 sable brush (*top*). Use a mixture of raw umber and black. Then build up the curtains further with yellow ochre and white (*above*). Apply the paint quite thickly. Put in the palm trees and the grass along the bottom of the wall with raw umber darkened with black (*below*). Use small strokes.

6 Adding highlights

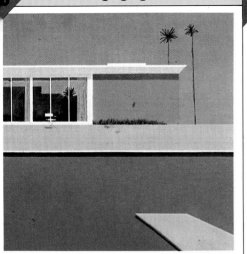

Mix together some cadmium yellow and monastral blue to make a fairly pale green. Working with a thin brush, like a No 4 sable, paint in highlights on the grass. Use short brushstrokes and do not use the paint too thickly. Try to follow the original as closely as possible. Use the same paint to add a few highlights to the palm trees. However, paint in most of the leaves with viridian and black. Highlight the trunks with white and burnt sienna.

7 Outlining the splash

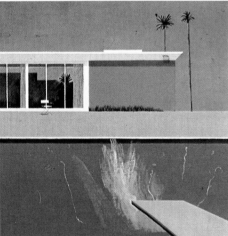

Next, put in the basic shape of the splash (above). Use white with just a little monastral blue added to it. Work with a No 6 flat bristle brush. Drag the paint over the surface so that the texture of the canvas shows through (top). Visualize where the splash lies in relation to the diving board before you start to paint. The whitest part should be above the left corner of the board. Move the brush freely, laying down one brushstroke on top of another. Build up the paint in thin layers rather than applying it in a solid mass. Refer back to the original as you paint.

8 Completing the splash

Finally, add more detail to the splash to give it body. Using pure white intensify the wide splash line on the left (below). With the tip of a No 4 sable brush, dab little dots of white for the spray (right). Place the dots in small groups extending up over the side of the pool. Add some more thin trickles on the right of the splash and then increase the density in the middle. Cross-hatch the strokes to make a solid area of white in the middle of the splash (below right).

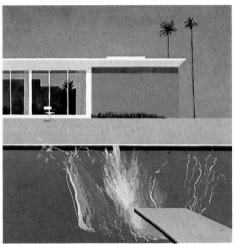

The final version

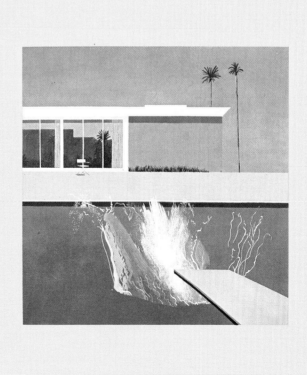

157

Index

A

Numbers in italics refer to illustrations

Acrylic mediums *13*
Acrylic paint *12*

B

Binder, linseed oil *13*
Boards 16, *17*
 priming *19*
Botticelli: *The Birth of Venus* (*c*1485) 28-31
 biographical notes 29
 brushes *29*
 colors *29*
 final version *31*
 other equipment *29*
 step-by-step procedure *29-31*
 support *29*
Brushes, choice of 14
 for oil and acrylic *15*
 for priming *14*
 for watercolor *15*
 hog's hair bristle *14*
 quality *14*

C

Canvas, choice of 16, *17*
Canvas, preparation of:
 priming *19*
 stretching *18*
Cassatt: *The Sisters* (1885) 112-15
 biographical notes 113
 colors *113*
 equipment *113*
 final version *115*
 priming *113*
 step-by-step procedure *113-15*
Cézanne: *Mont Sainte-Victoire* (*c*1885) 108-11
 biographical notes 109
 brushes *109*
 colors *109*
 final version *111*
 mediums *109*
 priming *109*
 support *109*
Chardin: *Still Life: The Kitchen Table* (*c*1731-1734) *72-5*
 biographical notes 73
 brushes *73*
 colors *73*
 final version *75*
 mediums *73*
 other equipment *73*
 priming *73*
 step-by-step procedure *73-5*
 support *73*
Constable: *Boatbuilding near Flatford Mill* (1815) 76-9
 biographical notes 77
 colors *77*
 equipment *77*
 final version *79*
 mediums *77*
 support *77*
Craquelure effect, to produce *20*

D

Degas: *Woman Combing her Hair* (*c*1886) 120-3
 biographical notes 121
 colors *121*
 equipment *121*
 final version *123*
 step-by-step procedure *122-3*
 support *121*
Diluents *13*
Drawing materials *15*
Dürer: *Young Hare* (1502) 32-7
 biographical notes 33
 brushes *33*
 colors *33*
 final version *37*
 other equipment *33*
 step-by-step procedure *34-7*
 support *33*

E

Equipment, choice of 14, *14-15*
 brush for priming *14*
 brush quality *14*
 brushes for oil and acrylic *15*
 brushes for watercolor *15*
 drawing materials *15*
 hog's hair bristle brushes *14*
 mahl stick *15*
 painting kits *15*
 palette knives *15*
 palettes *14*
 rags and sponges *14*

F

Finishing a painting:
 craquelure effect *20*
 varnishing 20
Framing 20, *20-1*
 corner clamp *21*
 cutting miter *21*
 double corner clamp *21*
 parts of shadow box frame *21*
 spring clamp *21*
 tools *21*
 types of moldings *20*

Index

G

Gauguin: *Tahitian Women* (1899) 138-41
biographical notes 139
colors *139*
equipment *139*
final version *141*
step-by-step procedure *139-41*
support *139*

H

Hockney: *A Bigger Splash* (1967) 154-7
biographical notes 155
colors *155*
equipment *155*
final version *157*
mediums *155*
step-by-step procedure *156-7*
support *155*

L

Leonardo da Vinci: *Mona Lisa* (c1502) 38-43
biographical notes 39
brushes *39*
colors *39*
final version *43*
mediums *39*
priming *39*
step-by-step procedure *39-43*
support *39*
Linseed oil:
as binder *13*
as medium *13*
types *13*

M

Mahl stick *15*
Manet: *Olympia* (1863) 88-93
biographical notes 89
colors *89*
equipment *89*
final version *93*
mediums *89*
priming *89*
step-by-step procedure *90-3*
support *89*
Materials *see Drawing materials, Paint, etc*
Matisse: *Lady in Blue* (1937) 146-9
biographical notes 147
brushes *147*
colors *147*
final version *149*
mediums *147*
other equipment *147*
priming *147*
step-by-step procedure *147-9*
support *147*
Media, choice of 12, *12*
acrylics *12*
oils *12*
pastels *12*
watercolors *12*
Mediums *13*
for acrylics *13*
linseed oil *13*
poppy oil *13*
Michelangelo: *Delphic Sibyl* (1508-1512) 44-7
biographical notes 45
brushes *45*
colors *45*
final version *47*
other equipment *45*
step-by-step procedure *46-7*
support *45*
Millet: *The Gleaners* (1857) 84-7
biographical notes 85

brushes *85*
colors *85*
final version *87*
mediums *85*
other equipment *85*
priming *85*
step-by-step procedure *85-7*
support *85*
Mondrian: *Composition with Red, Yellow and Blue* (c1937-1942) 150-3
biographical notes 151
brushes *151*
colors *151*
final version *153*
mediums *151*
other equipment *151*
priming *151*
step-by-step procedure *151-3*
support *151*
Monet: *The Waterlily Pond* (1899) 134-7
biographical notes 135
brushes *135*
colors *135*
final version *137*
priming *135*
step-by-step procedure *135-7*
support *135*

O

Oil binders and mediums *13*
Oil paint *12*

Index

P

Paint, choice of 12, *12*
 acrylic *12*
 oil *12*
 watercolor *12*
Painting kits *15*
Palette knives *15*
Palettes, choice of *14*
Papers *16*
 right and wrong sides *16*
 stretching *19*
Pastels *12*
Picasso: *Seated Woman in a Chemise* (1923) 142-5
 biographical notes 143
 brushes *143*
 colors *143*
 final version *145*
 mediums *143*
 priming *143*
 step-by-step procedure *143-5*
 support *143*
Pointillism (Seurat) *117*
Poppy oil as medium *13*
Preparing for painting *19*
Priming canvas or board *19*
 choice of brush *14*

R

Rembrandt: *A Woman Bathing in a Stream* (1655) 62-7
 biographical notes 63
 colors *63*
 final version *67*
 mediums *63*
 other equipment *63*
 priming *63*
 step-by-step procedure *63-7*
 support *63*
Renoir: *Woman's Torso in Sunlight* (1875) 104-7
 biographical notes 105
 brushes *105*
 colors *105*
 final version *107*
 mediums *105*
 priming *105*
 step-by-step procedure *105-7*
 support *105*
Rossetti: *Proserpine* (1874) 98-103
 biographical notes 99
 brushes *99*
 colors *99*
 final version *103*
 other equipment *99*
 priming *99*
 step-by-step procedures *100-3*
 support *99*
Rubens: *Portrait of Susanna Lunden* (c1620-1625) 56-61
 biographical notes 57
 brushes *57*
 colors *57*
 final version *61*
 mediums *57*
 other equipment *57*
 step-by-step procedure *57-61*
 support *57*

S

Seurat: *Bridge at Courbevoie* (1886) 116-19
 biographical notes 117
 brushes *117*
 colors *117*
 final version *119*
 mediums *117*
 Pointillism *117*
 step-by-step procedure *118-19*
 support *117*
Squaring up an image *19*
 diagonal division method *19*
 simple grid method *19*
Stretching canvas *18*
Stretching paper *19*
Support, choice of 16, *16-17*
 fabric (canvas) 16, *17*
 papers *16*
 wood *17*
Support, preparation of 18, *18-19*
 priming *19*
 squaring up *19*
 stretching canvas *18*
 stretching paper *19*

T

Titian: *Mother and Child* (1570-1576) 48-51
 biographical notes 49
 brushes *49*
 colors *49*
 final version *51*
 mediums *49*
 step-by-step procedure *49-51*
 support *49*
Toulouse-Lautrec: *Jane Avril Dancing* (1892) 128-33
 biographical notes 129
 colors *129*
 equipment *129*
 final version *133*
 mediums *129*
 priming *129*
 step-by-step procedure *130-3*
 support *129*
Turner: *Norham Castle* (c1845) 80-3
 biographical notes 81
 brushes *81*
 colors *81*
 final version *83*
 other equipment *81*
 priming *81*
 step-by-step procedure *81-3*
 support *81*

V

Van Eyck: *Man in a Turban* (1433) 24-7
 biographical notes 25
 brushes *25*
 colors *25*
 final version *27*
 other equipment *25*
 priming *25*
 step-by-step procedure *25-7*
 support *25*
Van Gogh: *Cornfield and Cypress Trees* (1889) 124-27
 biographical notes 125
 brushes *125*
 colors *125*
 final version *127*
 priming *125*
 step-by-step procedure *125-27*
Varnishes *13*
Varnishing 20
Velazquez: *Old Woman Cooking Eggs* (1618) 52-5
 biographical notes 53
 brushes *53*
 colors *53*
 final version *55*
 other equipment *53*
 priming *53*
 step-by-step procedure *53-5*
 support *53*
Vermeer: *Head of a Girl with Pearl Earring* (c1665) 68-71
 biographical notes 69
 brushes *69*
 colors *69*
 final version *71*
 mediums *69*
 priming *69*
 step-by-step procedure *69-71*
 support *69*

W

Watercolor paint *12*
Whistler: *Harmony in Gray and Green* (1873) 94-7
 biographical notes 95
 brushes *95*
 colors *95*
 final version *97*
 mediums *95*
 other equipment *95*
 step-by-step procedure *95-7*
 support *95*